THE
BABY
GAME

THE
BABY
GAME

Randall Hicks

W

W O R D S L I N G E R P R E S S

San Diego, California

THE BABY GAME. Copyright © 2005 by Randall B. Hicks. All rights reserved. Printed in the United States of America. No part of this book may be used or reproduced in any manner whatsoever without written permission, except in the case of brief quotations embodied in critical reviews or articles. For information, contact WordSlinger Press, 9921 Carmel Mountain Road, Suite 335, San Diego, CA 92129. WordSlinger Press books are distributed by SCB Distributors, 15608 S. New Century Drive, Gardena, CA 90248, www.scbdistributors.com

www.wordslingerpress.com

 Library of Congress Cataloging-in-Publication Data

Hicks, Randall, 1956-
 The baby game / Randall Hicks. – 1st ed.
 p. cm.
 ISBN 0-9631638-5-X
1. Adoption–Fiction. 2. California, Southern–Fiction. 3. Adoption–Law
 and legislation–Fiction. I. Title.
 PS3608.1285B33 2005
 813'.6–dc22

 2005043658

First Edition

10 9 8 7 6 5 4 3 2 1

For my children,
Ryan and Hailey

Don't take life too seriously. You will never get out of it alive.

—Elbert Hubbard

Acknowledgments

Writing may be solitary, but the final product is through the help of many. So in no particular order, I would like to thank:

My wife, Angela, for not kicking me out of bed when my cold feet and I came to bed late, night after night, as I stayed up to write "just one more page."

Jeff Parker for his encouragement, and letting me hold his Edgar—for a small hourly fee.

Maddy Van Hertbruggen, 4MA grand diva, for the kind words and support. There's no one with whom I'd rather discuss books over an ice cold Coke, with or without the cherries.

The first draft readers who had the *cajones* to make lists of recommended changes: Bill Rockey, Gary Ritchie, Rita Parker, Angela Hicks, Carmi Cosmos, Barbara "Barfly" Fister and Tammy Rendon. Special thanks to Brian Wiprud, whose helpful thoughts continued until the bar closed down.

The best club tennis pro ever, Mark Littrell of the Pala Mesa Country Club, for the tennis lingo, and for not giving up on my volleys.

My doctor friends who patiently explained all things medical, without once making me get undressed: Drs. Tammy Hayton, Kevin Milke and Paul Hartfield.

Gregory McDonald, whom I have not yet had the good fortune to meet, for writing my favorite book, *Fletch*. When I first read it twenty-odd years ago I told myself, "Someday I'm going to write a book like that."

My editor, Bill East, for the friendship, and buying me lunch to celebrate finishing the book. . . thanks for giving me the bigger half of the *Subway* footlong.

Please blame one of these people for any errors. I can't handle the guilt.

1

I SWEAR, SAMMY was going to pop.

"Will you stop looking at me and watch the damn road?" Coming from Sammy in the back seat, it was an order and not a question.

Normally, it's not the job of the adoption attorney to drive a birth mother to the hospital, but when she's selected your two best friends as the adoptive parents, and she's temporarily almost your next door neighbor, it seems natural.

My cell phone rang at a few minutes after two a.m. Sammy. In labor. I had only done twenty-four adoptions prior to Sammy, my stumbled-into-specialty, but from what I've seen labor never seems to occur between nine to five. Since I'm basically a paper jockey, I usually visit the hospital the day after the birth, when the tough stuff is over. Flowers and a card and I'm out of there. "Wasn't it sweet of him to come by," echoing behind me.

"Son of a *biiiiitch*," Sammy moaned, which turned into a scream designed to reincarnate Satan.

I adjusted my rearview mirror to see if her head was spinning around. Or maybe that monster from *Alien* had escaped Sigourney Weaver's womb and was now sticking its head out of Sammy.

"Call the hospital, Toby! Tell them I want *drugs. Lots of drugs.*"

"But you told me you wanted a completely natural birth. No epidural. No medication to affect the baby. They have the immersion tub ready and the whale sounds tape, and—"

Another scream direct from hell. "Screw the whale sounds! *Get. . . me. . . drugs!*"

I would have preferred if she were in the front seat next to me so I could keep my eyes on her, but the Indian filled the seat. As a prank, my friend Brogan had bought me a life-sized wooden Indian when I graduated from law school. A year later, it was still there, unable to be wedged free, its feet hooked under the dashboard, and the passenger seat reclined to the max. This left only one seat in my two-tone, red over white '64 Ford Falcon convertible. Directly behind me.

I thought a reassuring pat was in order, so I reached behind me blindly to soothingly pat Sammy's leg. Given that she was nineteen to my thirty-two, I made sure it was fatherly, or at least big brotherish.

"*Pervert! Get your hands off me!*"

I knew from movies how women sometimes act in the throes of labor. I should have expected this. But I'm not an expectant dad. I never took a birthing class or anything. I'm just a lawyer who talks a good game. My part is the legal stuff. Anything I know about birthing I learned from *Redbook* standing in the "ten items and under" line at Safeway. Still, this was a far cry from the Sammy I'd met ten days ago.

She'd walked into my office without an appointment. Waddled actually, given the fact she looked eight months and twenty-nine days pregnant. She was a cross between a Valley Girl and a Barbie doll,

assuming Valley Barbie had been knocked up by Ken.

The first thing she did was show me her red underwear. Well, not the first thing. She had to sit down first. But before I even had her name written on my legal pad, she propped her heels up on the corners of my desk as if it had stirrups.

I knew there was nothing flirtatious on her mind. She was just subconsciously assuming the birth position. My quick calculation of her pelvic angle confirmed a spontaneous birth would launch the baby across my desk and into my lap.

I slid my business card holder over to try to block the unintended view as I handed her my card. "Toby Dillon, Attorney at law." I'd tried to think of a little tag line to go beneath it, like my dad's firm which said "Established 1934," but I didn't think "Serving the community for almost a year" or "Established July" would inspire confidence.

I'd become an adoption attorney because I liked the law, but also liked to help people. I'd been in the Peace Corps for a couple of years and found it very fulfilling. Still, $264 a month and all the rice you can eat left something to be desired. So, I gave in to dad's dream—another lawyer in the family. Like the world needed one more.

Where most attorneys are hired to destroy, I'm hired to build. Families. I like my job. I like the people I work with, both the birth mothers and the adoptive parents. If the babies could talk instead of just slobber, I'm sure I'd like them too.

I'd explained to Sammy that adoption was a very open process. She could personally meet and select the adoptive parents—even stay in contact after birth if she wished. That way she could be confident in her decision, and proud of the family she created. I truly believe placing a child for adoption is one of the most loving and unselfish acts a woman facing an unplanned pregnancy can do.

And then there was Sammy. I'd asked her if she'd like a glass of

water. Foolish me. This got her started on men she'd had sex with *in* water. I tried to move her off the subject of water sex, and her belief that pregnancy could not occur from sex in a swimming pool. Evidently the little swimmers would be killed by the chlorine.

I'd been trying to direct the conversation back to the subject of birth fathers, and the fact they have rights too, so I fell back on one of my smooth-as-silk segues.

"So, speaking of chlorine, what can you tell me about the birth father?"

If she thought this was an odd transition, she kept it to herself. Of course, considering her fifteen minute water sex narrative in response to my offer of a glass of water, I shouldn't have worried.

"What do you want to know?" As she spoke, she started to pop her knees back and forth, keeping pace with her gum chewing. For a moment I thought she was sending Morse code with the flashes of red. The wind force from her flapping dress produced a wind volume sufficient for me to pose for a shampoo ad.

"Can you tell me his name? I have to give him notice of the adoption if we can find him."

"Hmm. . . Bob. Or Rob. Or Roy. No. Bob. Yeah, I think it was Bob. Or Roy. Maybe."

I thought about asking if Bob Roy Bob had a southern accent, but decided to keep that gem to myself. Even the California Supreme Court flashed a rare display of humor, dubbing these short-relationship birth fathers *casual inseminators*.

"It must not have been very long," I said.

"Oh, he was about average." She held her fingers six inches apart.

"No. I meant your relationship must have not been very long."

Nothing like telling me more than I want—or need—to know.

"Well, can you tell me what he looked like?"

"I don't really remember what he looked like exactly, but he was

really, *really* good looking."

"How do you know he was good looking if you don't remember what he looked like?"

She looked at me like I didn't have a clue. "Because I only sleep with *really* good looking guys."

The consultation should have been over thirty minutes ago, but I was beginning to think unlocking her heels from my desk was going to take the Jaws of Life.

"I still don't see how I got pregnant."

I didn't want to go there. "Well, sometimes only once is enough if you don't have protection—like chlorine."

I stood up, which never failed to get hard-to-budge clients on their feet. Actually, doctors invented the move, but we attorneys know physical maneuvers are not copyrightable, so we stole it. All it accomplished for me was a higher angle view of the red underwear. I could swear there was some sort of pattern on them.

Eye balls.

The pattern on her underwear was little eyeballs, staring back at me, saying "We see you looking."

I finally got her on her feet. In her hand was a stack of adoptive parent profiles. Each of the couples I work with waiting to adopt write a *Dear Birth Mother* letter, providing pictures of themselves, and describing why they wanted to be parents and what a child's life would be like with them. Soon she'd choose one and I'd set up a meeting to be sure they hit it off. It was the first stage of the unique mating dance of adoption. Some called it the *baby* game.

Usually I had no idea which family she'd choose. This time I did. The deck was stacked in their favor. They'd just given me their resume letters a week ago and Sammy was the first birth mother to come in since then.

But now my only thought was to get her to the hospital. That, and

wishing I'd put the top up before I picked her up. It wasn't cold in June in San Diego, even at two a.m., but California freeways are never empty, and by now we were attracting an audience, judging from the cars boxed around us. Like they never saw someone driving a wooden Indian and a pregnant teenage girl screaming in the backseat. Judging from the cell phones held to their faces, each one was making a 911 call. Finally the exit for Palmorado Hospital came up. I drove like I was Gene Hackman in *The French Connection*. If I were in a better mood, I would have said like Elvis in *Speedway,* but there was no risk of me breaking into song tonight.

I pulled up to Emergency. A pond and waterfall, surrounded by lush vegetation, decorated the entry. For a second I wondered if I'd pulled up to Caesar's Palace. All it was missing was people. Even in the middle of the night, I expected to be greeted by a team of white-coated, highly trained professionals leaping to Sammy's aid. Instead, there was no one. But the landscaping *was* lovely. Good to know hospitals know where to put their money. I spotted a security camera above the doors and waved frantically, hoping the camera was somehow related to patient care, and not monitoring against plant theft.

I hopped out of the car—actually catapulted was more like it—and looked down at Sammy. She'd given up screaming and was now curled in a fetal ball, like a child on a long trip in mom and dad's back seat. Either Linda Blair was in remission, or one of my two wheeled turns banged her head against Woody, and she was knocked unconsciousness. Thanks for watching my backside, Kemo Sabe.

I put one arm under her shoulders and tried to raise her.

"Sammy. . . C'mon, Sammy. We're here!"

All lifting got was a groan from her, and a turned testicle for me. What law of physics makes a sleeping person weigh twice that of someone awake anyway? I gave up. How to get help? I could wade through the koi pond and start tearing leaves off the Boston ferns,

which would likely have hospital personnel out here inside of ten seconds, or I could race inside and find whoever was supposed to be sitting at the counter visible through the glass doors.

Inside. No one.

"Hello! Help!"

Behind the counter was a hallway which ran the length of the hospital. Palmorado is small. It caters more to facelifts and dehydration on the golf course than medical emergencies. Still, it was the first place I thought of when Sammy's call woke me up. It wasn't until I was pulling into the lot that I remembered she was registered at North County Regional, fifteen miles away. That's where the adoptive parents were expecting us to go, and were now headed. But another twenty minutes to get to Regional wasn't an option.

I figured I could run all the way to the other side of the hospital and search for signs of life in less than one minute. One thing I am is fast. My best tennis shoes carried me down the hallway in no time, a squeaking blur. Halfway down a door blocked my way. I hit it running, turning to hit the *open* bar with my hip. The bar depressed but didn't open, and I crashed to the shiny linoleum.

Locked.

I got up to look through the door's tiny window. *Yes*! People. White-coated medical people. I banged on the door, but they were too far away. No buzzer.

What else could I do but head back? When I made it to the reception counter I saw what I missed before. A small placard sat on the counter: "Midnight to 6:00 a.m. - please use ambulance entry at back."

I ran outside. And stopped. There was still no one in sight. But now my car was gone. And so was Sammy.

2

NATURALLY, I DECIDED to do the sensible thing—let the adoptive parents decide what to do. Cynics would call this passing the buck. I call it attorney-client privilege. It was their case after all. But when I reached for the cell phone on my belt to call them, it hit me that I'd left it in the car. The missing car. At least my phone was not alone in my glove compartment. My wallet was there too. My second thought, as my fingers brushed soft cotton, was that I was wearing my pajamas. Worse, in a rare surrender to whimsy at Sears, I'd bought Cat in the Hat pj's.

The good news was the police finally arrived. The bad news was someone else called them. About me. Hmm. A man in cartoon pajamas. Wandering around a hospital parking lot at three a.m. No ID. A tale of a disappearing car with a wooden Indian and a pregnant teenager in the backseat. Yeah, that would go over big. All I needed was my sighting of an alien spacecraft to make the evening complete.

I had to think quick or I'd be looking at a seventy-two hour psych eval. A judge, on little more than a cop's opinion, could lock anyone

up for a seventy-two hour psychiatric evaluation if there was reason to believe they were a danger to themselves or others. Actually, I heard it wasn't so bad once you got past the anal cavity search.

"Nice jammies, Toby." This from one of the cops.

I looked closer and recognized Barry Gittleson climbing out of the cruiser. One advantage of a small town is knowing people. Fallbrook was too small to have its own police department, but we have a substation of the San Diego County Sheriff. A few of the cops were locals. Barry was one.

I did report my car stolen, but the only passenger I mentioned was the wooden one. Some instinct told me not to mention Sammy yet, and I was glad I didn't a few minutes later.

Within minutes of the cops' arrival, hospital employees started to filter outside to stare at the crazy man in the pajamas. Barry's partner suggested a breathalyzer, but Barry nixed it. He turned to the hospital staffers and indicated the security camera.

"Who monitors the cameras?"

One of the gawkers spoke up. "During the daytime we have security here watching them, but at night it just goes on tape I think."

Barry nodded his thanks and turned to me and his partner. "We'll write it up and let the detectives check it out later. Maybe they can see who took the car." He went back to his report.

"What kind of car did you say it was?"

I thought we'd covered that. "A '64 Ford Falcon."

He looked up. "I thought you were kidding. You're still driving that piece of crap you had in high school?"

"It's a classic!"

"Well," he said diplomatically, "we all have different taste in cars."

"And pajamas," added his partner.

This brought a snicker from the eavesdropping hospital clan. Los-

ers. No wonder they were assigned the graveyard shift.

Taking pity on me, and at the request of the hospital to not leave me on the premises, Barry and Smart Ass put me in the cruiser's back seat and brought me home. Home for me was the Coral Canyon Country Club in one of the ritzy condos ringing the golf course. It'd be an impressive address if I paid to live there, but I got the condo for free as a perk to my side job as their assistant tennis pro.

They pulled up to my place and there it was.

"Is that your car?" Barry asked.

Sure enough, there was the Falcon, right in front of my condo.

"And is that your Indian?" asked the other.

I acknowledged it was my car and my Indian.

From inside the cruiser, I couldn't see if Sammy was curled up in the back seat. And I wasn't about to ask them if they could see a pregnant teenager in the back. I assumed my evening of fun was over, but they got out and walked toward my car, leaving me alone in the back seat. They shined their flashlights all over both the interior of my car, and Woody. I don't know which one was responsible for the laughter. Suddenly their laughing stopped as they looked up sharply at the sound of screaming tires.

Rounding the corner at Indy speed came a car, heading straight toward us, then neatly skidding to a stop. In perfect harmony, Barry and his partner raised their flashlights to their shoulders, and put their hands on their holstered gun grips. Then they dropped their jaws.

The flashlights shining in their faces didn't faze Brogan Barlow and Rita MacGilroy as they climbed out of their car. They were used to a lot more candlepower than that.

The fan mags described Brogan as a young Cary Grant, if you threw in a dash of Mediterranean blood. Dark hair, naturally bronzed skin, and brown eyes one reviewer gushed as "almond and melting." Brogan had laughed so hard at that one he'd almost choked. But it

was less his looks that made him a star, and more his inexplicable resonance of honesty and character. Next to him, Rita was as fair as Brogan was tanned. Her first commercial, pre-stardom, was for Irish Spring soap. Never was anyone so well cast. Her auburn hair caught the streetlights and framed her face, highlighted by the light sprinkling of freckles over the bridge of her nose. Her eyes were green enough to belong to a mermaid of the deepest seas.

To me though, Brogan and Rita were simply my two best friends since kindergarten. We remained an inseparable troika all the way through high school, united in our adolescent geekiness. It was after college that we went our separate ways. The Peace Corps for me. *Rich white boy guilt* my father said, in the only accurate statement I can recall him making. Hollywood for Brogan and Rita. It was hard to guess who was taking the surest path to career obscurity. Them waitering at Denny's between acting auditions, or me serving rice bowls to toothless farmers in Nepal.

A few years later, a small role in a big picture jump-started Brogan's acting career, and he hasn't turned back. Now he makes something like twenty million dollars a picture. And he's still willing to be my best friend. At first, Rita's career dragged behind, and for several years was known more as Brogan Barlow's wife than as an actress. Then three years ago, she turned in a truly gifted performance in one of those small, low budget pictures reviewers love to *discover*.

Since then, she's been Brogan's equal in the Hollywood power game. They were America's premier couple. Even worse, the nicest people you could ever want to meet, assuming you could get close to them. The more they hid from the Hollywood scene, the more sought after they became. One funny thing about celebrity is that everybody wants a piece of you. The motivations of everyone else suddenly become suspect, and you shrink further and further into your self-imposed shell. For people like Brogan and Rita, this makes childhood

pals like me seem safe. That, and the sharing of childhood nerd-dom as a lifelong bonding experience.

Infertility strikes the rich and famous too, and when it hit Brogan and Rita, I was there with a baby. Well, my job was to find a birth mother. The baby part was up to Sammy.

Brogan walked up to the cops, glancing at me. "What's he doing in there?" He said it softly and politely, but people tended to listen when he spoke.

Barry's partner trotted over to the cruiser and opened the door for me. "There you go, Mr. Dillon." Before I could let go with a smart aleck reply, he ran back to Rita's side, anxious to protect and to serve.

"What's going on, Toby?" Brogan asked. "Where's Sammy?"

Out of the corner of my eye I could see Barry and Smart Ass share a "Who's Sammy?" look. Not that they cared. They were focusing all their energy on flattening their stomachs into washboards for Rita.

Rita gripped my arm. "We got to the hospital and tried to call you but—" She stopped mid sentence as her cell phone chirped.

Sammy?

The relief which flooded Rita's face gave me the answer.

It turned out pancakes were to blame.

It was just after three a.m. when we pulled into the Denny's parking lot. I could see Sammy through the window. She probably weighed only a hundred and thirty pounds, even pregnant and dripping wet. Twiggy with a basketball tummy. When I once asked her how she kept so thin while eating six meals a day, she told me, "An orgasm burns six hundred thirty calories—you do the math."

Except for the sleaze sitting across from Sammy, the restaurant

was empty. As we approached their booth, I could see four plates of pancakes in front of Sammy, a portion of each gone. Each one had a different topping on the stacks—strawberries, blueberries, whipped cream and syrup.

Across from her was her boyfriend, Travis. Sammy had told me she met him six months into the pregnancy. What kind of guy picks up a pregnant chick? Even one as foxy as Sammy. He was good looking without trying and I hated him for it. Tall and lanky, with Fabio blond hair which was constantly in need of being swept from his eyes, he was a good ten years older than Sammy's nineteen. Another reason to dislike him. Nineteen year olds never looked at me.

When I'd met him a couple of days ago, he'd told me he'd been an Army medic until a misunderstanding led to his early discharge. Probably the disappearance of some pharmaceuticals, I thought.

"Wha 'appened to 'ou?" Sammy asked me through a mouth full of pancakes.

"What happened to *me*? Where did *you* go?"

"Hey, I woke up and you were gonesville, man! And my labor'd stopped. And God! I just had to have some pancakes."

Travis spoke up. "Cravings, man. Got to respect 'em," He nodded meaningfully at his own words like one of us was expected to carve them on a handy stone tablet. "She came back to our place and I brought her here in my car. No offense man, but your car sucks."

Travis's place was actually Sammy's place, one of the Coral Canyon units rented for Sammy by Brogan and Rita.

I kept my sarcasm minimal. "Well, thanks for giving us a call so we wouldn't worry about you." I felt like strangling them both, but one was pregnant and the other was bigger than me.

"What you talking about man?" Travis said. "We called you to pay the check. You can't expect us to pay for all these pancakes!"

3

NINETEEN HOURS LATER we tried it all again.

"Toby?" A voice on the phone.

"Wosisit?" That's "Who is this?" when it's half past one in the morning and you slept two hours the previous night.

"Toby, it's Sammy. It's happening. . . it's time for the baby."

I barely recognized her voice. Or maybe I should say the tone. She sounded more human, more real, than she ever had, evidently stripped of attitude by a few hours of labor.

I was awake now. "Just relax Sammy. I'll call Brogan and Rita. We'll be right there. Okay?"

I think she was already hanging up and didn't hear me, but as I was speaking I could've sworn I heard what I couldn't be hearing. Not yet anyway. A baby crying.

Brogan and Rita had taken a room at Coral Canyon knowing the birth could be any day and were at my front door inside of ten minutes. Looking at them, I felt good. Great actually. The joy on their

faces as parents-to-be was equaled only by six year olds on Christmas morning. Knowing I helped it all happen gave me a pride I seldom allowed myself to feel.

As we trotted over to Sammy's I noticed Travis's van wasn't parked in his normal parking spot in the handicapped zone. Thank goodness he wouldn't be here for the birth. Leave it to him to run out for some smokes with his girlfriend due to give birth.

Sammy's door was ajar. Brogan simultaneously knocked and stuck his head around the door. "Sammy?"

"I'm in here." Her voice came from the bedroom, weak but proud.

We impatiently pushed each other toward her room. Sammy awaited us sitting in bed, a beatific smile on her face. In her arms was the baby. My God. She'd delivered it alone. At home. Little House on the Prairie revisited.

"It's a girl." Sammy seemed to beckon to Rita without moving a muscle in the silent language of motherhood, and Rita gently sat next to her on the bed.

"She's yours," Sammy said, placing her in Rita's arms. "Do you think she's pretty?"

There was such vulnerability in the question. Subconsciously asking "Will you love her as I would love her? Is she as beautiful to you as she is to me?"

Rita didn't answer. She couldn't. Her body racked with soundless sobs as she lowered her face to the baby, kissing her head, her stomach. Virtually breathing her into her soul.

Rita's voice was husky when she finally spoke. "How can we thank you, Sammy? She is so beautiful."

Brogan moved behind Rita and cradled them both, his tears melting into Rita's hair. The four of them stayed like that, locked in a moment of timeless joy. A birth. A life. A precious gift which could not be measured. It was Brogan who first noticed the blood.

Several of my Peace Corp buddies had told me stories of helping with births in Nepal. Home births there, like in many third world countries, were not unusual. Neither were they clean. Babies did not come out like a Gerber baby photo op.

My eyes followed Brogan's. It wasn't to the baby. The blanket covering Sammy was saturated where it covered her thighs.

Brogan moved quickly from behind Rita, alarmed.

"Sammy?"

He gently pulled down the blanket. The blood was thick and gelatinous. But there was more than blood. There was the umbilical cord and a bloody mass and. . . That was the last thing I remembered before the walls began to lose their shape and the carpet rushed up and hit me on the face. The next thing I knew I was on the ground and Brogan was kneeling over me. I could hear a siren in the parking lot.

"We called an ambulance," Brogan told me.

I hated that they had to focus on me. "Don't worry about me. I'll be okay."

He gave me a look. "The ambulance is for Sammy. You just passed out."

Oh.

"Is Sammy okay?" As I asked it, two paramedics came into the room. They did the usual double take at the sight of Brogan and Rita, but then thankfully went about their jobs without a second look in their direction. From what I could overhear from my resting place on the floor, it appeared Sammy was fine. They were telling Sammy it appeared her placenta had torn, then went on to describe what was evidently called *afterbirth* discharge. I don't remember the details, mainly because I briefly blacked out a second time early into the description. Yikes, God wasn't kidding when He talked about making women pay for that apple thing.

4

FOR THE NEXT month I lived in the netherworld of stardom. Actually, the netherworld of stardom-hanger-on-er, but that was more than enough for me. Brogan and Rita, normally media wary, were joyful participants on almost every talk show, and even a hurriedly produced Barbara Walters' hour-long cry fest on adoption. I couldn't even count the magazine cover stories.

Brogan and Rita had now been parents for twenty-seven days, occupying a state of euphoria not seen since *The Brady Bunch*. The only scary moment had been the discovery days after birth that Remy, as they named the baby, had a severe thyroid imbalance. Actually, millions of people had thyroid problems, but Remy was born with a complete "Out of Order" sign on hers. Luckily, hypothyroidism—my first six syllable word—is the best disease to have, if you've got to have a scary-sounding disease that is. Take a daily thyroid pill, and have a completely normal life. Don't take it, and a quick and permanent slide into severe mental retardation would begin about two

months after birth. Scary stuff, but a bullet dodged by Brogan and Rita. I guess that heel prick they do on babies to test for things like that isn't so mean after all.

Whether it was the new joy of parenthood or a desire to promote adoption, Brogan opened up like never before, particularly the mini-bombshell he dropped on *Leno*. When I watched the tape of the show later, I could literally see my jaw drop. Even Leno was taken aback.

I don't think any of these shows, or the magazine cover shoots, were thrilled to have some unknown attorney tagging along. But to get Brogan and Rita, they were happy to oblige. At first I thought Brogan insisted on including me out of lifelong loyalty as a friend, knowing the attention would rocket my small town adoption law practice into big bucks territory. But he knew a strong kick serve and forehand drop shot ranked much higher on my list than money or accolades.

So why?

I think Brogan's intent was to bring a new image of adoption. He was well aware that when adoption stories made the news, it was usually for a negative reason. A birth mother reclaiming her baby, the child screaming while being taken from the adoptive parents' arms, who crumple to the ground as they watch the child they thought was theirs leave their lives forever. For at least awhile, Brogan was going to single-handedly change that. Maybe he was afraid without me discussing the "legal how-to" side of it, the interviews would turn into celebrity pieces. Or maybe he just wanted an excuse to hang out together, like we did each day of our lives from the age of five, until adult dreams and obligations turned us in different directions.

I was greeted by the wardrobe person on *Leno* with the question, "Excuse me, but didn't you wear that same tie last week on *Today*?" Turns out each show watches every other show to know what was asked, what was answered, what stories or jokes you told, and what

you wore. No repeating allowed. So I was whisked off to *wardrobe*. My anticipation of a closet of clothes was wrong by only three thousand square feet. I don't know if it was only for *Leno* or all the shows shot on the lot, but it was like a small department store.

I stood like a little rich boy, as minions removed my clothes and dressed me. There is very little privacy in stardom evidently. Or in my case, very temporary, semi-stardom. Every mom's sage advice about the importance of wearing clean underwear came to mind. As I was escorted from wardrobe, I realized I wasn't wearing a single item that belonged to me. Their suit. Their shirt. Their tie. Their socks and shoes. Their belt. They even put a watch on my wrist.

Next they diverted me to *make up*. They had done this on *The Today Show* so it wasn't a surprise, but they hadn't stripped me down and changed my clothes. Of course, I wouldn't have minded if that little hottie Katie Couric had handled that chore.

Make up had three salon type chairs, illuminated as bright as an airport. Reclining in one of them was some guy with a very familiar face who was always in some TV show or another, usually as the goofy next door neighbor. I couldn't think of his name, and when I introduced myself he didn't offer it. Actually he didn't respond at all. I'd been informed he was guest number two unless we went over, then he'd be bumped. Eat my dust.

The make up lady was a cutie, and with a small sponge she started giving me what looked like a really good tan.

"Where are Brogan and Rita?" I asked the cutie.

Familiar Face answered bitterly. "Above-the-titles get their own room. This is for the also-rans."

Cutie was more judicious. "I can't do everyone. Bridget is doing them."

After a few minutes of her ministrations, she stood back and looked at me, then turned to one of the many assistants who seemed

to fill every hallway. Even the assistants had assistants.

"Better get *hair* over here."

Hair turned out to be a man, sort of. He introduced himself as Billy, the gayest of the gay. Actually, he only offered the Billy part. I added the rest. But hey, if you can't be ultra gay as a hairdresser, in the entertainment industry, in Hollywood, where can you?

"Oh, my." He critically scrutinized my hair as Cutie moved over to Familiar Face. "Oooh, my," he finally said again.

This wasn't sounding good. I'd never liked my hair, brown and annoyingly wavy. Usually I did a good job of hiding the waves with various goops, but maybe it wasn't slicked down enough to suit Billy.

"Okay. Here's what I'm thinking. . ." Billy finally said, trailing off as he reached for some scissors and started snipping around my ears. Evidently thinking meant doing, and no one bothers to ask the snipee.

"Your face is 'lil bit wide, so I'm going to lengthen it a 'lil bit." Sounded painful. "Add a 'lil body up top. Maybe bring in a 'lil sunshine."

I didn't know what the hell that meant, but he had stopped trimming for a moment and was doing some kind of scalp massage or something. I didn't realize I'd closed my eyes until I felt my chair tilting back. What were they doing now? Calling in a dentist? Actually, I wouldn't have objected to a little teeth whitening, but I guess that was beyond the beautification attainable in a few hours. Turns out a shampoo was what Billy had in mind. Someone even came in to polish my shoes.

Well, their shoes. Whatever.

I didn't open my eyes until Rita come into the room. "Looking good, Toby," she said.

Billy raised up my chair and I opened my eyes. Oh, God! What had they done to me? My hair was loosely finger-combed straight

back from my forehead, which showed more, not less, of the hated waves. Worse, now it seemed to have faint rivers of blond in it. I guess that was *sunshine*.

Tears would ruin my make up, hurt Billy's feelings, and make me look like a wus. So I took it like a man.

"What do you think, Rita?"

"Well, I don't think anyone will laugh. Not out loud anyway."

Great, a female Brogan. Two wise asses I didn't need. They lived in front of a camera. I was a nervous wreck about to go on TV. Now I was doing it wearing someone else's clothes and sporting a new head.

"I look like one of those guys selling real estate seminars in those late-night infomercials."

"Toby, you look fine. It's just different than what you're used to. I think you look handsome. Really."

"Me too. Definitely." This from Billy.

"Oh, me three," from Familiar Face, sarcastically gushing. Then he added, "Get over yourself already. You're a damn lawyer! No one's even gonna look at you."

Well, he was right there, but Rita shot him daggers anyway as Brogan walked in holding Remy.

"Whoa. What happened to you? You look like you're ready to do a real estate infomercial."

Rita gave him an elbow.

"Only kidding," Brogan said. "I heard you from the hallway. I would've said TV weatherman."

Yet another production assistant came in and pulled Brogan and Rita into the hallway for an urgent discussion on some last minute decisions, like did they prefer to hug or shake hands with Jay. I followed them backstage, where we could see Leno finishing his monologue on big monitors hanging from the ceiling.

I hadn't been too nervous on the morning shows. There'd been no

live audience and I'd never seen the shows to care much. My mornings were filled with tennis and the occasional court appearance. But this was *Leno*. Brogan noticed me hyperventilating.

"Toby. Don't worry about anything. Jay's gonna ask you that one question about birth parent rights. Right?"

I managed a nod.

"And you know the answer. Right?"

Another nod.

"So what's there to be nervous about? You met Jay earlier. He's a nice guy. He throws you the softball. You ace it. Right?"

"Yeah." I could speak after all.

"And you know what? You really do look good."

"Thanks."

"And if you do screw up, only fourteen million people watch the show."

And with that, we were on.

The first thing to hit me were the lights. I had no idea they were so blindingly bright. And hot. I defensively threw up a hand to shield my eyes as we passed through the curtain. Luckily, no one was looking at me. Everyone's eyes were on Brogan and Rita. Even when I watched the tape later, I was cut out of the picture. Familiar Face had been right. Maybe the few people with widescreen TVs could see me.

I made it to my assigned seat without falling down or giving Brogan a wedgie. Midway through the first segment, Jay served up my question and I answered without forgetting what I was going to say, or blowing a spit bubble. I could now sit back and enjoy the show. A monitor faced us so I could see I was usually off camera while Brogan and Rita were speaking, which was fine with me. It was so nice to see Brogan effortlessly handle himself. Witty, charming, intelligent.

It amazed me how far he'd come.

I could still remember the first time Brogan had been on a stage. We were in our sophomore year at Fallbrook High School. The entire student body was crammed into the bleachers of the gym and a stage had been set up on the basketball floor. It was to be the usual assembly featuring the popular kids: the football team, the cheerleaders. The thing different in today's assembly was that Brogan proudly sat on the stage.

One of us.

He'd received the highest SAT mathematics score in the entire state. It was a big deal for those of us in Geek Central, as we rarely got recognition for anything. Even his parents were there. Brogan would give little secret waves to Rita and me as he waited to get his award. I could see the muscles in his mouth twitching in his attempt to suppress a grin.

When his turn finally came, our student body president, Troy Blake, came to the podium. Probably the only person less pleased about it than Brogan was Troy, forced to publicly pay homage to someone in the Nerd Club.

"It's an honor to have our state's highest achieving mathematics student right here at FHS," Troy said haltingly, making it obvious he was reading from a note card, as if to make clear the words weren't really his. "And on behalf of the student body and faculty we'd like to present him with this medallion."

If we were in gym class right now, Troy would have Brogan in a headlock, but under the eyes of twelve hundred students, faculty and parents, he had to display the sham golden boy face his parents and teachers expected to see, and put an award around Brogan's neck. I'm sure it was killing him.

There was polite applause, half what it would be when the football team and the cheerleaders stood. But it was more than enough for Brogan. He walked across the stage and stood next to Troy as the

Fallbrook Village News photographer and his mom took his picture.

He'd fretted for days on what to wear. He wasn't fat, but he was definitely overweight, and he was always conscious of how he tended to jiggle in all the wrong places when he even walked fast. Rita and I had given him the thumbs up on his favorite dark blue shirt. It didn't actually make him look any less chunky, but we knew it was his favorite shirt and he felt better about himself when he wore it.

Troy put the medallion around Brogan's neck, and grinned in a way that suddenly made me shiver. For some reason I thought of the movie *Carrie* and the bucket of blood pouring down on prom queen Sissy Spacek. But Troy chose a more painful medium.

Words.

"It must be nice for Brogan to have his parents here today," Troy said. "And we can see where he gets his good looks. He's got his father's chin. . . and his mother's breasts."

The worst part of it was the laughter.

With the cruelty that only children know how to inflict, the bleachers erupted, with Brogan just standing there. Actually, I'm wrong. The worse part wasn't the laughter. Our little group lived with that every day. The worst part was the witnessing of it. We all want to hide our embarrassments and ignore our pains. Yet here he was, forced to endure them before his friends. His parents. His teachers.

Brogan, Rita and I never talked about what happened that day, but looking back, it was the day that changed Brogan's life. He never made any dramatic announcement or resolution. But he started to exercise. Not weights in the school gym. He knew the other kids would see him and make more jokes. Laugh at the fat boy for being fat, and laugh at the fat boy for trying to not be fat. It was no win.

So in the privacy of his room he did pull ups. He did push ups. Sit ups. He worked up to hundreds of each every day, broken into sets of twenty, over and over again. Changed his diet too. Nothing radical.

Just healthy. By the time we were eighteen, his body was changed forever. Not that of a weightlifter, but a tremendously fit and healthy person.

But he changed more than his body. He was still Brogan, but somewhere deep something had been lost, as if he would never allow himself to be that vulnerable again. Never be a victim again. Seventeen years later I knew he still did his hundreds of reps every day. And he still had some of that wall up, visible only to those of us who knew the first Brogan.

We were into an unplanned third segment with Jay—goodbye Familiar Face—when Brogan surprised us.

I'd known Brogan was adopted as a baby of course, as did everyone in our little circle of friends. Brogan never talked about it though, just unquestionably accepted it as part of himself as much as being right handed or having brown eyes. It was just part of who he was. I hadn't even thought about it in years.

But evidently *he* did, because he broke from the planned topics and blurted out he was adopted, like his new daughter. Not the world's biggest secret considering millions of people are adopted, starting with Moses. But it was something that had never been revealed in his often picked-over life by the *National Enquirers* of the world. It was what followed that statement a minute later that was the kicker.

"Our adoption of Remy is open," Brogan said. "We got to know her birth mother and she got to know us. Back when I was adopted they didn't do it that way."

"So you never got to know your birth mother?" Jay asked.

"I don't even know her name. My parents never got to meet her either. And the records are sealed. There's only one way I can think of to find her."

As Brogan turned to look directly into the camera, I instantly

knew what he was going to do. And I couldn't believe it.

"This is what I know from my birth certificate. I was born March fourteenth, 1972 in Fallbrook, California at 6:11 a.m. My parents were told by the adoption agency that my birth mother was Italian, and she was twenty when I was born. That's all I know about her."

Brogan took a moment to collect himself. Jay wasn't about to interrupt. This was gold for him. He waited for Brogan to go on, probably guessing where he was headed. And even though I knew as well, my skin still tingled when I heard it. Brogan's eyes stayed fixed on the camera lens.

"I won't address you as *mom*, because my mom was the mom who raised me and loved me every day of my life until she died last year. But you created me. You gave birth to me. You're my biological mother."

For a second I thought he wouldn't be able to continue, but he regained his composure, although his voice was cracking.

"If you're out there, I want to meet you. I'd like the honor to get to know you, and I hope you'd like to get to know me."

To Jay's credit, he could have milked Brogan about the subject, and in his present state, Brogan likely would have shared anything. Instead, he was practical. He wrapped up the show by offering his show as a point of contact. Brogan seemed too drawn to continue anyway.

After the show, I was halfway home before I realized I was still wearing the *Tonight Show* clothes and accessories, including the Rolex on my wrist. I didn't know if I should go back and return everything, or they were just the equivalent of game show parting gifts.

I took a closer look at the Rolex. Figures. It was a *Rolexe*. Maybe it was a parting gift after all.

5

BROGAN AND RITA had a party the day the baby was kidnapped. Actually, the party was celebrating the adoption, not the kidnapping. The kidnapping *ended* the party though. If you could call it a kidnapping. If you could call it a party.

The celebration was on the 31st day after Sammy signed her consent to adoption. July 18th. Under California law a birth mother has thirty days after she signs her consent to change her mind. On the 31st day, however, her rights end. Although Brogan and Rita never seemed worried about Sammy, it was still a big day. Things like being a movie star meant nothing compared to keeping your child.

I'd been looking forward to seeing them, although I hated both the long drive to L.A., and the anticipated poor air quality.

Not the city air. Me.

It's just that I get gassy when I have cold pizza for breakfast. That

was one advantage to a convertible. But the morning the day of the party was chilly so I put up the soft top. I wasn't a Playboy playmate who got paid for stiff nipples. That left only one solution. I removed the CarFresh Pine Tree deodorizer I usually hang from my mirror.

And sat on it.

It took just under two hours to make the drive from Fallbrook to Brogan and Rita's place. Usually I felt no place compared to my hometown. Fallbrook is one hundred twenty-seven square miles of verdant green hills appropriately dubbed the *Avocado Capital of the World*, nestled in a rural corner of North San Diego County. When I was a kid, agricultural collectives owned thousands of acres. Now most of the land had been divided into two or three acre home sites, but the towering avocado trees remained.

I had to admit, though, Brogan and Rita found a beautiful place to live. They'd purchased six acres in Palos Verdes, a wooded peninsula on the coast above Santa Monica. Although it was in Los Angeles County and only twenty miles from the studios, it was as far removed from what I thought of as Los Angeles as could be.

Horse trails ran along each road, and the few houses were all set back so only foliage and gated entries were visible. Brogan and Rita's land was on the sea side of a hillside, offering a stunning view of the Pacific just over a mile away. Just for the land, it was considered a bargain at just under nine million. A figure I couldn't quite get my mind around.

As I passed through their gate, I could see Rita's sheep grazing. Of course, I'd seen the wooly guys before. Wooly *gals* actually. I couldn't recognize who was who, but Rita though could stand fifty yards away and identify each ewe, like a mother could her children.

Brogan, Rita and I had all been born and raised in Fallbrook, and agriculture and animal husbandry was in our roots. Kids in our day went two routes, sports or 4-H. For us, it was 4-H, and Rita won more

than her share of blue ribbons for her lambs.

Rita's father and my grandpa had been the 4-H community leaders. Rita's dad was one of Fallbrook's two doctors, and my grandpa the only lawyer. They had been great buddies, two of a kind. Both liked people more than money. Each helped the poor in the community, particularly the migrant workers. Invisible people, riding their bicycles from grove to grove, making twenty bucks a day back then, now fifty, for a full day of hard labor and a lunch.

When a landowner accused a worker of stealing tools or fruit, my grandpa made sure the worker wasn't locked up on just the farmer's accusation. Half the time the farmer would later find he'd simply misplaced his tools. When an adolescent Anglo impregnated a young migrant girl, Dr. MacGilroy would provide the medical care and grandpa would convince the boy's family to contribute funds for her to return home, or help find an adoptive home.

I reached the top of the driveway, where it widened enough for cars to angle park on the side. I parked the Falcon next to a new Aston Martin. I'd seen one like it in the latest James Bond movie but never in real life. I could guess who owned it. I parked a little too close to it, just to make him panic and search for door dings.

You'd think after paying nine million for a piece of land, they'd build a mansion matching the investment. But Brogan and Rita weren't like that. They didn't buy the land for prestige, but for privacy. In fact, I think they were looking for what they'd grown up with in Fallbrook. So instead of building a twelve thousand square foot showplace to match most of the neighbors, Brogan and Rita designed a craftsman style bungalow a third the size of the neighboring estates, nestled under a pair of hundred year old oaks in the middle of the property. To the left was a small guest cottage backed by giant bleach-bark eucalyptus trees, their towering branches reaching high enough to always catch a slight breeze. Down below they'd built a

huge barn the way barns were supposed to be—out of wood and painted red. Encircling it was the sheep enclosure, as big as the infield at Dodger stadium, and the grass almost as perfect.

There was a pool next to the house, designed to look like a natural spring cascading into a pond, and as I walked up I could see a few people were swimming, and jumping off boulders like kids.

Watching them like a lounging lizard was Stephen Weiss, inadvisably wearing a Speedo. The last time I'd seen anything packed that tight was the vacuum packed peanuts the airlines hand out. It also appeared the contents were equally small.

He was the ultimate hyphenate. He was a very successful infertility doctor, popular with celebs like Brogan and Rita. I knew from Brogan he was in his fifties, but thanks to several nips and tucks, he looked closer to forty. The first time I saw him I thought he was George Hamilton, but with blond hair. How else would the infertility doctor to the stars look?

Stephen wasn't happy with only being a doctor, however. He was a doctor-screenwriter-producer. No one said you had to be good at something to add a title to your self-awarded hyphenate. But Brogan was a good judge of character, and Stephen was not only his doctor, but Brogan had put up two million dollars for a low budget film Stephen had written and produced. It had gone straight to video, but that's usually the intent all along when your budget is in that neighborhood. I would have thought Brogan's eye for good film projects would have led him to something besides *Beach Party Bunko*, Stephen's spoof of the Frankie Avalon-Annette Funichello oldie, updated around bikini-clad girls who run scams on the beach, usually involving the loss of their bikini tops in the rough tide.

But maybe Brogan knew what he was doing. His name wasn't attached to it in any way, and he told me that after video sales, cable, foreign distribution rights, and an inexplicable run as the number one

movie for six weeks in Turkey—all fourteen theaters—he'd made an eighteen percent profit.

Still, giving him two million dollars was one thing. Inviting him to your home in a Speedo was another. He climbed off his lounge chair and wandered over.

"Yellow!"

I hated his trademark stretching of *hello* into what sounded like a color. I think he believed it made him sound slightly British. "How ya' doin' Tobe."

I hated that too. Dropping the *y* and turning my name into a single syllable was cute when Rita did it. No one else did. But Stephen had embraced it in the Hollywood fashion of instant intimacy.

"D'ya catch the car?" He asked.

I knew it. The Aston Martin was his. Next I'd hear how much he paid for it.

"Paid just under three large for it. Got it through a friend at Paramount."

"Nice car." I didn't know what *three large* was, but I was guessing it meant three hundred thousand in Stevie Talk. If it involved money, and his accumulation or waste of it, I knew he'd get around to it.

"It was one of three prototypes they used on the new Bond film. They'll start selling them next month, but the side skirts and spoiler will be a little different. Only the two other ones like mine in the world. A good investment, don't you think?"

What could I say? "Yeah. Why feed a thousand Eastern European orphans for a year when you could buy that car?" But I only thought that. Clearly he needed a car that could reach one hundred eighty-five miles per hour on L.A.'s clogged freeways, where the average speed equaled that of a parking lot. But hey, what did I know? I'd spent three years in the Peace Corps, drove a Falcon and wore a Rolexe.

Instead I asked, "Brogan and Rita inside?"

"Brogan is. Rita's down with those stupid sheep."

Before I could go inside, Gina Volenti pulled herself out of the pool. She also pulled my eyes out of my sockets, even though I saw her at all the Barlow get-togethers. Gina had been Brogan's first agent, plucking him from a small actor's showcase. When he hit it big with *Angel's Run,* instead of fighting to keep him and claim a superstar to her stable of starter talent, she practically pushed him toward MCI, one of the huge packaging agencies. She'd stayed his friend and advisor, and seemed quite content in that role.

Even though she was probably old enough to be my mother, she was one of those women whose body was twenty years younger than it should have been. Kind of a Raquel Welsh, defying time. As she stood in front of me, with her naturally bronzed body and minuscule bikini, it was hard to keep my eyes on her face. I didn't mind getting wet when she game me her trademark European twin cheek kiss.

"Toby! Remy is beautiful! Thank you!"

She seemed so happy, you'd think *she* was the new parent. But then, she was like family to Brogan. With Stephen, it was usually like fire and ice. They reminded me of a divorced couple forced to get along at their child's birthday party. She turned to him.

"Stephen, if you stare at my tits any harder, they're going to fall off."

He just grinned and dove into the pool. Gina made a face and turned back to me. "By the way, congratulations Mr. Godfather."

"And congratulations to you, too. You're pretty sexy for a godmother."

I didn't tell Gina I wasn't exactly sure what a godparent did. I'd always assumed a married couple was usually selected as the godparents, but I guess two single people could do the job.

"Does that mean we have to get married?" I joked.

"No, but you might have to bang my bones a few times." She laughed as she walked away. Joking. I guess. I never knew with these people.

The two rock jumpers in the pool swam over and introduced themselves as neighbors, Neal and Patti. In their 30's, they were retired dot-comers. I left them before they started discussing computers and I'd have to admit I still used a typewriter.

Just as I was turning to go into the house, I saw Rita cresting the hill. She was a far cry from the glamorous Rita the public saw on screen. Her disheveled hair was littered with strands of straw. An oversized work shirt of Brogan's fell to her thighs, half of it carelessly tucked into her jeans. She looked radiant. It was a snapshot perfect enough to be an ad for tampons or cigarettes.

Spoiling the image was Morrie Verney, walking at her side. Like a lot of young directors, he had the early Spielberg beard and the Quinton Tarantino laissez faire attitude. He'd directed her last picture and wanted her for his next one. She'd been ready to commit until Remy was born. Morrie was having a hard time understanding "no films for the next three years" included *his* films.

Rita put her arm around me. "Look at you, Tobe! Keepin' the doo!" She laughed and mussed my hair.

She was right. I felt silly about it, but I'd kept my *Leno* hair. For some reason the conscious effort to look good embarrassed me, as if I didn't deserve the effort. When Rita ushered me toward the house, I was surprised when her hand softly grabbed my butt.

"I think you forgot this," she said, handing me something. "You had a Pine Tree deodorizer stuck to your butt."

Sometimes, you just want to disappear.

"For the baby's room," I offered weakly. "Helps with the diaper smell." No lie there.

Brogan greeted us at the french doors overlooking the pool, left

open to welcome the breeze. He thumped his heart twice with his fist then pointed at me, his parody of Hollywoodese. In his best Scorcese he said, "Welcome, Godfather."

"Remy?" Rita asked.

"Still sleeping," Brogan said. I could hear Remy's breathing from the baby monitor clipped to Brogan's belt like a pager.

"I saw you met Neal and Patti," Rita said. "Have you met Rosa?"

"No. I just got here."

When I got the *godfather* invitation from Rita last week, she told me she'd invited Rosa to their little get-together. Rita and Brogan had been active in a children's charity called *L.A. Kids* for years. Rita had gone from doing the grunt work—sorting donated clothes and begging on the phone for donations when she was an unrecognizable starting actress, to becoming a spokesperson as she became a celebrity. Typical Rita though, she still did her share of the grunt stuff, and that was how she met Rosa, one of the new volunteers.

"Toby, you've got to help me!" She cast a playfully annoyed look at Brogan. "He's no help."

Brogan just laughed. "Don't look at me. You invited her!"

"I'm so embarrassed. I don't know what to do." Despite her light mood, I could tell she was more distraught than she was letting on.

"Toby, I had such a nice time with Rosa that day at the center. She's just the sweetest lady. So poor herself, but spending all week there helping others. So I invited her over. I told her we were having some friends over around two for lunch and would like her to come."

Rita had told me on the phone Rosa was like many of the migrant women we grew up with in Fallbrook, and who were filling Southern California in rapid numbers.

"So she shows up at *eleven* and heads straight for the *kitchen!* To start *cooking.*" Rita paused. "Toby, she thinks I was hiring her to cook for us! She's supposed to be a guest!"

I couldn't help but laugh. "So why don't you just tell her you invited her as a guest?"

"I would, but if she thinks I was hiring her to cook, she'll want to get paid. She may really *need* that money, Toby. I don't want to embarrass her into not accepting it."

"So pay her."

"I would, but I don't want her to see me as a *padrone*. I want her to see me as a friend."

The field workers we grew up with would never call their employers by name. Probably because they were working a different field every day and had no idea of the name of that day's boss. They all called the bosses *padrone*.

"Toby, she's really sweet. I don't meet many people like her. I. . . just don't want to do the wrong thing."

I suddenly realized I was wrong to be taking the situation lightly, as Brogan seemed to be. For all Rita's fame, she was in many ways a lonely person. She'd lost the key people in her life early and was likely still living the consequences. Her mother had died in child birth, and her father arranged for a nanny. We knew her as Lettie, but to Rita she was *Nana*. We knew Lettie's sad story from Rita's dad. She'd been one of his patients, one of the many migrant workers who would have received no medical care if not for him. Lettie's baby had been stillborn, so instead she loved Rita, and no mother could have loved or nurtured her more. When Rita's mind's eye looks back at a mother, it likely wasn't the mother in the framed photograph whom she never knew, but her Nana who raised her like her own daughter. So it was even more hurtful to Rita than the death of her own mother when Lettie left when Rita was six or seven.

I had vivid memories of those early years. Brogan, Rita and I become fast friends our first day of kindergarten, and it continued every day after school, our red Keds wore paths though the groves that con-

nected our properties. Brogan and I became virtual additions to the family. But there was still no one as important to Dr. MacGilroy as Rita, and years later when he found Brogan's hand in Rita's bra, he acted like any father of a fifteen year old girl, swearing to bar Brogan from their home for life, and demanding a sworn promise from Rita "never to see that boy again."

I'm sure a month or two later Rita's dad would have calmed down and things would return to how they were before, but the car accident which took Dr. MacGilroy's life occurred four hours later. A routine drive into town with his best friend. A drunk driver's loss of control.

It was just all to much to bear. The loss of her mother. Her Nana. Then her father. Worse, her father's last words forbidding her to see the boy she loved, even though she knew they were said in haste and anger. How many people could she lose?

Rita had no relatives. Luckily a foster family was found who lived on the other side of Fallbrook, so we could still see each other at school, but our well-beaten paths through the groves were forgotten and slowly filled with weeds.

"Toby?" I realized Rita was staring at me, actually wanting me to solve her dilemma about Rosa.

"Is she enjoying herself in the kitchen?" I finally asked.

"She seems to be. Actually, yes. She's humming and smiling. . . and I can't wait to eat. It smells *delicious*."

"And do you think she'd have a good time mingling out here with everyone?"

Rita's eyes roved around at her millionaire, director, agent, doctor friends. Point made.

"So why not let her keep things like they are?" I asked.

Rita thought for a minute. "You're right, Toby." She rewarded me with a megawatt smile. "Now come and meet her."

Rita brought me into the kitchen. Rosa was busy at the stove, confident in her culinary movements. She had eight plates spread out, and she was just starting to fill them with Spanish rice and beans.. A pile of six taquitos—tightly rolled, fried tortillas filled with carnitas beef—filled the center of each plate, with small bowls of salsa and guacamole. Everyone grew up with Mexican food in Southern California, not surprising with half our population being Hispanic. Still, I couldn't remember food smelling this fantastic.

"Rosa, this is Toby. He is our best friend."

She said it very formally, honoring me by the designation, and Rosa complimented by Rita wanting her to know. Typical Rita. Then Rita emphasized it in the limited Spanish even the Anglo Fallbrookians possessed, "*Mejor amigo.*" She didn't need to add it, but it was Rita's way to humble herself before Rosa, showing her second language skills were inferior to Rosa's.

Rosa gave me one of those smiles only grandmothers and Santa Claus can make, somehow completely selfless and encompassing all the good things in life.

"Is nice meet you, bes' frien' Toby," Rosa carefully said in her heavy Spanish accent.

She was about as old as Gina, but a hundred pounds heavier. She had smiling almond eyes and flawless café au lait skin.

"You ready for the lunche?" She asked, indicating the heavily piled plates almost ready to serve.

"Yes, Rosa. Thank you." I could have said *si*, but why show off.

Rosa smiled and added some blue tortilla chips as a finishing touch on the plates.

"Rosa, there are only eight plates," Rita said.

"*Si*. Eight friends. No?"

"But *you* make nine, Rosa. Let me make a plate for you."

"You want me at table with the friends?" Rosa asked.

"Yes, I'd like you to join us. Will you?"

Rosa's eyes were moist. "Si. Is very nice, *Senora* Rita. *Gracias*."

I watched the two move contentedly around each other. Rosa grabbed one taquito from each plate, leaving five. As much as I was glad to see Rosa join us, I mourned the loss of one taquito. Rosa put five of the confiscated taquitos on her plate, leaving her with three extras, which she then cut into three equal pieces, making nine. Now she almost joyfully moved to each plate, and pushed one of the nine segments into the beans on each plate. Now all nine plates had exactly five and one-third taquitos.

"Now is fair for all the persons," Rosa said.

Wow, I thought. I'd like to take this lady to Vegas sometime. She could count cards for me any day. I tried to work out the equation she'd instantly applied to equally divide them, but gave up when I remembered I'm only a lowly lawyer with a dominant right hemisphere brain poorly suited for practical thinking.

We each grabbed a few plates and headed for the dining room. Everyone was inside now, except for Stephen who was swimming laps. Or maybe Gina locked him out.

Brogan ignored the phone when it rang and let their answering machine get it, but he leaped up when he heard the words, "Hello, Mr. and Mrs. Barlow. This is Dr. Silva, from BioGenetics. I wanted to tell—"

Brogan picked up the phone. "Hi, doctor. This is Brogan. Thanks for calling."

He waved Rita over as he said, "Rita's here too. Can I put you on the speaker?"

Brogan must have got a *yes* because he replaced the receiver and we could all hear the doctor clear his throat in readiness. At that mo-

ment Remy let us know she was awake with a small cry via the moni-
tor, and Rita darted down the hall to get her.

"Just a minute, doctor, Remy wants to be here too," Brogan
laughed. To the rest of he us he said, "Dr. Silva's from the stem cell
cryogenics lab. We've been waiting for the results."

As we waited a moment for Rita to join us I marveled at the bene-
fits of stardom in health care. I'd never had a doctor call *me* with test
results. I could be dying, and I'd be on hold two hours to speak to a
nurse trainee. Yet here was the doctor personally calling, waiting, and
chuckling at Brogan's inanities.

Likely no one in the room outside of Brogan, Rita and me knew
about stem cell preservation. If plans are made in advance of a birth,
stem cells from the blood of the umbilical cord are cryogenically pre-
served. The cells are potentially beneficial in fighting leukemia and
various cancers if they occur later in the child's life. They must be
preserved quickly, however, and since Sammy's birth was at home,
there was a long delay to bag the placenta and cord. They hadn't been
optimistic.

Rita and Remy came back into the room.

"Okay, doctor. We're all here," Brogan said. "We have a few
friends over too. Everyone say hello to Dr. Silva."

"Hello, Dr. Silva," we all said in unison, like a well-mannered
kindergarten class. Actually, it was fun to share in Brogan and Rita's
excitement. I realized none of the rest of us had children, so maybe
we were all living a bit vicariously through them.

Brogan asked, "So, doctor, how did it go?"

"Well, bad news and good news. The bad is that just too much
time passed before the hospital could preserve the placenta. To re-
move the cord blood for stem cell preservation, it has to be captured
almost instantly or it clots. I think you were aware it was a long shot?"

"Yes, the hospital told us," Brogan said.

"But the good news is that we can take another shot at it with the other cord. That's what I called to ask you. Do you know if the hospital is preserving it for some reason?"

"What other cord?" Brogan asked.

"Well, obviously there were two cords. What I'm saying is we were sent only the placenta and one of the cords. Are you saying you don't know where the other one is?"

"No," Brogan said. "What I'm saying is I don't know why you're talking about *two* umbilical cords. Samantha had only one baby."

There was a pause as the doctor cleared his throat uncomfortably. "Mr. and Mrs. Barlow, maybe there's some mistake. The placenta I have in front of me is tagged as that of a Samantha Ellen Burroughs. Is that correct?"

"Yes," Brogan and Rita said in unison.

"And we're talking about a birthing date of June 17, 2:12 a.m., Fallbrook, California?"

"Yes."

"Well. . . I don't quite know what to say, Mr. and Mrs. Barlow. But this is a single placenta, and there were *two* umbilical cords emanating from it. One was still attached. The other was severed, causing a rupture of the placenta. . ."

"You're saying. . ." Rita trailed off.

"What I'm saying, Mr. and Mrs. Barlow, is that Samantha Burroughs gave birth to twins."

6

THE ROOM GOT quiet fast. For a long moment the doctor said nothing. This wasn't what he bargained for when he decided to make a fun celebrity call.

"But doctor, we were *there*! Right after the baby was born!" Rita said, holding Remy tighter. "Sammy only had one baby, not two. She's here with us now. Remy."

"Mr. and Mrs. Barlow," the doctor said nervously, "I'm just a pathologist. I can only comment on what's in front of me. But the placenta I examined was a single placenta, with *two* umbilical cords. That means she gave birth to twins. There's no doubt about that, unless someone bagged the wrong placenta, but I've never heard of that happening."

He went on uncomfortably. "I have down here you're the adoptive parents. You're saying you only have one baby?"

"Yes." Brogan's voice was barely audible. "One baby."

There was dead silence in the room, as well as from the speaker phone. What could anyone say?

Finally Rita spoke up. "Doctor, is there anything you can tell us about this other. . . this other baby?" She sounded like she didn't want to believe what was going on, but a part of her knew it was true.

"Well, there were remnants of only one sac, meaning the twins would both be girls. *Identical* twins actually."

Brogan had gone completely white.

"Doctor, I hate to sound stupid," Rita said, "but if we have one baby, where is the other one?"

I could almost hear the doctor gulp through the phone.

"I don't know what to say. I guess you have to ask the mother."

The doctor couldn't get off the phone fast enough. I'm sure this would be the last time he broke protocol and took over a nurse's job.

"Identical twins," Brogan said numbly, staring at Remy.

We all just stared at each other, no one knowing quite what to say. I wandered over by the fireplace to think alone, and give Brogan and Rita some privacy. Stephen chose that moment to enter from the pool, oblivious of the odd silence and somber mood in the room. I was the lucky one he approached. At least he'd covered his Speedo with some shorts.

"Did you check out the hi fi?" He indicated a tiny box of chrome with countless knobs and dials, compact enough to sit between books on the built-in oak bookshelves next to the fireplace. I wanted to say no one called a stereo a *hi fi* in the last twenty years, but I preferred that he keep aging himself.

"It's a Nakamichi," he went on. "Most expensive system in the world. $11,000 retail, but I know a guy if you want one. Absolute studio sound. Completely programmable. I can set it right now to turn on and off exactly when I want, and it gets stations all over the

world." He shrugged modestly. "Bought one for me and one for them. Little gift for the baby."

Yeah, perfect baby gift, I thought. Remy will have fun with that. And not ostentatious at all.

Stephen finally realized everyone was staring at him. He always spoke a few decibels louder than needed when describing his money. How else can anyone overhear about his generosity? He noted the somberness of the room.

"What's going on? What's wrong?"

Brogan walked over. "We just got a call from the lab, Stephen. Some test on the placenta showed that Sammy had *twins*. She gave us Remy and. . . kept the other baby. We don't know what the hell is going on."

Stephen slowly sank next to me on the ledge in front of the fireplace. "Oh, Brogan. Rita. I am so sorry." Rita had walked over and he reached out a hand to her.

"How could this happen, Stephen?" Rita asked. "Sammy's doctor had to know it was twins. Wouldn't she?"

Although Stephen was an infertility doctor, the underlying training was always obstetrics and gynecology. This was his territory.

"Yes, she'd have to know." Stephen looked to me. He might as well have been pointing his finger.

Suddenly I was feeling stupid. This was my adoption after all. Sammy had moved from Palm Springs to Fallbrook right before she was due. I'd referred Sammy to a doctor pal, Janice Whitney, but Sammy gave birth just a week later, before her first appointment. Sammy had neatly boxed us all out of knowing the truth. Still, Janice would have ordered Sammy's medical records from the Palm Springs doctor. I'd have to call her to find out why they didn't show the twins.

Rita didn't wait for an answer. "What about the paramedics?

They were there right after the birth. Couldn't they tell?"

Stephen stood up magniloquently and I started disliking him again. He assumed a professorial tone and addressed the room. "Let me explain. The umbilical cord is of course attached to the baby. The other end is attached to the placenta. When the baby is born, the placenta is discharged right after the baby. There's one placenta for a baby in a single birth. With twins, there can be one or two placentas, but if there's only one there'd be two umbilical cords coming from it."

"But there was only one cord," Rita said. "We were there!"

"Well, if someone wanted to hide the fact twins were born, they could cut off one umbilical cord from the placenta. They often rupture anyway, so anyone casually looking at it probably couldn't tell the difference. There'd be a lot of blood camouflaging it, so you wouldn't know until it went in for pathology."

The room was silent, staring not at Brogan and Rita, but at Remy. Our thoughts were all the same. Somewhere out there was her exact duplicate. For some reason that made it more terrifying and horrific than if they were not identical. It almost felt like Remy herself was being pulled away. I could see Rita's arms tighten around her.

"They'll find her. She belongs to *you*," Stephen said vehemently. "There is no way that woman can get away with this." He looked to me, the supposed adoption authority, for affirmation and more words of support. The problem was I could foresee complications of which none of them were aware. Legal issues I'd never had to face before. No one had to face before. But I kept them to myself for now.

"Oh, God," Rita blurted suddenly as her eyes filled with fear. She looked at Stephen. "The hypothyroidism. . . won't the twin. . . ?"

His eyes lowered to the floor, and he hesitated as if he didn't want to heap more misery on Brogan and Rita, but had no choice. Finally he said, "Yes. . . if one twin has it, the chances are likely the other

one will too." He looked up. "I'm so sorry."

He didn't need to spell it out. We'd learned the harsh realities when we learned what Remy had been spared with the early discovery. A baby can only go so long without sufficient thyroid hormone to make the brain and all the other body organs work right. Unless Sammy had the baby tested, which seemed unlikely—if the baby was even *with* Sammy—by the time she noticed something wrong, it'd be too late. We were about a month away from the baby starting to literally lose her mind. Or at least, her intelligence.

I turned to Brogan. "Sammy's still living at Coral Canyon. That's where we need to be."

Everyone said their quick goodbyes. As much genuine sympathy as they had, I think they were still relieved to leave. Only Rosa did something useful, picking up the untouched, heaping plates of food from what had only minutes ago been a festive table. I could see she was quietly crying, and not over the waste of her beautiful meal. She paused only to give a hard stare at Stephen's back as he left. Evidently I wasn't the only one who picked up on his untimely pontificating.

Brogan, Rita and I huddled together, glad to be alone. Somewhere out there, Remy had an identical twin. Safe? Alive? A pawn in a black market adoption? The worse part was not knowing. With any luck, we were a few hours away from finding out.

"What's going on, Toby?" Rita looked lost. "If Sammy had twins, what did she do with the other baby?"

"I don't know." I turned to Brogan. "What we have to do is get to her right away. Not let her know we know there's another baby until we're face to face."

"What are you talking about?" Rita wailed. "You need to call the police!"

"Trust me, Rita, it's better we handle this ourselves. I'll explain

later."

She didn't agree. I could see it in her eyes. It was against her every instinct, but the value of a lifelong friendship and trust made her accept it. It must have been killing her.

"Okay," she said.

I didn't want to tell her the problems she and Brogan couldn't begin to see. Problems the police couldn't help with. Now wasn't the time to tell them.

"How do we know she's still there?" Rita asked me.

Now that I thought about it, Sammy had hardly been around her place. Neither had Travis. I hadn't given it much thought.

Brogan spoke up. "Why don't we call her to see if she's still there? If she's gone, we can save time and call the police right now."

I nodded and ran through an imaginary conversation in my mind, then picked up the phone and dialed. It was picked up after two rings. Sammy, sounding cheerful.

"Hi, Sammy!" I tried to sound cheerful myself. "How you doing?" Brogan nodded at me encouragingly. I must not be sounding too phony.

"Hey, Toby. I'm okay. How 'bout you'?"

"Fine. Hey listen. I'm going to be out of town the next couple of weeks. I thought I'd drop off your relocation check later today in case you need it before I come back." Adoptive parents are allowed by law to help a birth mother with expenses related to the adoption and the pregnancy, meaning they can pay her living costs for a month or two after the birth.

"Sure. Hey, can you pick me up some cashews and a Dr. Pepper? I've been dying for some."

"No problem. See you then."

My short phone call had produced a thin bead of sweat on my face. In fact, my whole body felt clammy. This acting was hard work.

I looked to Brogan and Rita.

"That was good," Brogan said. He turned to Rita. "Honey, you and Remy need to stay here. Okay? I'll call you right after we talk to Sammy. We'll find Remy's sister. I promise."

Rita was probably dying to come, but didn't even try to argue. It looked like she could barely stand. And they couldn't bring Remy into the uncertain situation awaiting us at Sammy's. Rosa came into the room and stood awkwardly. Brogan turned to her.

"Rosa? Can you please stay with Rita and Remy until I get back?"

Rosa walked to Rita's side with all the seriousness of an aged veteran wearing his tattered uniform in a Memorial Day parade. She placed her hand on Rita's shoulder.

"I stay for as long as she be needing me."

Brogan and I practically ran for the door.

7

WE TOOK OUR own cars, with Brogan in the lead, and my Falcon struggling to keep up. Luckily, the traffic was light and we pulled in front of Sammy's place at ten minutes to four. Without cashews and Dr. Pepper.

There was no answer to our knocks. There was also no answer to our pounding. Finally, we tried the door. It was open.

Damn it!

The place was empty. Sammy was gone. Her clothes were gone. Everything was gone but the furniture. A few small items littered the floor, as if they fell during a hurried departure.

Brogan sank to the couch. "Toby, I can't believe this. Why would she do this to us?"

I didn't have an answer, just another question. "Do you think she planned it all along, and that's why she gave birth at home?"

"Travis. Toby, it's got to be Travis." We were both thinking about Travis's odd absence that night. And with his training as an

Army medic, he could handle a routine birth, not to mention the cam-
ouflage job on the placenta.

"What has that asshole talked Sammy into? This is kidnapping!"
Brogan said. "We've got to call the police."

"It's not kidnapping, Brogan."

I wasn't happy to say it. It was what I'd avoided telling Rita.
They had enough to worry about without realizing they were virtually
powerless against what Sammy had done.

"What do you mean it's not kidnapping? Those kids are ours
now! She signed her consent!"

"No. She signed a consent to adoption for *Remy*. Not for the other
baby. There's no law that says she has to place *both* her kids for
adoption. There's not even a requirement she *tell* you."

But I was thinking about a lot more than that. Things I didn't
want Brogan thinking about yet. Like why would Sammy go to all
this trouble? Risking her life to give birth at home to hide the twin
birth. The stakes must be high for her to take that chance. What she
did was not illegal, just terribly cruel. To separate twins, and lie to the
adoptive parents about one child's existence, was unforgivable. And
why was she gone now, less than two hours after we called her? Had
someone tipped her? Or was she suspicious from my call? Maybe my
acting wasn't as good as I'd thought and she got spooked.

Was there a scam coming? Ransom? My head was spinning.
These options would occur to Brogan and Rita all too soon, but I did-
n't want to heap too much on them. Racing through their minds were
imaginary horrors of what was happening to Remy's twin, their al-
most daughter. Where was she? Who was she with? Was she safe?
Alive even? Would they ever know? And what about Remy? To go
through life knowing you have an exact twin, but never knowing her.
Maybe thinking her birth mother loved the child she kept, but not her.

"So we can't even call the police?" Brogan finally asked.

"I didn't say that." I knew we should. The question was how much would the police do. Obviously Sammy was in on whatever was going on. She must have called us just after Travis left with the other baby. If she'd wanted, she could have told us right then if Travis had run off with one of the babies against her will. Instead she was calm and composed. She wouldn't have been like that if there'd just been an altercation with Travis, or someone else taking the baby. I had to think there was a big picture I wasn't seeing yet. What was the alternative? Was it possible we were just dealing with a person skirting the edge of sanity? Of all the options, that was the one I feared the most.

"I think we're wasting time," Brogan said, dialing 911 on his cell phone. "I'm getting the police here. Now."

As we waited for the police to arrive, Brogan called Rita to fill her in. It suddenly hit me I had some leads to Sammy. Like all birth mothers, she'd completed the required California adoption forms covering health history and background information. I didn't know if I'd get a lead from her information, but with Sammy now on the run, I needed to act quickly. I explained to Brogan where I was headed and agreed he should wait for the police. I knew if I ran, I could be at my office in no time. It was only a quick five hundred yard dash away.

My office was actually the Coral Canyon Golf and Tennis Pro Shop, official home of overpriced high-end sports equipment. But nestled in its former storage room was The Law Offices of Toby Dillon, Esquire. Non-traditional, yes, but it suited me fine. And like my apartment, free is free.

My career, my home, my office—all sprang from the Coral Canyon courts. My path to lawyering had been a circuitous one. When I'd

returned from Nepal five years ago, I learned my old bedroom had become a sewing room ten minutes after I'd left the country. What hurt was that my mother didn't even sew. At least my old Falcon was still in the garage, if for no other reason than to hide it from the neighbors' view. I'd bought it with money I earned myself in high school and was a sign of independence I still held in a death grip.

Not to mention it was a wise investment. I'd bought it for $525 when I was seventeen. Now, fifteen years later, it was easily worth $550. It didn't have air conditioning, but the holes in the floorboards provided a nice breeze on my feet, and the 8track player still worked good as new. Considering you can pick up 8 track tapes for about a nickel each at garage sales, I'd built up what must be the nation's largest collection. Of course, the last group to release something on 8 track was Abba.

My first worry upon returning to American soil should've been to look for a job. Not to mention an apartment. Maybe new clothes which didn't smell like three years of Nepalese donkey dung, the fertilizer of choice of discriminating Nepalese farmers. Instead I'd headed for Coral Canyon.

It was Fallbrook's numero uno country club. Serpentining along the first and ninth holes were its one hundred sixty-eight rooms, in two story condo style units done up in a classy Santa Barbara Spanish look.

Playing poor sister to the pampered golf course were the tennis courts, hidden in the middle of the golf course behind a stand of trees. To get to them you had to drive down a narrow road running between two fairways. In that brief five hundred fifty yard run we'd hit seventy miles per hour as we tried to outrace the golf balls which were searching for a fender to smack. You could tell the loyal tennis players by the number of golf ball dings in their car. You'd think someone in their new S class Mercedes would get pissed, but every-

one wore their dings with a badge of honor. The scars of battle on the way to the battlefield.

As I pulled up I could see the club pro, Lars, through the green windscreen on the fence. He was at the net, giving a lesson. It looked like Janice Whitney. She'd been one of the regulars when I'd left for Nepal, and judging from the rockets leaving her racket, she'd been working hard at her game for the last three years.

"Just trace da path, Janice. Trace da path of da ball right back to me, yaah?"

Lars' thick Norwegian accent was even more pronounced than I'd remembered. But his volleys were the same as always—perfect, as he placed each one within a foot of the service line, allowing Janice to hammer them as they rose to her swing's sweet spot just above her knees.

"Da longer da strings on the ball, da more power in da shots, Janice. Yaah? Trace da path of da ball right back to me."

I entered through the gate behind Lars and walked over to a table with a green market umbrella and took a seat. Helped myself to the chilled Fallbrook water from Lars' cooler.

"Toby!"

This from Lars without turning his head or breaking stride in his volleys to Janice. Tennis pros have the greatest peripheral vision. They must have been lizards in a prior life. Of course, considering Shirley McLaine had all the good prior lives, little was left. "Home from da war to visit vit Lars, yaah?"

Janice ignored Lars' feed and ran over to give me a sweaty hug. "Toby! It's so good to see you! Lars put up all your post cards on the bulletin board. So, three years on a clay court, huh? Must have been awesome."

Here is the perfect illustration of The Tennis Player. Janice, an intelligent, successful woman, an obstetrician in fact, but also a Tennis

Addict. She did not have a single comment or question about Ne-
pal—the people, the food, the weather. All she wanted to hear about
was the clay court I'd written about. Actually, it was more dirt than
clay, part of the recreational wing of the U.S. Embassy there, dubbed
The American Club. Embassy staffers and us lowly Peace Corpers
spent most of our off time there.

"Lotta slidin' on clay," I told her. "Run, slide, hit. Took me
awhile to get used to it. Glad to be back on American cement."

"So Toby, are you back for da good, or just on da vacation?"

"Back for good, Lars. Gotta look for a job."

"Well, I hope you'll be a regular again," Janice said. "We've
missed you around here."

Lars' eyes dropped to my hand. "So, you come ta play? Or ta
talk?"

I followed his eyes to my hand, and was surprised to see my ten-
nis racket in it. I must have subconsciously grabbed it from my trunk
without even thinking about it. I grinned. The truth was that I was
dying to hit some balls. Wanted to feel good solid concrete under my
feet and the true bounce it would give. Plus, unlike Nepal, there
wouldn't be any chickens running across the court at match point.

Janice gave my butt a push with her racquet. "C'mon. My les-
son's over. Let's hit."

There were still balls all over the court from the lesson, so I
stuffed my pockets, and headed six feet behind the baseline, a good
spot to warm up with some easy ground strokes. We only planned to
rally, just keeping the ball in play, focusing on that est-like perfect
striking of the ball. Still, instinct makes you look for weaknesses, and
soon we were moving each other around the court, testing forehand,
backhand, speed to the net for drop shots, speed back for lobs. Like
Lars, I kept her moving, but subtly made sure each shot was hittable.
Not too much spin. Nothing to everyone's Bermuda Triangle, the

deep backhand baseline corner I knew I could hit on demand if I wanted.

She had just spent seventy bucks for an hour lesson, and had been Lars' eleven o'clock on Tuesday for almost a decade. It was important to send her home feeling good about her game. Lars had not only taught me what I know about tennis, but in one summer of helping him run his kids' tennis camp, the business side as well.

I shook her hand over the net. The tennis court, last bastion of good manners. "Nice strokes, Janice. They're really looking good."

She grinned. "Next time I see you here, it's a set for dinner, okay? Spot me two games."

"You hit like that and you want two games? It's even or nothing."

"Okay. It's a deal."

With a wave to Lars, she was off. For a moment Lars and I said nothing, both of us respecting the unspoken male ritual of watching her small bottom swing its way off the court in her pleated skirt. She'd be the first to admit she'd be checking out Lars given the chance. You could paint a bulls-eye on my shorts and still no women would check out my skinny buns.

"Ya look good, kid." Lars pulled up a second chair and put his feet up. "What's this about looking for a job? The old man didn't offer you something cushy at the firm?"

Lars' heavy Norwegian accent was gone, and would not appear until the next student appeared. I'd known him for twelve years before I was in on his secret. Although he was born in Norway, he'd been raised in California and would not know a *cruller* if I waived one in his face. As Lars put it, a good tennis pro can get fifty bucks an hour, but a good tennis pro with a European accent went for seventy.

Talk of jobs and my father brought me down from my endorphin

high. "Yeah. He'll offer me something. But you know my dad. He'll want to see me fail first, so he can pick me up."

Lars just nodded. He knew my father. "Hey, did you hear I bought a house?"

"Hey, congratulations!"

I guessed that was what you were supposed to say about things like marriage and home buying. Personally, I wasn't interested in any of them just yet, but I put on a happy face for Lars.

"Three bedrooms, two baths, hardwood floors. About an acre. Nice view." He rattled it off like he was reading a brochure, but I could tell he was proud. His eyes drifted to his unit at the end of Building Seven overlooking the courts. "Plus more privacy."

Ahhh. Now I got it.

Lars' deal with Coral Canyon was the usual eighty-twenty split. Pros were never salaried employees. He kept eighty percent of all he brought it, and paid back twenty to the club. Sort of like rent for the courts. When he was wooed by one of the big clubs along the coast a few years ago, Coral Canyon offered him a free apartment in addition to the split. It gave Lars little chance for privacy though. Not that tennis pros score with the regularity their reputations would lead us to believe, but Lars saw his share of tennis skirts fall to the floor.

"Here's what I'm thinking, Toby. I can't budget giving you a salary, but my contract gives me the apartment. How about I give it to you, and you help me out on the courts. Plus you get all the court time you want, of course."

I was savvy enough to know we were now entering serious negotiations. I put on my poker face.

"What are you grinning about?" Lars asked.

So much for my poker face. What could be more perfect? My own apartment, at a country club, next to the tennis courts. "What would you want from me?"

"Just be a court rat, like you used to be. Hang around. Hit with people. Build them up. Take them down just enough so they want some lessons." Lars grinned. "People seem to like you, Toby. Don't ask me why."

The deal was struck in about five minutes. I even got a title, Assistant Tennis Pro, which came with the honor of rising at 5:30 a.m. to blow off the courts each morning and chasing off skateboarders at night. Small price to pay for my own apartment. This ranked right up there with being with my first girl. I just hoped the apartment would last longer.

I still needed a job to pay for food and gassing up the Falcon, but I figured I could go jobless for a few months thanks to my meager Peace Corps savings. Four days later I dove for a ball on the court, landing on my chin and rendering me temporarily unconscious. When I came to, my first thought, after *ouch*, was I'd forgotten health insurance in my budget. This became apparent when I received the $3,200 hospital bill. Suddenly I was in debt to my only available lender, the Bank of Dad.

Dad's solution was to put me to work at minimum wage, plus paying an extra dollar an hour toward my debt. This would keep me under his thumb for three thousand two hundred hours. I believe pre-Civil War plantation owners used this same strategy to give slaves the false hope of one day buying their freedom.

Dad determined the only job I was qualified for in his law firm was on the janitorial staff. Don't get me wrong. All work has dignity, and after what the Peace Corps makes you do, being a janitor was no ego-shaker for me. But emptying the waste baskets of my two older brothers, both attorneys in the firm, tended to grate a little.

Actually, I knew my dad wanted me to be a lawyer, and I assumed my janitorial duties were somehow tied into that goal. Kind of like in *Karate Kid*, when aged karate expert Mr. Miagi makes ninety-

eight pound weakling Daniel-san paint his fence and wax his car. When little Daniel-san finally explodes that he is there to learn karate, not do chores, he learns wise old Mr. Miagi had been teaching him karate all along. When Mr. Miagi shouts, "Paint da fence!" young Daniel-san's painting motion becomes a perfect block. When he yells, "Wax da car!" we see yet another masterful blow.

For me though, it turned out that when dad said, "Scrub the toilets," he meant scrub the toilets. It was not the groundwork of learning grandiose circular hand gestures to impress a judge or jury.

I was Cinderella looking for a glass slipper. A month later it appeared in the form of my Uncle Charlie, dad's younger brother. He had a solo practice in neighboring Escondido. He learned law at my grandfather's knee, as had dad. The difference was that there was only enough money to send one son to law school. Or maybe grandpa just wanted dad out of the house. So my uncle stayed behind, clerking for grandpa and becoming an attorney through a little known California law studies program called *apprenticeship*.

Even most attorneys don't know the program exists. If you have at least two years of college, you can mentor under an attorney for four years, earning the right to sit for the California bar exam. It constitutes a giant investment of time for both teacher and student, and few attorneys would take the time. But as his dad did for him, Uncle Charlie did for me.

Law school graduates have a thirty-nine percent passage rate on the California bar exam. It is considered one of the toughest in the nation. Apprenticeship students like me have only a one percent passage rate. Says something for traditional law school and the four years of undergraduate study they require.

Still, I passed. First try.

Since I was a graduating class of one, Uncle Charlie bought me a double cheeseburger at *In and Out Burger* for my graduation party.

There was no diploma or graduation cap to throw in the air, unless I borrowed one of the paper hats from the counter guys. There were also no job offers, not even from my dad. Although I was a graduate of UCLA, the problem was that *my* UCLA stood for Uncle Charlie's Law Academy.

The deal I'd made with Lars four years ago had worked great for both of us. It didn't strike *me* as odd the guy who cleaned the courts was an attorney. But luckily for me Lars did.

That was a year ago. So Lars came up with another sweet deal for me to keep me around. He found an office I'd get for free, allowing me to start my own practice rather than have to choose between the law firms he imagined were vying for my attention. Enter pro shop storage room. And if you didn't mind having to squeeze past the golf club display to get in, it wasn't bad. I only had to keep doing what I did before on the courts, only now a free office was part of the package. Some may have turned up their noses at the sight of the office, but Uncle Charlie Law Academy graduates with no job offers didn't.

Lars even scrounged up a desk and eight six-drawer file cabinets, which spoke highly of his opinion of my future law practice. Now, almost a year later, forty-seven of the forty-eight drawers were still empty. Empty of files anyway. I could fit all my client files into one file drawer. I let the pro shop put extra golf shoes in the other forty-seven. Seemed fair since I took away their storage room. But I did have to ask them to not come into the office during client meetings to search for size nine, cleated Reeboks. I didn't even have to pay a secretary, as Hilary the pro shop counter girl was always willing to give me a courtesy bang on the wall to let me know clients had arrived. I even got a ten percent kickback if my clients bought a golf club set, excluding sale items.

I got my first adoption case just a month into my fledgling practice, thanks to a referral from my tennis pal, Janice Whitney. One of

her patients confided she wanted to place her baby for adoption, but didn't know whom to call. Like all OB/GYNs, Janice also had a ton of couples fighting infertility who were anxious to adopt. She started sending them all—birth mothers and wannabe adoptive parents—to me.

Janice spread the word among her doctor friends, and soon I had a couple of girls a month calling me to help them place their babies for adoption. Before I knew it, I'd found a niche I enjoyed. I was surprised to learn few lawyers knew much about adoption. Nor did they care to learn. Like it was too sissified an area for real lawyers.

I was hardly winded from the run from Sammy's thanks to at least six sets of tennis every day. I skipped my usual banter with Hilary at the counter as I raced past the tennis racquets and golf sets and into my office. I mentally crossed my fingers as I opened Sammy's file.

8

IT WAS EARLY in the adoption and the adoption file was still pencil thin. It would be another six months before Brogan and Rita's home study would be done by the Los Angeles Department of Children's Services, and another two months after that before we'd get into court to legally make them Remy's parents. So at this point, my file on the case was just the Petition for Adoption we filed in court, and Sammy's personal and health history forms. Of course, I already knew there was nothing in them about a thyroid issue, but even if Sammy had filled them out honestly, the thyroid problem was usually the result of a recessive gene no one even knew they carried.

I stared at the permanent address Sammy had given. Her parents, in Sherwood, Iowa. She didn't list a phone, but normally there'd be no reason to call them anyway. I tried directory assistance.

"What city and listing please?"

"For Sherwood. Sean and Martha Burroughs?"

"Sir, how are you spelling Sherwood?"

I spelled it.

"I'm sorry. I show no such city. Are you sure it's in Iowa?"

My heart sank. That was what I'd feared. "Can you, check the names anyway? Statewide? And also Samantha Burroughs?"

"Not without a city, sir. Is there another city you'd like me to check?"

What would be the use to guess cities? Obviously the address was a sham. She must have been planning this from the moment she entered my office. Maybe it was even *why* she came to my office.

My next call was to Janice. I already knew why Janice had not known Sammy was expecting twins, despite Stephen's grumblings. Although I'd set up an appointment for Sammy with her, she'd cancelled it, saying she was sick. Then she gave birth days later. Obviously she was avoiding seeing a doctor to hide the truth. Janice didn't treat her until hours after the birth, and absent analysis of the placenta, there'd be no proof of a twin birth. Besides, who'd expect someone to hide something like that?

But what I was hoping was that Janice requested Sammy's medical records from her initial obstetrician, before she moved to Fallbrook. I could only hope maybe Sammy goofed and her real address would be in that doctor's records, before her scam had taken shape.

Tammy, Janice's receptionist, answered the phone. I asked for Janice.

"She's delivering over at Regional, Toby. I don't know when she'll be back."

"Can you check something for me?" Tammy knew about my role in the adoption, but not the newest turn it had taken. "Did Janice request Samantha Burrough's medical records from her first doctor?"

"We always do. What do you need?"

We'd worked together enough on adoption cases that annoying

technicalities like doctor-patient privilege weren't taken too seri-
ously.

"I need to see if you have a prior address for Sammy. I thought
maybe your paperwork, or the old doctor's file, would have it."

"Why don't you just ask Sammy, Toby?"

"I would but she's not around and I need it now."

No lie there.

"Let me see what I've got. Hold on."

She was back quickly. "We don't have much, Toby. In our ques-
tionnaire she just lists her address at Coral Canyon... Hmm."

"Hmm? What'd you mean *hmm*?"

"Well, it looks like we never got her first doctor's records on the
pregnancy."

"You didn't? Don't you always ask for those?

"Of course we do, but it looks like Sammy forgot to sign the Au-
thorization to Release Information form, so we couldn't request them.
No doctor's going to send a patient's records without that. I should
have followed up on it, but to be honest, since she already gave birth
and she and the baby were fine, I didn't see any urgency to it I guess.
Is everything okay?"

"I. . . I just need the address."

"You could always call the doctor yourself, Toby."

"You mean you've got the doctor's name?"

"Sure. Sammy filled that part in. It's Paulette Johnston. She's a
general practitioner in Palm Springs. She didn't put down a phone
number though."

Maybe there was a glimmer of hope. I thanked Tammy and called
directory assistance a second time, this time with better luck. I was
given a number.

"Dr. Johnston's office. Please hold."

Yes! In a moment, the voice returned.

"This is Carolyn. May I help you?"

"Carolyn, this is Toby Dillon. I'm an attorney assisting in an adoption planned by one of your former patients, Samantha Burroughs. Last month I sent you a request to send her medical records to my office to forward to her new physician here in Fallbrook. Can you check to see if they were sent?"

Of course, I had done no such thing, but you had to go at these things gently. I couldn't just ask for a patient's address.

"Let me check. Hold on please Mr. Dillon."

When she came back she was more guarded. "I just spoke to doctor, Mr. Dillon, and I can't give you any information without a signed release from the patient."

So much for bluff number one.

"Oh, I'm aware of that," I said. "Actually, I already sent it to you, but I'd be happy to fax it again right now. Before I do though, can you tell me at least if she was your patient? For all I know I'm calling the wrong Dr. Johnston."

I asked this knowing doctors' offices aren't even supposed to reveal if someone is a patient without their permission. Doctors knew this, but secretaries and nurses rarely did. I crossed my fingers.

"Sure," she said. "I can do that."

Looking good.

"What was her name again?" she asked.

"Samantha Burroughs."

"Hold on and I'll check for you."

Yes!

After a moment, she came back on the line. "Mr. Dillon?"

"Yes."

"Her file is closed now so it's in the back, but yes, I can see she was one of our patients."

Try and outsmart Toby Dillon and see what happens. Likely

Sammy's adoption scam wasn't in place when she started her prenatal care, so her records should be accurate—with an address to find her.

"Great. Can you fax those records over to me, Carolyn?"

"I'd be happy to. . . but I really need that release. You know I can't send you her records without that."

"No problem. I've got it right in front of me."

I did have a release right in front of me. The only problem was it was blank. So do I commit the felony or not? I made up my mind. When in doubt, do the stupid thing.

"Just give me your fax number and I'll send it right over," I heard coming out of my mouth.

I found Sammy's signature on her health history form, and did my best forgery on the information release. Was it technically wrong to do that? Yes. Was it the right thing to do under the circumstances? *I* thought so. Besides, who was going to accuse me of anything? Or even notice for that matter. Certainly not fugitive Sammy.

I faxed over the freshly signed release, backdated to the date Sammy signed her health history form. We forgers are crafty that way. When I got back to the phone, Carolyn said she had the fax in front of her.

"Hold on," she said. "I've got to pull it out of the back."

She could have driven the file to Fallbrook in the time I was holding. Or at least it seemed that way. But when a voice finally came back of the line, it wasn't Carolyn, and it wasn't friendly.

"Hello, this is Dr. Johnston."

Oops. Unless you happen to play tennis with them, doctors can be a real pain to work with.

"Hi, doctor, my name is—"

"Yes I know. I was told you're an attorney handling an adoption for one of my patients."

"Yes."

"An adoption of *what*, exactly?"

An adoption of what? What kind of a question was that?

"What do you mean, 'an adoption of what?'" I asked.

"I mean, is this some type of probate matter?"

"Probate?" Now it was me that was confused.

"Didn't you say you were her lawyer? Surely you know she died three months ago."

That I didn't see coming. There had to be some mix up. I'd seen her in the flesh just days ago, so I knew she was still above ground. What else could I do but press ahead.

"Actually, the Samantha Lynn Burroughs I'm calling about placed a baby for adoption."

"Mr. Dillon, now I know you've got the wrong person."

"Why's that?"

"Because when she died, Samantha Burroughs was eighty-four years old."

She didn't put the phone down gently.

9

I MADE A copy of everything in the file for the police, with the exception of the forged information release. No need to advertise that one.

I ran back to Sammy's apartment. There were already two patrol cars in front. Inside, Brogan introduced me to Detective Hawkes. He was tall and black and wore his tie loosened. It looked like they don't waste any time with kidnappings, especially when the victim's adoptive parent is Brogan Barlow.

The police were definitely treating it as a kidnapping anyway, and I wasn't going to volunteer anything about the fine points of adoption law to set them straight. It was reasonable for them to think that a consent to adoption would include any child of that birth. Most people would. But I knew they were wrong. This is called "withholding material information," and it's a crime. I just wasn't sure if it was a felony or a misdemeanor. But they'd look harder for Sammy, Travis and the baby if they saw it as a kidnapping. The fact the baby was

potentially sick wouldn't change much, as being sick or dying didn't make it a police matter.

Hawkes was keeping the uniform cops outside the apartment to avoid contaminating the crime scene. Brogan and I were allowed in with Hawkes only because we'd already been in there. Even so, he made us stay in the kitchen, not leaving the vinyl floor. Hawkes was bright. It was obvious in the intense way he listened, and the conciseness of the questions he asked. His intelligent eyes had a sparkle which belied his fifty odd years.

I gave him the copies of Sammy's papers and filled him in on the blanks I'd drawn. If he was annoyed I took some initiative to try to find Sammy he didn't show it. He struck me as a results-oriented person. Maybe he would have forged the information release too if he knew he'd get away with it and find a missing baby faster.

"Didn't it strike you as odd this doctor had a patient with the same name?" He asked me. "I doubt it was coincidence."

I nodded, but things had moved so fast I hadn't really thought it through.

Hawkes went on. "So, she must have used the Samantha Burroughs name knowing she was a patient of that doctor. She probably knew someone would request medical information, and knew if she gave you some sham doctor's name you'd catch on right away. She had to give you just enough information to make her seem credible enough to work with, but give it in such a way that you wouldn't catch on until too late."

I nodded. "But now we've got nothing but dead ends."

"The doctor's not," Hawkes replied. "Even if your Sammy got the Samantha Burroughs name from the obituaries, it wouldn't list her doctor. So, how'd she know?"

This guy was definitely smarter than me.

"So Samantha wasn't even her real name?" This from an emo-

tionally drained Brogan. It was just hitting him, the depth of the con, or whatever it was. We didn't even know the true name of Remy's birth mother.

Like his own adoption thirty-two years ago.

A closed door.

"Have you got a picture of Sammy?" Hawkes asked. Even if that wasn't her real name, what else could we call her?

"I don't," I said.

"Neither do I," Brogan said. "We told her we wanted pictures to show Remy what her birth mother looked like, and to see all of us together. You know, like a team. Making a great life for Remy. But she always said she felt so ugly and fat while she was pregnant. She kept telling us we could do it later."

Hawkes had been thumbing through Sammy's background papers I'd brought over. He indicated the driver's license and Social Security numbers she'd filled in. "I'll check these out, but I wouldn't hold your breath. I'll let you know tomorrow."

Brogan spoke up. "I don't mean to be pushy, but can you let us know today?"

I didn't blame him. It would probably take the cops thirty seconds.

Whether celebrity had its privileges, or Hawkes just felt sorry for him, he said, "Let me see what I can do." He walked over to one of the uniform cops at the door and gave him the information, then walked back to us. "He'll radio it in right now. Should have something in a couple of minutes."

"Thanks," Brogan said. "I appreciate it."

"No problem." Hawkes turned to me. "I've got a question for you about how these adoptions work. Doesn't the judge or whoever witnesses the consent to the adoption check some kind of ID to be sure the birth mother is who she says she is?"

As soon as he asked the question I felt a twinge of optimism, because he was right. I explained it to him.

"Yeah, they do. Each birth mother has to meet with a social worker called an Adoption Services Provider. Her job is to provide counseling, and make sure the birth mother understands her rights. It's also her job to witness the consent. And you're right, she has to see an official ID. Actually, it has to be *photo* ID."

"So who was this Adoption Service Provider person?" Hawkes asked. "Any way I can talk to her right away?"

"I'll call her right now. Her name is Sherry Rosman." I worked with her enough that I'd memorized her number. She was in when I called and I explained what had happened. She promised to come right over.

A fingerprint team had arrived and started dusting surfaces all over the apartment. They printed Brogan and me as well to eliminate us from matching prints in the rest of the apartment. They said later they'd do the same with Rita, and any cleaning people who'd been in the room. Hopefully what was remaining was Sammy and Travis, or whoever the hell they actually were.

The cop who'd taken the information from my forms about Sammy came back upstairs. He addressed Hawkes. "Sorry, sir. The SSN belongs to a Montgomery Allen Morgan in Texas, age forty-one. The driver's license isn't even a valid number."

"Thanks. Get a phone number on Morgan anyway so I can follow up."

He turned to us. "It's possible this Dr. Johnston and Morgan guy know Sammy by her real name, or maybe not, but we're going to need a picture of her to know." He caught the eye of the patrolman by the door. "We're going to need a sketch artist over here. Now."

So far, he'd only focused on Sammy. Finally he started talking about Travis. "You got a last name for him?"

Brogan and I looked at each other helplessly. "He was just 'Travis,'" I said. "We never heard a last name." I felt there was a *stupid* meter on my forehead and it was pointing in the red zone. Brogan and I gave Hawkes what information we could. His description, and the fact he'd said he'd been an Army medic.

"What about cars for either one of them?"

"Oh, yeah!" Finally something I could offer. "Sammy didn't have one. Travis always drove her. But I can tell you what he drove." Cars I knew. "It was a Volkswagen Vanagon. You know, those van-sized campers they made in the eighties. It had California plates. I don't know the number though."

"Color?"

"Light blue, but it was a repaint. You could see the old dark blue paint where it was scratched up."

"Where'd he park? Maybe another tenant noticed the plate number. Not that it's likely, but we can ask."

"Handicapped space right in front," I said.

Hawkes made a face. "Bastard." The fact he parked in a handicapped space seemed to incense him almost as much as the kidnapping.

A cop came in to tell Hawkes that Sherry had arrived. He told us he'd talk to her outside and asked us to join him. I think he still felt a little fish-outa-water with the adoption aspect of it.

Sherry was waiting downstairs. As a career social worker, she had likely seen more human tragedies than most people outside of doctors, cops and ministers. Still, she always had a smile on her face and usually greeted me with "Isn't it a beautiful day?" regardless of the weather.

Not today.

She was heavyset and favored voluminous kaftans with brightly colored silk scarves trailing from her neck. She carried herself with

graceful dignity and always made me think of an old-time film star.

When I'd first started doing adoptions just a year ago, I'd had the good fortune to meet her at an adoption conference, and she became a bit of a mentor for me. I was grateful for the insight into adoption, and she was appreciative to have an attorney actually care about the emotional side of adoption in addition to the legal stuff.

"I'm Detective Winston Hawkes. Thanks for coming so quickly." He'd heard me explain everything to her on the phone so didn't waste time with any preliminaries.

"Ms. Rosman, our immediate problem is that there's now some doubt about the true identity of Samantha Burroughs. Mr. Dillon has explained to me you have to see an ID before you accept a consent. Was it a photo ID?"

"Certainly. It was a regular California driver's license. And I got a photocopy, like I always do."

Hawkes' ears perked up so high you could have confused him with Mr. Spock. "You have a copy?"

Sherry reached in her purse. "When Toby told me what happened I assumed you'd want it. Here it is." She handed it to Hawkes, and Brogan and I crowded next to him to check it out. My hopes dropped when I saw all the information on it was the same information we already knew to be false.

"There was one thing kind of odd," Sherry added. "I didn't think much about it at the time."

"What was that," Hawkes asked.

"When I asked to see her license, she gave it to me. But I always like a copy, so I told her I needed to run down to Kinko's to make a quick copy."

"And what was odd?"

"Well, she'd already *made* a copy. She gave it to me and said she assumed I'd need one, so made one in advance just in case."

"The picture," Brogan said. "She didn't want us to have her picture."

He was right. It was a dark copy, and Sammy's photo on the license was virtually a black rectangle. Photos often darkened when photocopied, so Sherry wouldn't have been suspicious. Besides, the only reason she wanted a copy was to keep a record of the information on it. She wasn't expected to be an official Dick Tracy crimestopper.

So Sammy was one step ahead of us again.

Sherry didn't know we already knew the driver's license number and all Sammy's information was phony. "Is there something wrong with the license?"

I filled her in. While I did so, Brogan asked Hawkes how Sammy could have obtained a false driver's license. I stopped talking to Sherry to hear his answer.

He started with a laugh actually. "Got fifty bucks?"

When we looked at him blankly, he went on. "There's probably a hundred guys in San Diego alone pushing false IDs. Pretty good ones too. It's become a nice sideline for the drug dealers. Kids want 'em to buy cigarettes and beer. Jeez, the copiers they got out nowadays are almost good enough to print *money*. Laminate the things and most people outside of cops and banks aren't gonna spot 'em."

Hawkes turned to Sherry. "Isn't there any process to verify the ID? Doesn't the state or the court or someone check out this stuff?"

Sherry and I looked at each other. It was required that adoptive parents go through a six month home study to be sure they were suitable parents. They're fingerprinted and thoroughly checked. But there was never an investigation of the birth mother. In fact, most of the information was based upon trust. Maybe Hawkes was right and there was a hole in the process, but we're talking about placing a baby for adoption, not joining the FBI.

"Toby," Sherry said, guilt in her voice. "I am so sorry."

"Sherry, don't even *think* about feeling this is your fault. You did everything you were supposed to. If anyone missed something it was me." Hopefully it wasn't my fault either. One thing I did know for sure. Something like this had never happened before. Anywhere. Ever.

Sherry maternally cupped her hands around Brogan's troubled face. "Brogan, I can imagine what you and Rita are going through." Actually, she knew *exactly* what they were going through. Besides counseling birth and adoptive parents, Sherry was an adoptive mother herself. Four grown children, not counting one that failed. The birth mother had reclaimed the baby after five months in Sherry's home. That was years ago when California law gave a birth mother longer to change her mind. Sherry had described the loss of the baby as being as painful as a death.

Sherry scribbled on a piece of paper and handed it to Brogan. "Here's my home number. I want you and Rita to call me tonight. We'll talk about some things. Okay?"

"Yeah. Thanks. We will, Sherry."

Brogan wasn't the type to turn to others for emotional help, even at a time like now. He'd defeated the Troys of the world all on his own. But I knew he'd call Sherry tonight. Maybe not for himself, but for Rita.

Hawkes thanked Sherry for coming, and as she left he called over one of the uniform cops.

"Mike, I'd like you to get a pad and a pen for Mr. Barlow. Let him sit in one of the cruisers." He turned to Brogan. "Mr. Barlow, I'd like you to make a list of everyone you know who was aware you were planning to adopt with Mr. Dillon's assistance. People who knew about it *before* Samantha Burroughs picked you."

"I live just over there," I said, pointing out my building. "He

might be more comfortable there."

Hawkes nodded. "Good idea."

"What are you thinking?" Brogan asked. "Why do you want those names?"

"Mr. Barlow," Hawkes sighed almost sadly. "I don't think this woman went to all this trouble to trick just anyone. Let's face it. You're rich. You're a celebrity. That can make you a target these days. I think this was planned well before she went to Mr. Dillon's office. She had to know she could pick you as adoptive parents before she walked in there."

There was only one thing worse than the scenario Hawkes just described: the only people who knew about Brogan and Rita's adoption plan with me were some of their closest friends. But even friends talk to friends, who talk to spouses, who talk to co-workers, who talk to hairdressers, who talk to their cousin in Cincinnati. Nothing evil in that. Just human nature, especially when you're passing along *nice* information—like adoption. Brogan and Rita were already feeling terribly vulnerable. I hated to think they were going to stop trusting their friends when they needed them most.

I couldn't have imagined Brogan looking worse than he did an hour ago, but as he walked slowly to my apartment, shoulders sagging, he did.

A tech approached holding a tagged baggie with a tiny oblong pill inside. "Found this on the bathroom floor, behind the toilet. Some kind of medicine."

Hawkes looked over the top of his glasses, old man style, scrutinizing the writing on the pill. "Terbutaline. Never heard of it." He turned to me. "Mean anything to you?"

Actually it did. "Yeah. It's a medicine used to slow contractions. Doctors usually prescribe it to stop premature labor."

Now my trip to the hospital that night with Sammy made more

sense. She must have gone into labor and panicked. Maybe Travis wasn't around—probably off preparing the hidey-hole they were in now—so she called me. But by the time we got to the hospital it had stopped her contractions, and she just waited for a chance to get away before a doctor could examine her. I filled Hawkes in on what happened.

Hawkes nodded. "So this Sammy got her hands on some in case she went into labor early, before she had everything set up." He gave the tech some instructions and sent him on his way, then turned back to me.

"Mr. Dillon—"

"I'd really appreciate it if you'd call me Toby. And I know he'd prefer Brogan."

"Sure." He was silent for awhile, then finally spoke. "Toby, I've seen a lot in my time. But I've never seen something like this. Most of the stuff I see—even murder—it's instant. It's one second of anger and bang. Someone's dead. But this. . . this is pure, methodical evil. You know what I'm saying?"

I was grateful he waited until Brogan left to speak his mind. I nodded. Sadly, I knew exactly what he meant.

He was a more a person and less a cop when he spoke next. "So we've got not just a missing baby, but a baby with the equivalent of a ticking time bomb in her brain. And we've got about a month before it goes off. Is that about it?"

"Yeah, that's one way to put it." A depressing way, but accurate.

Hawkes shook his head. "I'm afraid this may not end very well for your friends. You have any idea what's coming next?"

I had no idea.

10

BROGAN WAS TOO wiped out to drive home, but he had to be with Rita, so I drove him home in his car. Considering how tired I was it was probably not the smart thing to do, but I couldn't just put him in a cab, or a limo, or whatever.

We didn't finish up at my place until almost midnight. Brogan's list for Hawkes was larger than I'd expected. There were their close friends, like everyone at today's party. My God, it was hard to believe it was the same day. Actually, not everyone, as Rita had not met Rosa until well after the birth.

But what I didn't realize was how many people Brogan and Rita had to tell. Evidently there were literally hundreds of millions of dollars affected by Brogan and Rita's possible unavailability to various producers and studio personnel to take time off for a planned adoption. Even though the list was so long it appeared to be futile, Hawkes discussed each name with Brogan.

Just when Hawkes finished with us, the sketch artist arrived. Ac-

tually, she didn't *sketch* anything. Instead, she had a laptop computer with a special software program. She insisted one of us leave the room while the other tried to find the perfect eyes, chin and nose for Sammy and Travis. Like playing advanced *Mr. Potato Head*. It was painfully tedious and frustrating, and much harder than I would have guessed. I had no idea there were so many variables in a face. Thirty-four I was told, with each of those variables having as many as one hundred and forty elements. Three hours later, when Brogan and I had each finished, she showed us our respective finished products.

Brogan's and mine were somewhat different, but both fairly accurate. I agreed Brogan's renderings of both Sammy and Travis were better than mine, and we went with those. When I asked her how they'd use them, she told me to ask Hawkes.

Brogan slept on the drive home. When we got there, Rita was asleep on the sofa, as if she'd get news from Brogan faster by staying closer to the front door. But she was so beat she didn't even wake up when we came in. Rosa was sitting in the chair next to her, making me think of a babysitter guarding a baby, the baby being Rita. Remy was in her room.

Brogan had called Rita at least five times from my place and again in the car. He'd nothing encouraging to tell her, but knew she'd go crazy hearing nothing. Rosa rose on stiff legs as we came in.

"She sleep one hour," she smiled. "I go. I am saying prayer for you."

"Thank you, Rosa," Brogan said with true sincerity, walking her to the door. "Thank you so much for being with Rita."

He pulled some bills from his wallet, and Rosa uncomfortably put them in her purse without looking at them. I'd seen the same thing when I saw migrant field workers paid. They never counted the money, as if it would insult the *padrone*. They would count it as soon as the padrone wasn't watching. If he shorted them, they'd never

complain. They'd just never agree to work that grove again.

Brogan woke up Rita and they embraced wordlessly. I looked in on Remy to give them some time alone. As I came back in Rita looked around.

"Where's Rosa?"

"She just left," Brogan told her.

She glanced at the clock. It was almost two in the morning. "Brogan! You can't let her go home this late. Stop her, honey!"

This was classic Rita. For all her troubles, she was worried about a new friend, an older woman driving home alone late at night. I volunteered to go after her and ran outside.

Rosa's car was a Nissan so old it was a Datsun. Probably rolled off the assembly line about the same time as my Falcon. From the sound of her engine though, I didn't think it was going to be around much longer. After some persuading, Rosa came back inside. We were all too tired to talk. Rosa became the first person to occupy the new guest house, and I took the sofa, still warm from Rita.

I was the first to wake up. I left a note and called a cab for the long ride home. I didn't want Brogan and Rita worrying about getting me home. Besides, they and Remy needed some time alone, and at least some semblance of a normal life.

When I got back to my place, there was already a message on my machine from Hawkes. Evidently he slept as little as we did. The message just said to call him. I did.

"Hi, Toby. Listen, we got something. When you mentioned Travis always parked in the handicapped space over there, I had a thought. Probably if he did it there, he did it all the time. So I checked with traffic for all the handicapped parking violations in Fallbrook since June eleventh. . . and we got him."

"That's great! What—"

"On June fifteenth, a blue 1990 Volkswagen Vanagon was tick-

eted in front of 2154 North Main here in Fallbrook. I ran the plate. Registered to a Travis Benton, age twenty-eight. DMV's got him as 6'1", 185 pounds, blond hair, green eyes. Got the DMV photo right in front of me. Except for shorter hair, it's a dead match to your sketch photo."

What could I say? Hawkes was brilliant. "Detective, that's great news. I can't believe you thought of doing that!"

"Yeah. That's why I make the big bucks."

"Do you know anything else about him?"

"Checked him out. No arrests, but a dishonorable discharge from the Army back in November for going AWOL. No record except for that, meaning he's been clean, or too smart to get caught."

"So what's next? Do you think you can find him?"

He exhaled slowly. "We've got an APB out on the car, and we've circulated his license photo and Sammy's sketch to law enforcement all over the state. The DMV address for Travis is in NoCal, so I've asked for a stop-by with the local PD up there. We've notified every pediatrician and hospital to be on the lookout for a one month old baby girl brought in as a new patient. I've got people checking with the Palm Springs doctor and relatives of the real Samantha Burroughs. Now we've got a sketch to show them. The rest I'm putting on the back burner for now."

The rest? How much could this guy think of? He was a black Barnaby Jones. I'm glad I wasn't a bad guy.

"How about the fingerprints?" I asked. Now we had a line on Travis, but still no idea of who Sammy really was.

"Nothing yet. And I wouldn't hold your breath. She's probably what, nineteen, twenty? Unless she's been arrested, she wouldn't be in the system. I'll let you know when I hear something."

I thanked him and hung up. Then I slept for fifteen hours. I didn't want to, or plan to. I knew I should be worrying or something, but I

laid on my sofa to rest my eyes and when I woke up it was going on one in the morning. At 1:00 a.m. there's nothing to do but sleep, and of course, I couldn't fall back asleep. Thanks to *Nickelodeon,* I filled an hour with double episodes of *Hogan's Heroes,* but for once even Colonel Klink and Sergeant Shultz couldn't bring a smile.

I finally fell into a fitful sleep around three, and woke up at dawn. Maybe I was finally back on my usual body clock. I knew one thing. Lars would be pissed if I missed cleaning the courts two days in a row. Usually I strap on my blower and get all the dirt and leaves off the courts. But there'd been a light rain during the night, so I had to use the sponge roller. Even though it was four feet wide it was a long, tiring job for six courts.

Working out there alone, in the early dawn quiet, I considered how odd it felt to have the events of the last twenty-four hours kept secret from the world. Hawkes had told us we could give the story to the press. Circulate the pictures of Travis and Sammy and tell of the danger to the baby. The media would jump on the story, of course. They'd be on every TV screen and newspaper in the nation.

The flip side was it could drive Sammy and Travis further underground, and ruin any chance for the baby to get the medical care so desperately needed. Or worse, maybe make them panic and dispose of the baby in a way I didn't want to think about. Hawkes recommended silence for now, especially with the lead on Travis's identity and car. The question was how long could we keep the story from the press?

11

THE NEXT FEW days came and went slowly. Hawkes called me each day, but never with anything to report. The early excitement of an imminent arrest was gone. The prints turned up nothing. The real Samantha Burroughs' friends and family didn't recognize the sketch of Sammy, nor did the Palm Springs doctor. Sammy could have heard her name in too many ways to count. Travis's parents still lived at the address listed on his driver's license, but they hadn't spoken to him since he left home to join the Army. The leads his parents gave the police on Travis's old friends led nowhere.

On the third day, Travis's van was spotted parked in the North County Fair Mall parking lot, thirty miles south of Fallbrook in Escondido. They'd staked the van out, but the person who put a key in the lock and was promptly handcuffed turned out to be someone who'd bought it from Travis barely twenty-four hours earlier.

There were no clues in the van. Worse, the van was the only link we had to find them, and now it could lead us nowhere.

Hawkes had also done some studying up on adoption law the last few days. He dropped by to see me in fact. He wasn't exactly mad. But I could tell he was annoyed.

"I talked to someone at LADCS yesterday, Toby."

He was referring to Los Angeles County Department of Children's Services. It was the county office which conducted the adoptive parent home study, and supervised the placement until the court approved it. Although the birth had been in San Diego, the office which is assigned to oversee the adoption is determined by the county in which the adoptive parents live.

He gave me a hard look. "They explained a few things I didn't quite understand before."

He let the sentence hang for a minute. We both knew what he meant. I hadn't exactly lied about anything. I just didn't clarify some of his natural perceptions.

When I didn't say anything, he went on. "Tell me if I've got this straight, okay? We start off with the Adoption Service Provider person, Sherry, filling in the name of the baby, birth date, all that stuff. It also has the adoptive parents' names on it too. Then the birth mother signs it. Am I right so far?"

"Yes."

"Thirty days go by after a birth mother signs the consent to adoption, and then she can't change her mind. The baby basically belongs to the adoptive parents, they just have to wait six months for Children's Services and the court to approve it."

"Right," I said. He was about to get to it.

"But the consent form your Sammy signed named *one baby*. Remy. That's the consent she signed. Right?"

"Yes."

Now he looked at me a bit harder. "So she never gave up *any* rights to this *other* baby."

What could I say? "Right."

"So, it's legally her baby." It was a statement, not a question.

"Yeah."

"I guess you didn't quite understand that when, what with you being an *attorney* and all, you saw I was approaching this as a kidnapping?"

"I. . . I thought. . . I thought that—"

"Yeah, I know what you thought." He let up a bit. "If we looked at it as a kidnapping, it's getting a lot more attention from my office than if we just consider it a missing persons case. Even if one of the missing people is a baby."

"But we're looking at fraud," I stammered, reaching for an offense to keep Hawkes involved. "We're looking at falsifying documents—"

"You know what I'm talking about, Toby."

I did and he knew it.

"I'm not going to turn my back on this case. But the fact is it may look and feel like a kidnapping, but we both know it's not. As far as we know, the baby's with her legal mother. There's not even fraud from what I can see. Lying's not fraud without a financial taking based on it. The most we've got on her is falsifying documents. Wow. She might get the chair."

"But if we don't find the baby—"

"I know, Toby, and I'm sorry. You know I am. But there's only so much we can do without evidence of a crime."

"So where do we go from here? Hope she contacts us?"

"Don't worry. I'm not going to cancel what's already in place, but I've got to downgrade it to a missing person. Can't have them get shot by some patrolman believing we're dealing with fleeing felons."

"Thanks."

"Don't thank me. I still think something bad is going down here,

and I'm worried about that kid. I just don't know what it is yet."

Hawkes had let me off easy. We both knew I'd had a legal duty to tell him everything I knew, but my desire to help Brogan and Rita had kept my mouth shut. Besides, my omission of information to the police was a nice bookend crime to my recent forgery.

Even though Hawkes had come by to give me a little chewing out, it was still better than nothing. The worse thing was that life was starting to feel sort of normal again. I felt guilty about it, but there it was.

I would think of Brogan, Rita and Remy hundreds of times a day, but with each passing day there were more seconds in between where my mind focused elsewhere. Even Brogan and Rita felt it, telling me they didn't know how to feel. One minute the joy of a new daughter in their arms. Then covering it like a shroud was the pain and worry of her missing twin. It was cheating Remy, and killing Brogan and Rita.

I was glad the next day when Lars asked me to handle his Wednesday clinic. I hadn't been playing any tennis. It had felt wrong to play a game with so much sadness around me. Not that I was actually accomplishing anything other than chomping my fingernails to the point of bleeding. I even neglected what few cases I had.

It felt good to have a racquet back in my hand. Only six days had gone by since I'd played, but that's a lot considering I normally play at least two or three hours every day. Some of the usual morning gang was there, housewives, self-employed guys who worked as little as I did. I didn't exactly duplicate Lars' drills, so it gave the regulars a change they seemed to like.

Today's group was a good one, from solid to exceptional, no beginners where we had to keep politely saying "good try," when all we wanted was a solid return.

When I've missed a few days, it always takes me about fifty

strokes on both the forehand and backhand side to get my ground strokes to feel right. I remind myself of the basics. Take little steps to the ball. Get your racquet back early. Hit with enough topspin to get two feet of air over the net. Aim for a particular spot on the court. Exhale on the stroke. Hold your follow through. Soon my muscle memory was back and I could slug the ball without thinking.

It felt great. By the time I was done I felt I'd sweated out not just water, but also some of the frustration and stress my body didn't know what to do with from the last week. But the minute I stepped off the court, the shroud fell again, and I vowed to myself I'd find a way to make things right again.

12

THE FIRST BIG break came where I would have least expected it.

My parents' house.

I received the summons a week ago. Dinner with my parents and my brothers. It had arrived the day after we discovered Remy had a twin, so I'd spent the last week meaning to call and cancel. I already had too much on my mind. I didn't need to add my dad to my miseries. But as the day approached, I decided to go. I wasn't helping Brogan and Rita staring at the phone.

Don't get me wrong. I loved my family. Even my dad. But he believes in living a certain way. His way. If you don't conform to his view, you're rejecting him as a person. In his view I'd spent a lifetime rejecting him.

One of my brothers had called me and spilled the secret. Dad was going to "forgive" my past indiscretions. I was to be offered a job at the family firm. No, not the old janitor job. A lawyering one.

I could have phoned in my rejection of the offer, but I didn't want

to reject my family at the same time. And to be honest, I had my own side agenda. I didn't know where to turn with Brogan and Rita's case. A full week had now gone by. There were no leads from the police. No contact or demands from Sammy or Travis. Dad, for all his faults, was a brilliant lawyer and strategist. He could see every angle in play. I'd willingly humble myself to get an idea of where to turn to help Brogan and Rita.

After a quick hi to my mom and my two brothers' wives—as usual each competing for Best Stepford Wife—I made my way to the billiard room. I could smell the cigar smoke through the door. Since my dad smoked, so did my brothers. No offending dad, even if it may mean a few years off your life.

A game was in progress. As kids, we didn't play basketball, football, baseball or soccer with our dad. It was pool. I don't know if this was because he rarely had free time until about eight at night, and it was too dark to play outside, or because he subconsciously knew lawyers and pool players were both considered sharks. Maybe he was preparing our psyche for lawyerdom at an early age.

"Toby," dad intoned from the other side of the table when I entered. He stood cue in hand, watching my oldest brother, Curtis, sink the last ball on the table. Dad waited for me to walk around the table to greet him. No meeting halfway in shared "it's been five years, son" enthusiasm going on here. A firm handshake awaited me. Greetings in our family were always five pump handshakes. Never hugs.

"Hi dad." I shook hands with my brothers too.

My dad was wearing a charcoal pinstriped suit, even though it was Saturday. That was how he dressed for dinner. My brothers were equally dapper. No one even had their ties loosened. It was if the call to court could come at any moment, and they were fireman ready for action. At least my Dockers were clean.

I grabbed a cue as my other brother, Brent, moved to rack the

balls. Before we could lag for the break, a cell phone chirped, causing the three of them to scan their beltware. Each wore two cell phones, a pager and a Blackberry. This was their definition of being well hung. They looked like nerdy superheros, with electronic devices hanging from their Batbelts. If there was any truth to the rumors cell phones caused brain tumors, my family would be among the first to go. The last surviving member would file the class action suit.

They each had a business and personal cell phone, although they were actually both for business. Dad had all the attorneys in his firm give their clients their "business" cell phone number, and also their "personal" cell phone, acting like the latter was a well guarded secret and only that particular client was special enough to be granted the personal number. After five p.m. and on weekends they'd ignore their business cells, forcing the client to call on the personal ones, knowing it meant double fees. Dad was a true innovator in such things.

I could recall cleaning the conference room during one of his lectures to that year's three new recruits. I'd been introduced as I always was to new attorneys, "my son Toby, our janitor." Evidently this was designed to say, "if I did this to my own son, imagine what I'll do to you if you screw with me." Evidently it worked. No one ever disagreed with my father, at the office or at home. The first to do so at both was yours truly.

"Who here wants to make partner?" he'd asked the three shiny new law school graduates. I won't describe them, because they looked identical. Lawyer clones. One from U.S.C., and the other two from Yale. Of course, they all raised a hand to dad's question. Each started as an associate, a salaried attorney, $92,000 plus perks adding another twenty grand the first year, but the really big money was for the partners of *Dillon, Dillon and Gillings*.

"I *want* you to make partner," my dad told his three newest legal eagles. "The more money you make, the more money the firm makes. The more money the firm makes, the more money you make. Make sense?"

They nodded in symmetry, like bobblehead dolls on a dashboard.

"So I'm going to *tell* you how to make partner. It's simple. Here it is: bill a minimum of one hundred hours a week. Every week. Every week for seven years and you will be made partner."

A timid hand went up from U.S.C. "Sir, if we work five days a week, that's twenty hours a day, assuming we can actually bill for every hour we work." He then hurried to add, "Of course, I know we'll be working *seven* days, but still that's—"

"No one said you have to *work* a hundred hours a week," dad interrupted. "You don't do me any good dead. I said you are expected to *bill* a hundred hours a week. In fact, if you can work two hours a day and bill your twenty, more power to you."

Dad scanned his audience before he went on.

"Practicing law is a science. Trials, motions, it's all one big dog and pony show. Anyone with half a brain could do it. But billing. . . billing is an *art*. Most lawyers don't have a clue how to do it right."

I wanted to interrupt that maybe most lawyers knew, they just elected not to. Something to do with purgatory and all that. But I was just the guy with the Mop and Glo. What did I know?

"You all understand the billing hour," dad went on. The new attorneys nodded. Ten minute segments had been the standard method of attorney billing for decades. At dad's firm's billing rate of three hundred hourly, that was fifty per segment.

"Now, here's the first key." Dad paused to emphasize his next words, "It's standard that you bill for *any portion* of one segment. If you talk to a client for ten minutes, you bill one segment. If you talk to a client for *one* minute, *you bill one segment*! So how long are you

going to spend on the phone?"

"One minute," rushed out one of the Yalees in the three way quest to get the brownest nose.

"And we can bill for almost seven hours for less than an hour's work," added Yalee number two with a grin.

"Right," dad said. "Now let's do some math. If you average forty calls in a day, and believe me, forty is easy—to clients, witnesses, experts, court personnel, opposing counsel—that's fifty bucks times forty calls. That's two grand per attorney per day. If that attorney works the average of two hundred forty-two days in one year, we're now at $484,000 income annually per attorney. Now multiply that times the forty-six attorneys in our firm, and we've generated just over twenty-two million annually. Just for phone calls."

The three of them and my dad sat grinning at each other for a moment, enjoying the shared legal lechery which bound them. If they bonded any more, they'd be having gay sex on the floor.

I was finding the session obscenely fascinating and searched for any excuse to stay in the room. It had never been so well cleaned. It was there, on my knees cleaning the floor boards, that I decided to become an attorney. Maybe "anti-attorney" would be more accurate. My grandpa had started his small Fallbrook law practice, based on helping people in need. My dad learned law at grandpa's side, but somehow missed the ethics.

But my dad was just getting started. He was now at his holy grail; drafting briefs and pleadings. He explained how such detailed legal work could take ten, twenty, even a hundred hours.

"So twenty hours on a brief, and we just bill the twenty hours?" Young U.S.C. seemed outraged. Twenty hours at the slave wages of $300 hourly. A measly $6,000 for a few days work.

"That's right. Twenty hours." Dad smiled. "The first time."

"What do you mean, 'the first time?'" U.S.C asked.

"We bill for the time spent to draft the brief or the pleading the first time we do it. But the same action will eventually come up again. And again. And again."

The three men smiled as one, and my dad went on.

"So thirty minutes or so to change the names and you're done. Some briefs we've used more than a hundred times."

The lawyers were falling over with glee. Turns out one minute phone calls were small time foreplay. Now, here was a way to bill twenty hours for one hour's work. Their erections almost lifted the table off the ground. I was afraid a circle jerk was imminent.

Suddenly one of the Yalees had a sobering thought. "Do clients ever complain about their bills?"

"Never," dad said firmly. "Every client of our firm is a corporate entity, usually grossing at least five million a year. *They* don't pay the bill. They just pass it along to their customers or shareholders."

"So society at large is footing the bill," said U.S.C.

That was just what I was thinking. But if I said it, it would be an accusation, delivered with all the fervor of Jesus, or the very least, Oprah or Ralph Nader. When he said it, I heard only admiration.

My dad didn't mention the biggest reason their clients never complained: his firm always won. This was partly because my dad was a gifted lawyer, but his political donations didn't hurt. Not to politicians, or to elect judges or D.A.s. Those would have to be disclosed, and my dad was too smart for that. Instead he'd contribute to causes supported by key judges. NRA, Save the Whales, my dad didn't care. As long as he was seated on the dais to acknowledge his contribution, subconsciously noticed by the attending judge.

My dad and brothers all looked to their electronic belt ware to see who was beeping. It was Brent, his business cell. He ignored it, wait-

ing for the client to call back at double rates on the personal number.

"So, Toby," my dad said. "You've become quite the celebrity. Your phones must be ringing off the hook."

"That's just Brogan and Rita letting me tag along, dad. It's been fun, but it doesn't have anything to do with my practice."

He stopped lining up the break to stare at me. "You can't be serious? You couldn't buy that advertising for a million bucks!"

He turned his attention to the table.

"Eleven to the corner pocket." Sunk it. "I had a talk with Cam Elliot last week, Toby."

Cameron Elliot was widely known in California as an attorney specializing in surrogacy, assisted reproduction and adoption. For those of us who knew the business, he was walking sleaze. Give him $50,000 and he'd find you a baby to adopt, a surrogate to carry your egg, or a fertilized egg to implant in your womb. A veritable *infant-preneur*. He had offices in Beverly Hills and San Francisco.

"Anyway," dad went on, "we had some preliminary talks about buying out his firm. He's asking for 2.4 million, and joining us as a junior partner. So I'm doing the math, and I'm thinking 2.4. mil, just to get instant entry in a new field.

He sighted his shot and sunk it. "So anyway, I'm thinking to myself. I know someone in the adoption field. . ."

This was as close to humor as my dad ever came.

". . . Who happens to have even more name recognition at the moment than Cam Elliot, and doesn't have a two million buyout. So I'm thinking why not start our own assisted reproduction division from scratch. . . with you in charge of it, Toby."

He moved uncomfortably close to me to be sure my eyes were focused only on him. Another of his tricks. "I'd buy you out at twice your annual receivables, and we'd bring you in at a third year associate salary. That's $160,000 plus the buy out."

Considering I was only making about twenty-four thousand a year at present, not counting the free tennis balls, it was a nice offer. If he could have waved a few million dollars in front of me, he would have. That's basically what he was saying. It was a good business plan on his part. He could make me into another Cameron Elliot if I let him, expanding into other baby-making fields with my new name recognition. But that wasn't why I was going to say "no."

"That's very flattering, dad." I thought the easy way out of the moment was to be a gracious son, let him know I was considering it, then cowardly call in my rejection at a later date.

But then he changed all that with, "but there are a few conditions."

"Conditions, dad?"

"All our associates get a company car: a five series BMW. I think you'll agree that's an improvement over your old Ford. So how about we make an overdue call to the scrap yard and have that conversation piece towed away?"

I said nothing, which my dad took as acquiescence. He pushed ahead.

"And you can keep living at the country club if you want, but you need to quit that tennis job. Can't do that and work for me."

He was right. I couldn't do both. Just one more reason to turn him down.

Then I said the one thing I shouldn't have. I didn't say it to bother him, although to be honest I knew it would.

"It's a nice offer, dad. Let me talk about it with grandpa. Then I'll let you know."

The self control which ruled my father's life abandoned him as his face reddened.

"You know you're forbidden to speak to your grandfather."

"Dad, I always talk to grandpa. And I'm not going to stop."

Even though it was his own father, he'd been dead to my dad for a long time. In fact, no one in the family spoke to him but me.

He tried to hold his temper. "Toby, if people find out you're talking to him, you know what could happen. You'd be a laughingstock, out there with him on that ridiculous boat."

The sad thing was maybe he was right. But he had his values and I had mine. And sometimes the laws and conventions of society were just plain wrong. I knew it wasn't just grandpa we were talking about. It was the car. The tennis job. The pro shop office. The desire to play tennis more than make money. The bargain basement legal fees. Worse, doing legal work for free when it felt right

Brent's cell rang again, the ubiquitous second call, this time on the personal cell. Dad must have known Brent was going to ignore it, giving priority to the family drama playing out before him.

"Answer it Brent," dad said. "It's business."

Brent did so, but must have been cut off. He said, "Bad connection." He wanted to forget it. Family history was being made.

"Star 69 'em," dad instructed him, as if to tell me business was business, and it was a priority over me, at least when I was displeasing him. It was a $600 an hour phone call after all.

That was when it hit me, like a thunderbolt. I should have thought of it days ago. I needed to get out of there. Now.

I backed up toward the door. "I've got to go. I'm sorry."

I could feel my father's eyes follow me out of the room.

" *I'm* not." I could hear him say after me.

But for once, I really didn't care.

13

I HAD MY cell phone dialed by the time I got to my car and pushed "send" as I pulled out the driveway.

"Good evening. Coral Canyon. Can I help you?" I recognized Sheila, the Coral Canyon lodging receptionist.

"Sheila, it's Toby. Can you check something for me real fast?"

"Sure."

"We set up a rental for Sammy in unit one-fourteen. Remember?"

"How could I forget. Our celebrity baby."

"Right. Has it been occupied since then?"

"I don't think so, but let me check." She only took a few seconds. "No. It's still vacant. What's up?"

"Nothing. I mean something, but. . . can you have someone meet me there in an hour to open the door for me?"

"There's no one here but me, Toby. Why don't you just come to the front desk when you get here and I'll give you the key?"

"Thanks, Sheila. Make sure no one goes in there. Okay?"

"Okay, already! Do I get to know what's going on?"

"Nothing. It's just that I'm an idiot."

"I could have told you that," she said sweetly. "See ya."

Fifty-seven minutes later, I pulled under the giant portico in front of Coral Canyon's reception lobby. With a stone fireplace big enough to stand in, and cushy, giant armchairs set in conversation groups around it, the lobby was impressive and ready for a Hunters and Gatherers convention. But at the moment I only had eyes for Sheila behind the desk. She gave me the key after a few more wise ass comments. Usually I enjoyed the repartee and would one day get the courage to ask her out. I figured she wouldn't be that consistently rude to me unless she liked me, but at the moment all I had on my mind was getting in Sammy's apartment.

"Don't Toby," she said, just as I was turning away.

"Don't what? Leave?"

"You know what I mean. Don't."

"Don't what?"

"Ask me out."

How did she know what I was thinking? Is it possible to be rejected just by thinking of asking someone out?

"I wasn't going to ask you out."

"Yes, you were."

"No, I wasn't."

"Maybe not this second, but you've been thinking about it. A girl can tell."

I really didn't want to have this conversation now, but it's hard to walk away from such unsolicited rejection.

"Okay, assuming I was going to ask you out, why would you tell me *no* before I even asked you?"

"You mean the pre-emptive rejection?"

"Yeah."

"To not hurt your feelings. You're a really nice guy."

"So how would telling me *no* before I even asked you out hurt my feelings less than waiting until I actually asked you? If I ever did, I mean."

"I just didn't want you to go to a lot of trouble or anything. You know, have you write out something."

That big mouth Gillie Haskill. Fifteen years later and she's still telling that story around Fallbrook. To conquer my nerves and assure myself of witty and casual repartee, I'd scripted out what I thought was a brilliant *ask out* for the senior prom. I was halfway through the call when she crushed me with, "Are you *reading* this?"

But I just gave Sheila a smile.

"Well, thanks for the advance rejection."

"You're welcome, Toby."

Does it matter to you at all that I wasn't going to ask you out?"

"You were."

"Whatever."

"I only did it because I like you so much, Toby."

"Can I go now?"

"I think you'd better."

I let myself into the unit Sammy had occupied until a week ago. I wasn't there to search for clues and play Hardy Boys or Nancy Drew, so I didn't look under drawers or in hollow curtain rods. I went straight to the phone. If no one had stayed there since Sammy left, the phone wouldn't have been used.

I still couldn't see what had spooked Sammy. I was sure she hadn't suspected anything when I'd called. No one knew Brogan and I were on our way except the people at their little party, and none of them had any connection to Sammy. But if someone had warned her, it was probably by phone. Dialing *69 on most phones will dial the phone that made the last incoming call. Each unit had a direct phone

line, so I crossed my fingers and hoped one of the phone company's extra features would work for a change.

I dialed *69 and listed as the phone rang.

I instantly had two thoughts. One was that it was probably the lab that called. After all, it was Sammy's bodily fluids and birth we were talking about. The poor lab doctor probably didn't know what was up the way we reacted to the mention of twins. Likely he'd called her on his own to clear things up. I'd know in a second if I got the lab.

My second though was that if someone else answered, I didn't have a plan about what to say. How could I find out their name without arousing suspicion? I was about to hang up and form a new plan when it occurred to me that the *69 feature may not work a second time.

It turned out none of these things mattered. On the fourth ring the phone was answered. I could immediately tell from the tone and background noise it was a cell phone. A man's smooth voice answered. His one word greeting was enough.

I numbly hung up, saying nothing in reply. I didn't need to. I knew who it was. I knew who called Sammy. I hadn't immediately recognized his voice, but I did his greeting. He answered with a color.

"Yellow!"

14

STEPHEN WEISS. SO *he* called Sammy right after he left the party. Clearly to warn her, but why? How could he be connected to her? He should be the last person to want to hurt Brogan and Rita. He was their doctor. Their friend. And how many people are willing to invest two million dollars in your movie?

I couldn't tell this to Brogan and Rita on the phone, and it was too late to drive up there tonight. So I waited until morning, then called them to say I had some information and was on my way. The Indian and I flew on the I-5 along the coast. It was probably the first time I'd neglected to notice the ocean on my left as I passed through Oceanside and South Orange County.

Rosa hadn't left since the day of the party. They'd asked her to stay. Despite their wealth, they never had any type of live-in or servant, unless you count the assistants provided to them by the studios when on a film project. At home, Brogan mowed the lawn, before the addition of the sheep anyway, and together they did what house

cleaning needed to be done. But neither was much of a cook, and eating out was something they usually enjoyed, at least pre-Remy. So Rosa seemed to be filling the chef void now that they were homebodies.

This was my first visit back since the party, although I spoke on the phone with Brogan or Rita at least once a day. There was an odd feeling to Brogan and Rita's house when I got there. I'm sure they felt it too, and hated it. They had the joy of a new baby. They had the terror of her missing twin. Where do those emotions meet? I didn't know, but I could tell it was wearing on them. Especially Brogan, who somehow seemed to be aging a year each day.

I had hoped to catch him alone and tell him about Stephen before I saw Rita. She needed to know, but I didn't want to be the one to tell her. It was terrible news a friend had betrayed you. But maybe it was good news. This was the first lead we'd had. Thank God Stephen evidently wasn't as smart as Sammy to hide his tracks.

As I entered their house, I could see Rosa in the kitchen, puttering. Her natural happiness was muted, but she moved with purpose and determination, a good example for Brogan and Rita.

"Rita's asleep in Remy's room," Brogan told me. "Let me get her."

"No. I mean, let me tell you what's going on first. Okay?"

"Yeah, sure. Why don't we go outside?"

We walked down to the far end of the pool where our voices wouldn't carry to the house.

"Brogan. It's Stephen." I explained my *69 and Stephen answering.

For a minute I thought the information didn't register. He just sat there, staring at me. Actually right *through* me. I'm not sure where he disappeared to, but in a moment he came back.

"God, Toby. . . what the hell is going on here? What are we going

to do?"

"Let's let Hawkes handle it. He'll bring in the LAPD and they'll question him."

Brogan thought for a minute.

"No. Forget that," he finally said, and I could see the fight coming back in him, the spirit that had conquered so much adversity in his life. "He's a rich, respected doctor. They're going to go slow. And then he'll just stonewall them. I mean, what do they have? You hearing a *color*?"

"But I know it was him!"

"I believe you. But you're the one who told me Sammy has the right to keep the baby, right?"

I had to agree that was true.

"So why will the police care even if we *could* prove he called Sammy? What was illegal about that?

Brogan was right. Hawkes would call Stephen, but there'd by no way to compel him to answer questions.

Brogan's eyes had turned into slits. "I'll tell you what I'm gonna do. I'm gonna drive over to his house, put my hands around his neck, and find out where that baby is." He meant every word.

"Brogan—"

"No. I mean it. I've thought about it before. . . When you see these stories about some guy who's suspected of taking some little kid. Everyone knows it's him, but they can't prove it. You know? I always thought if I was that kid's parent, I'd break into that SOB's house at night and torture him until he told me where my kid was."

I thought of that old line: *A good friend helps you move. A really good friend helps you move a body.*

"But Brogan—"

"And you know what, Toby? Now I *am* that parent."

I knew exactly what he meant. Still, I had to stop him.

"Brogan, think what could go wrong! He could have a gun! *You* could end up dead. Or what if he presses charges? The court would deny your adoption and take Remy away from you!"

Finally I'd said something that got his attention.

We sat for awhile.

"Okay. Idea number two," Brogan finally said.

"Does it involve a crime less than attempted murder, or whatever they call choking someone 'til they tell you what you want to know?"

He actually smiled. "Slightly less."

"Okay. I'm listening."

"I talked to Stephen just a few days ago. He told me he was leaving tonight to go up to Santa Barbara. I'm gonna break into his house and see what I can find. Maybe there's some information about Sammy."

We were headed in the right direction. Breaking into a house was still technically a felony, but at least we'd lost the strangling.

"That's still risky. He might have a dog. . . an alarm maybe?"

"Toby, I've been over there a bunch of times. I've known him for years. He doesn't have a dog. And I know the alarm code. I saw him type it in."

I didn't want to agree, not that I could stop him anyway. Plus, I was afraid if I talked him out of it, he'd go back to option one.

"Do we tell Rita?" I asked.

"Are you kidding? She can't know anything about this." He looked at me. "And what's with this *we*?"

"I'm not letting you do something this stupid alone. I'm coming with you."

Probably two stupid guys double your chances of being caught, so it wasn't a great idea. Plus, there was that little side issue of an attorney being caught in the commission of a felony, and I could say goodbye to my license to practice law. It occurred to me I was well

on my way to becoming a career criminal, with falsifying a docu-
ment, withholding information from the police, and now breaking and
entering.

I was waiting to be talked out of the offer by Brogan, but evi-
dently he was secretly glad for the company, because he moved right
into making a plan.

"Stephen told me he'd leave when the traffic died down. That'd
be a little after seven. How about we go around eight-thirty?"

"Because it'll be dark?"

"No. It's my turn for Remy's eight o'clock feeding."

Yeah, we were a couple of tough guys alright.

15

RITA GREETED US when we walked back to the house.

"Hi, Toby. What's up?"

"Oh, nothing."

"I thought you said on the phone you had some news."

Oh.

I'd forgotten that.

"Well?" She looked at me expectantly.

Well, Brogan and I are going to commit a breaking and entering of Stephen Weiss's house tonight, and if that doesn't work, Brogan will strangle him to death. I could have said that. Didn't. Still, it was the only thing in my head at the moment.

"He just wanted an excuse to see us," Brogan put in. "Playing the godfather role."

I thought it sounded pretty lame, but it put a smile on Rita's face.

"Great! Can you stay for dinner?"

That must have been Rosa's cue to enter from the kitchen.

"*Hola*, bes' frien' Toby."

"Hello, Rosa. It's nice to see you again."

"So you want to work on your godfather duties, huh?" Rita asked.

"Sure. Ready for training."

"Great. Let's start with diapering. Okay?"

I thought she was kidding. She wasn't. Maybe Brogan's comment hadn't taken her in after all and this was my penance.

We spent a nice evening together. Rita asked Rosa to join us by the fire and she seemed to be more at ease with Brogan and Rita socially. I got a kick how she'd sneak little glances at Brogan. She may be middle-aged, but he was still the equivalent of the Robert Redford of her generation. Or maybe for her I should say the Anthony Quinn.

Naturally, we couldn't stay away from talk of Sammy and Travis, and whether or not to reconsider the decision to keep it from the press. But each time we went around on it, the decision was the same—better to not risk the baby's safety by pushing them further underground. Oddly, the more time went by, the more convinced we were a demand of some sort would eventually come. That was the only comfort. But the question was, the baby for *what*? Ransom was the obvious answer, but was at odds with Sammy's careful attempts to commit only minor legal infractions in her actions to date.

When the sun finally went down and Brogan's bottle duty was done, we set out. We let Rita think it was just for some guys' night out time, and she pushed us out the door with smile. As we turned away I caught her reflection in the hallway mirror, catching her face in a completely unguarded moment. The look of despair which replaced her smile the second we turned away almost made me pull up and turn around, but I willed myself to keep walking. God knew she'd gone through enough lately. She was entitled to her private pain. But why was the look directed so intently at Brogan? His back anyway.

Brogan had changed into Levis and a dark blue shirt. I was already in Levis as well, and Brogan handed me a dark brown t-shirt in the car. Not exactly head-to-toe black ninja wear, which would be suspicious if we ran into somebody, but innocent looking yet effective for our planned nighttime crime spree.

"Stephen lives off Mulholland," Brogan explained on the way. "It should be easy to get to his place without being seen."

Everyone in L.A. knew Mulholland Drive, winding along the top of the Hollywood Hills, running from Hollywood past Westwood, home of the *other* UCLA campus. It was a rustic area, with homes hidden in small canyons or perched on poles over cliffs offering views of the city.

"There," Brogan finally said, indicating a driveway curving down from the road.

Brogan drove past it and pulled into a recessed area off the road, his car hidden from view.

We stayed off the driveway, and the moon threw enough light through the trees to let us see our way through the underlying brush. Neither of us had training in Nefarious Activities 101 to think to bring a flashlight. Now that I thought of it, we probably should have brought gloves too. Brogan crouched as we got closer to the house, and I followed his example. The house was a rambling one story ranch style. Lights were on in most of the rooms, but curtains were drawn and we couldn't see inside.

As we got closer we took refuge behind some shrubs lining the driveway, looking down at the house. I could hear music fairly loud, even though all the windows were closed. The Aston Martin was in the driveway.

"Damn it. He's still here," Brogan said.

"What do you want to do?"

"Wait, I guess."

So we settled in, feeling completely stupid, sitting down behind the bushes. I thought about proposing a game of 'odds and evens' to pass the time, but I didn't want to lose our tough-guy edge. Soon the lights and music went out and there was the sound of the garage door opening.

Peeking through the hedge we could see Stephen getting into a sedan in the garage. I guess the Aston Martin wasn't going to make the trip to Santa Barbara. I couldn't believe he'd leave it outside.

He backed out and the garage door closed behind him. When his taillights disappeared down the driveway we moved toward the house. As we got to the front door I turned around to see what I could see. Actually, I was looking to see who could perhaps see *us*. No one. We were isolated.

"What are you waiting for?" I asked as Brogan stood facing the door.

"I don't know how to get in."

"I thought you told me you had the alarm code!"

"I do! But I didn't think about needing a key!"

Brogan wasn't being funny. Inept, yes. Funny no.

"C'mon," he said, setting out around the house.

"Where are we going?"

"Let's check the windows. If one isn't open, I'm gonna break one."

"Won't that set off the alarm?"

"I don't know. I don't think so. Ours at home has a delay. I just need to get the code in fast after that."

We made our way around the house, checking windows. All were locked until we got to a small, high window, obviously a bathroom. We could see it was cracked open.

"Give me a boost," Brogan said.

I was so happy he didn't say "Let me give *you* a boost," that I

didn't hesitate, or make a last ditch attempt to talk him out of it. In fact, now that we were here, Brogan seemed more intense than I could ever remember him. Of course, he had more riding on this. A daughter.

He took off the screen, and slid through the window. The crime had begun.

"Meet me at the front door," he said from inside.

I went back around and Brogan had the door open only half a minute later.

"Why'd you put the lights on?" I asked.

"How else are we going to see anything? We've got to search the whole place. Besides, the windows are all covered. There's not even any neighbors."

Okay. Made sense. But still, this was my first breaking and entering. I suddenly had a very real need to use the bathroom.

The entry closet door was open, and I could see the keypad Brogan must have used to deactivate the alarm. I realized now that we were here, I didn't have a clue what to do.

"Let's look for any files or notes," Brogan said. "Anything that could have information about Sammy or the babies. Can you think of anything else?"

I told him I couldn't.

He knew the house from previous visits and pointed out the basic layout. "If you go through the living room there, you'll come to the dining room, a kitchen, then a bathroom. You take those." He pointed down the hallway. "His den and the bedrooms are there. I'll take those. Make sure you cover *everything*. Okay?"

"Yeah." As I moved into the living room I noticed some gloves on a sideboard. Probably driving gloves when he drove his Aston Martin. At least one of us wouldn't leave any fingerprints.

"Brogan, you want these?"

"You take 'em."

I pulled them on. If we were right and Stephen was behind the disappearance of the baby, he wouldn't be complaining to the police about stolen papers anyway.

"Hey, Toby?" Brogan added hesitantly, and I turned back. "If you find files or something. . . will you not open them? I want to be the one. It should be me."

"Sure." I understood. Well, actually, I didn't, but I didn't have a daughter with a missing twin out there.

It seemed much more likely Brogan would find files or records in the den or Stephen's bedroom, but I still took my *B side* search seriously. There was little to do in the living room. There was a gray leather sofa and matching easy chairs, a coffee table in the middle. A giant TV took up one wall, and a fireplace was inset into another, the dying embers in the fire still glowing red.

All I could do was lift sofa cushions and fan magazine pages for notes inserted inside. He had a collection of both straight and gay porno mags. I guess I'd lived a sheltered life. I didn't know some of those things could physically be done.

The dining room was spartan, with nothing but oversized chairs around the table. All there was to do was look underneath. The kitchen proved to be a tougher project. There were cabinets both above and below the counters filling the large kitchen, with countless drawers as well. I was making so much noise Brogan came from his side of the house.

"Toby! Could you make any *more* noise?"

"Hey. *You* try looking behind all these pots and pans."

Brogan went back to his search and I tried to be quieter, but the pots, pans, George Foreman Grills, rice cooker, iced tea maker and various culinary paraphernalia was carelessly stacked on top of each other. I couldn't imagine Stephen hiding papers inside his bread

maker, but Brogan said be thorough. And after what I'd seen in those magazines, I learned it was possible to fit things in a lot of places they weren't supposed to go.

It was in the bathroom that I found them. In the cabinet under the sink. Stephen probably assumed that if he was ever burglarized, they'd be carting off his plasma TV and German frappuccino machine, not looking behind the toilet paper rolls under the sink. And even if they did look there, to burglarizing drugees it was just an old briefcase with medical notes. If I didn't see a lot of medical records in my adoptions, I probably couldn't make much of them myself.

I should have called Brogan over right away. I'd told him I would. But first I just wanted to see if I could open the briefcase. It was locked. I turned the three numbers to "0," the usual preset by luggage manufacturers around the globe, and it opened. I suspected ninety percent of every briefcase in use in the United States was still set to 0-0-0. Evidently changing them was as hard as programming a VCR.

Then would've been a good time to call Brogan, but I wanted to see if the contents looked promising. For all I knew it could be more sex magazines, but so bad they had to be hidden. I hoped not.

But inside were thin manila files. Six of them. The top one bore the name of a fairly well known actress. In fact, she'd done a cameo in Stephen's *Beach Party Bunko*. Her appearance had been as much a mystery to me as Brogan's investment in the tacky film. The name on the second file was a diva of note. Stephen had escorted her to the People's Choice Awards. I couldn't imagine at the time why a talented, young beauty would want to come on Stephen's arm.

The third file was Brogan and Rita's.

It suddenly hit me I was looking at blackmail files, unless it was normal to keep parts of client files under your bathroom sink. He was in a perfect situation. A doctor to the stars, dealing with their most

personal secrets and problems in infertility and gynecology.

Image is everything in the entertainment industry, and even the wrong kind of rumor can set back or destroy a career. How much control over someone would he have if he threatened to anonymously leak the most damaging of personal sexual information to the tabloid TV shows and magazines?

Maybe not asking for money. Do a cameo in my film. Be seen with me at a premier. Invest in my project. . . *God*. That meant he and Brogan weren't even friends. His *friendship* was part of his demands. I'd always known Rita didn't greatly care for Stephen. He was primarily Brogan's friend. So that made him Brogan's blackmailer.

Then it hit me. This was what Brogan was searching for. Sure, there may have been information about Sammy, but this is what Brogan knew he'd find. Information Stephen couldn't keep in his office.

Stephen had gone too far in his manipulation of Brogan. Taking his money, Brogan could handle. But not taking a child. He had to try to stop it. Maybe he was planning to get rough with Stephen, but he needed to find the file first.

It was time for me to call Brogan. Or was it?

I don't know if it made me a good friend or not one at all, but I had to know what Stephen was holding over Brogan's head. Clearly Brogan had not found a way to break free. Maybe I could.

So I opened the file.

There were no notes. Just various tests on Brogan's sperm and Rita's eggs, and both of their blood and urine. It took me a minute before I caught it. *My God.*

My God, please don't let it be true.

It was just one thing. One test. One word. But there it was. The proof was there in the test results. It was worse, far worse than I could have imagined. And the most powerful blackmail of all was not that he leak it to the press, but to his wife.

And he would lose her.

For Brogan, that was the same as losing everything.

Brogan had fought so many battles during his life—and won—but could he come through this? I didn't see how. Suddenly a missing twin took a back seat in my mind.

I heard myself crying before I felt it. My tears were not just for Brogan, but for Rita, and even for me, as I realized how powerless I was to battle this.

I didn't open the other files. Didn't want to know their secrets. I put everything back in the briefcase and placed it back under the sink. I took a minute to make myself look normal again, but could I erase that knowledge from my face?

I headed to the other side of the house and found Brogan in the study. No wonder he was taking so long. There was a wall of file cabinets, each full of files.

"Brogan, I think I might of found something."

"Show me." He followed me to the bathroom. I pointed to the briefcase.

"There."

Brogan opened the case. I hadn't bothered to reset the lock. He thumbed through the files and saw his.

"Did you look inside, Toby?"

"No."

How could he not hear it in my voice?

He opened the file, angled away from me, then quickly closed it.

"Looks like it's just some of my medical records. They're not gonna help us." He tucked them into the back waistband of his pants.

"What about the other files?" I asked. I noticed Brogan didn't look in them either.

He thought for a minute. "Burn 'em."

He handed them to me and I walked to the living room. I tossed

the files in the fireplace. At first they didn't catch and I was afraid the red embers wouldn't ignite them, but slowly one caught fire. It must have included x-rays, because suddenly there was a quick burst of blue flames.

It was at that moment I heard the sound of a car coming down the driveway.

16

"*Toby!*"

Brogan ran into the room. He'd heard it too.

"*Turn out the lights! Try to get out!*"

The house was situated lengthwise from the garage, so Stephen or whomever it was would only see the garage door until he rounded the house. He wouldn't see the lights if we turned them off fast enough.

Brogan ran back to his side of the house while I took care of mine. I'd just finished when I heard the sound of a key in the lock. I stood numbly in the open as the door opened. Luckily, I was standing in complete darkness so I couldn't be seen, but I could recognize Stephen backlit in the doorway.

I silently backed myself into the same bathroom in which I'd found the briefcase. I quietly closed the door but didn't lock it, which would give me away if he tried to open it. The only place to hide in the bathroom was the shower. I pulled the curtain closed, but it was almost worthless in its opaqueness if he turned the light on. Janet

Leigh could not have been more terrified in *Psycho* as Norman Bates swung the knife at her than I was at that moment.

I couldn't hear anything. I couldn't see anything. It was the quiet dark of the womb, but it was terror-filled. There was no window to climb out. Architects who say a bathroom fan is just as good as a window don't know jack.

How many minutes went by? Ten? Twenty?

I didn't know if Brogan had been able to get out, or how I was supposed to. Stand here until I heard Stephen leave again, or fall asleep, then walk out the front door? The decision was taken from me as I heard the bathroom door furtively open.

Was it Brogan looking for me?

Or was it Stephen, who'd seen something suspicious and was searching his house, gun in hand? Did he notice his alarm had been turned off, or did he assume he forgot to set it?

I could only stand there. Whoever it was, I could hear his breathing. Did that mean he could hear mine? If it was Brogan, he couldn't risk speaking since Stephen might hear. If it was Stephen, *I* couldn't risk it.

I heard the barest of clicks as the door was softly closed.

"Toby?" *Thank God*.

Whispering, it was Brogan.

I quietly stepped out of the shower.

"He went in his bedroom," Brogan whispered. "Let's get out of here."

The only way out was the front door. Unlatching and opening a window could make too much noise. We had to pass the hallway to get to the door, and as we did I could see Stephen's bedroom door halfway open. If he happened to walk by and look out, we'd be in plain sight. The light was out in the hallway, but the light cast from his room would be enough to show us.

We made it past the hallway and I was reaching for the front door when Brogan grabbed my wrist to stop me from turning the knob.

"Shhh." He cocked his head.

I heard nothing and wanted to get out of there, but Brogan stood tensed, listening.

A few seconds later we were saved by the Beatles. From Stephen's room *Love Me Do* filled the house. That was our cue and our cover, and we got outside as fast as we could.

"What the —"

Just as we stepped out the door a wash of headlights swept the greenery in front of us. A small car had pulled in Stephen's driveway. Now we could hear the sounds of someone getting out of the car.

Would this night never end?

We had to move quick. We couldn't go back in the house. Our only move was to jump behind the bushes to the side of the door. We'd be seen if they came around the corner in time, but what choice did we have?

We didn't need to worry about making noise. John, Paul, George and Ringo were giving us cover. But we had to be fast. We made the jump and then looked from our hiding places. We were clear. No one was on the walkway from the driveway yet.

I could have made a few wild guesses about who was coming to see Stephen. It was the one person I wouldn't have guessed.

It was Rosa.

17

Rosa?

It seemed impossible. How could she be in league with Stephen? Had the impromptu meeting with Rita at the kids' center been a set up? Couldn't be. There would have been no way to predict Rita would like her enough to invite her home. That was a million to one shot. Even so, what would be the benefit to Stephen? But what other explanation was there?

Rosa walked with more authority than I'd seen at Brogan and Rita's. She rang the doorbell then immediately knocked, likely knowing the music was too loud to hear either one. *Love Me Do* gave way to *Eight Days a Week*, and Rosa waited uncertainly. Finally, she tried the door, and finding it open, cautiously let herself in.

"What the hell?" Brogan whispered.

This wasn't the place to talk. I pulled his sleeve.

"C'mon."

We moved quickly down the hill. I didn't realize how tense I was

until we pulled away in Brogan's car. The tension left me in waves big enough to cause a major tsunami by the time they reached Japan.

"*Rosa?*" Brogan asked incredulously.

"God, Brogan. I don't know *what's* going on."

We drove and stewed. There were no answers between Mulholland Drive and Brogan's house. When we got to Brogan's we sat in his car without getting out. The question was what to do with what we had just seen.

"I didn't want Rita to know about tonight," Brogan said. "But now she has to. We have to tell her about Rosa."

"I know." Rita and Remy wouldn't be safe around her. "Who knows what she's up to."

"I'll go tell Rita. I'll meet you at the guest house."

We both knew we had to look in Rosa's room to see what we could find. I walked over while Brogan went inside to talk to Rita. She would not take it well. I looked at my Rolexe. It was a few minutes before eleven.

The guest house was a small version of the main house, done in the same craftsman style. It was one large room, about eighteen by twenty-five feet, with a bathroom and walk-in closet. The room had a bed on one side, and a small sitting area on the other. A big bay window gave a view out to the sea, now black but for the reflected stripe of the low hanging moon.

There were only a few drawers to search, one in the bedside table, and several in a bureau. Neither had anything of interest. I moved into the closet, where there were some dresses hanging. Only one of them had pockets, and they were empty. On the shelf above the hangers was a purse. I'd seen Rosa with a purse at Stephen's door, so this must be an extra one. One of those *match your shoes* lady things.

It had a few bills sent to "Rosa Wilson." Rosa sure wasn't born a Wilson, so either she was married to an Anglo or it was a false name.

I wrote down the P.O. box they had been sent to. It'd be helpful to know where she lived, but all the bills just had the P.O. box.

I hadn't really paid much attention to Uncle Charlie's criminal law lectures, so I couldn't remember if entering Rosa's room without her permission was a crime considering she had an expectation of privacy, even on Brogan's property. Not that I cared any more, but if I was keeping count, I was now at crime number four.

The bills told me nothing. One was a department store credit card, the other for Chevron. The last item was a financial statement from Merrill Lynch, dated last month.

The balance was $127,320.

That was about $126,000 more than one would expect a woman of Rosa's apparent means to have. What was I looking at? A Stephen Weiss payoff for services rendered?

If that wasn't enough to rock me, flipping over the statement *was*. It was the name of the account holder. It wasn't Rosa Wilson.

It was Brogan Barlow and Rita MacGilroy.

My first thought was that she'd lifted it from Brogan and Rita's house, although I imagined their monthly investment statement was much heftier. But when I looked at the address it had been sent to, it was the same P.O. box.

So was this all part of some financial scam and had nothing to do with the missing baby? Was this an identity theft case in progress, and the statement in front of me was just a tip of the iceberg? Was she busy finding data in their home to transfer funds—account numbers and access codes?

A few minutes later Brogan came back. He said Rita wouldn't leave the house, so we'd go back there to talk. On the way, I told him about the brokerage statement in their names.

"Toby, I think I'm going to go insane. I mean it."

"Let's call Hawkes in the morning. We're getting in over our

heads here. I don't know what to do anymore."

"No kidding."

Rita was waiting for us in the living room, sitting in one of the overstuffed chairs fanned around the fireplace. She didn't look as wiped out as I feared she would. In fact, she looked somewhat resolute. I showed her the financial statement.

"We don't even *have* an account with Merrill Lynch," she said. "Our investment accounts are in a Schwab mutual and a real estate trust."

"It doesn't matter if it's a different broker," Brogan told her. "You can see she's up to something."

"I don't think so." She said it emphatically. "There has to be an explanation."

"Yeah. The explanation is she's probably finding our personal information around here when we aren't looking, so she can transfer our money to her account in our name. Identity theft. It happens all the time."

"No. Not Rosa."

"You can't be serious?" Brogan challenged.

"When she gets back, we'll ask her. Okay?"

"What about her showing up at Stephen's? Are you saying there's an explanation for that too?"

Rita was getting pissed, and it seemed more at Brogan than Rosa. "Listen, Starsky and Hutch,. . ."

She paused to turn the glare at me.

". . . maybe if you told me what was going on before you took off tonight, I'd know more about what's going on. But instead you come back a few minutes ago and tell me all this. Stephen calling Sammy and you staking out his house. And now Rosa's there. None of it makes sense. For all we know, she was there trying to help us, like you were."

"*What?*" Brogan couldn't believe Rita's protection of Rosa. "We never *told* her about Stephen's call to Sammy. Even *you* didn't know til just now."

"He's right Rita," I said. "She couldn't have known Stephen had a hand in this. So what could she be doing there?"

"And they never even spoke at the party," Brogan tried to make his case. "Then she shows up at his house. C'mon. They had to be hiding they knew each other."

Rita stood up, unconvinced. "Listen, it's almost midnight and I'm going to bed. You wake me up when Rosa gets back. We'll all talk to her then. Okay?"

But Brogan wasn't done. "What did she tell you when she left tonight anyway? Where did she say she was going?"

Rita didn't seem too thrilled to answer, not wanting to defeat her own argument in Rosa's defense. "She said she had to go back home. She needed a few more things since she's been here so long."

"Uh huh. Right. And instead she goes to Stephen's."

Rita was halfway out of the room, but came back.

"Brogan, this is all I can say to you. I get a *feeling* from Rosa. I don't know why, but she's *different* from other people. She's *good*. And I *never* get that feeling." She paused for a minute. "I just can't be wrong. I can't. Okay?"

I thought I understood. Maybe this was less about Rosa and more about Rita herself. If she invested certain qualities in Rosa, and she was completely wrong—that Rosa's intent all along had been to hurt her—what did that tell Rita about herself? Should she stop trusting Brogan? Me? Maybe she had a point. The only people who she knew for sure who lied to her tonight were Brogan and me. Maybe Rosa had lied for a good reason too, but I knew that couldn't be true.

While we waited for Rosa, Brogan called their brokerage. Thanks to twenty-four hour service, he could confirm that no money had

been moved from his and Rita's accounts. He put a freeze on them so nothing could be withdrawn or transferred.

Any smidgeon of credibility I gave to Rita's support of Rosa disappeared as the night turned to dawn.

Rosa never came back.

18

"LET'S CALL DETECTIVE Hawkes," Rita said.

Brogan and I nodded. It was a bit past seven in the morning. Rosa had never returned. The days and nights were getting muddled and I had to remind myself what day it was. Saturday. Rita's motivation for calling Hawkes was slightly different than Brogan's and mine.

"Something could have happened to Rosa over at Stephen's," Rita said for about the fourth time. "We should go over there."

"No way," Brogan said, "I just want to tell everything to Hawkes. I can't do this stuff any more."

"When you say *everything*. . ." I wanted to keep my law license at least another thirty years or so. I needn't of worried. Brogan's search for his medical records and its secret was something he'd die to hide. Especially from Rita. Plus, no sense making her an accessory after the fact. So we only told her about the stake out, not the break in.

"We can tell him about how you found out Stephen called Sammy, and we went over to ask him about it. We saw Rosa go in the

house, but she didn't see us…"

I finished for him. "And based upon our concerns for Remy's safety with Rosa living here, we looked in her room and found the statement with your and Rita's name on it."

So we called Hawkes. I wasn't sure if he'd be in on a Saturday, but we left a message and he called back within fifteen minutes. We gave him the short version together on the speaker phone.

"Tell you what," Hawkes said. "I've got some stuff I've got to attend to first, but I can be up in L.A. by around four. That okay for you?"

"That'd be great," Brogan said. "We appreciate all the time you're spending on this."

"Stop thanking me. I'm just doing my job. But remember, we only have some petty stuff on Sammy, so his calling her gives us nothing for a warrant. But who knows, maybe he'll panic with a badge in his face. I've seen it happen."

"I hope so," Brogan said. "But he's a pretty cool customer."

"Yeah. He sounds like it. But the thing with this Rosa Wilson sounds promising. I'm going to give what you gave me on her to our financial crimes unit. Maybe I can have something for you when I see you."

We dawdled over breakfast, a full day to fill before Hawkes would arrive. I had an idea I wanted to share.

"When Sammy first came to my office, I kept thinking how different she was from other birth moms. Kind of like a Hollywood version—how they'd stereotype someone placing a child for adoption. Not like a real one."

"Stop it Toby," Brogan said. "You've got to stop blaming yourself she did this. We don't blame you for getting tricked. We did too."

"And because of you, we have Remy," Rita added.

"Thanks, but I'm not blaming myself. What I was thinking was she. . . she was more like an *actress*. You know, playing a role of what she thought a birth mother would be like. And now we know Stephen knew her, maybe even put the whole thing in motion."

I wanted to add "as part of another scheme," but I couldn't let on I knew about the blackmail.

I continued. "So, Stephen was in the film business, right? Do you think maybe Sammy was an actress. Or someone trying to be?

Brogan and Rita looked at each other.

"That's a good idea, Toby," Brogan said. "We'd have recognized her if she'd done much though."

He turned to Rita.

"What do you think? SAG books?"

She nodded with enthusiasm, liking the idea. "Toby, he's talking about Screen Actor's Guild casting books. All the agents list their actors in categories. They've got *leading, character,* different age groups and so on. There are about five or six she could be in."

Brogan took it up. "Each book gives a small photo with the actor and agent's name. They're supposed to be for casting agents and production companies to look at for casting, but they rarely do. Just makes the new actors feel like they get something for their dues."

Brogan picked up the phone. "I'll give Mark a call."

I knew Mark was his assistant at his production company.

"Hey Mark, how you doing?. . . Good. Listen, I need you to send someone over here with all our SAG books for actresses. . . And the SEG books too. . . Yeah, right now. I'm at home. Thanks."

The top name actors usually have their own production companies, usually just a tiny office on one of the big studio lots, given gratis for the right for a *first look* deal on the actor's projects. Brogan's was at Paramount, which was about forty minutes away. We wouldn't have too long to wait for the books.

"What's SEG?" I asked.

"Screen Extras Guild. You know, the background people. I thought we should check those too."

I had another idea. "What about *Beach Party Bunko*? Could she have had a small role in that?"

"No," Brogan shook his head. "I had to go to the premier—"

"If you could call it that," said Rita.

"Whatever. I'd have recognized her if she was in it. She wasn't."

"There has to be a connection between him and Sammy though," I persisted. "She wouldn't be a patient, right? He was some hot shot doctor. She couldn't afford him. So that leaves the movie side. What about if she just auditioned for the movie, or maybe worked in some behind-the-scenes job?"

"He's right, Brogan. You put up the money for that piece of crap. Can't you get the names on the auditions and open calls?"

"Yeah, good idea." Brogan picked up the phone again.

"Me again, Mark." As Brogan's right-hand man so to speak, Mark was one of the few who knew of Brogan's backing of *Beach Party Bunko*. "Hey, who did the casting for Weiss's movie?. . . Yeah, that's right. I'd forgotten. Listen, can you call her and tell her I need a listing of all the actresses who auditioned for it. Open calls too. . . Yeah, and a list of the extras. And see if you can dig up a list of everyone in production too. . . And Mark? I want you to do this without Weiss knowing I'm asking. Okay?. . . Thanks."

He hung up and turned to us. "He thinks he can get everything by about noon."

All this brain work was making us hungry. Remy had awakened everyone at about five a.m. in what I was learning was an unending quest for nourishment and physical contact. But then, who couldn't you say that about? We were just finishing breakfast when the SAG and SEG books came, with word that Weiss's production information

would soon follow.

My heart sank when I saw them. They were the size of New York City phone books. Actually, I've never been to New York, or seen one of their phone books. But they were big. Real big. And there were a lot of them. We eliminated the books for older actresses, but that still left five categories which a young woman Sammy's age could be in. That was just for the SAG books. There were even more SEG books.

Each page had photos five across, in six columns. Thirty per page, alphabetically listed. Under each picture was the actress's name and her agent. The *ingenue* book I was looking in had four hundred and forty-one pages. That's a lot of pictures. Still, it was our best option right now.

An hour and about four hundred actresses later, I wasn't so sure. I was starting to think that even if I saw Sammy's picture I may not recognize her. Most of the pictures were going for a unique look of some type, sometimes costumed, making the actresses harder to recognize.

We'd been at it for about three hours straight when we decided our eyes needed a rest. We went out on the patio with some welcome cold Heinekens. No one wanted to sit after doing nothing but for the last few hours.

"You know, there's always the chance even if she *is* an actress, she's not in SAG." Rita wasn't trying to be negative, just realistic.

"What do you mean?" I asked.

"For every actor in the Guild, there's probably ten who aren't. They're doing small theater, workshops, anything just trying to get a break. Most of them will end up just giving up and going home after realizing how hard it is."

"So what she's saying is that there are a lot of wannabes out there who aren't in SAG yet," Brogan said. "They wouldn't be in the

books."

We were heading back inside when Mark's messenger brought the audition and production information from *Beach Party Bunko*. We settled back in at the kitchen table.

"I've got a suggestion," Brogan said. "Let's focus on Stephen's movie. I'll take the actress audition list. Rita, you take the extras. Toby, you take the production list. We'll check each name in the SAG and SEG books and see what they look like."

We stacked all the books in the middle, and went through each of the directories with every name. There were only twenty-seven names on my production list. Thankfully Stephen's movie had been low budget. Of those, only nine were women, so my list was done quickly. Rita's list was also small, so she finished right behind me. Brogan handed a few extra pages from his list to us.

Rita's sharp intake of breath was the giveaway.

"I found her!"

She swiveled the book for us to see.

"I think you're right!" Brogan said.

I was fairly sure as well. We were looking at the *character actresses* book. I reached for the *leading ladies* to see if there was a different photo.

"Tori Lynn Jamison," Brogan read from beneath the picture in Rita's book.

We all looked in mine. It was a different picture, and a better one. Our Sammy's hair had been blond and always tied on top of her head, while Tori's was dark and flowing, but the faces were the same.

"That's *her*. No doubt," Brogan said.

"*Yes!*" Rita said. "*Thank God!* We finally know who she is!"

"So how do we find her?' I asked.

Brogan pointed just below the photo and Tori's name. "That's her agent."

"I've never heard of him," Rita said. "Robert Schwartz, Sunset Talent Associates."

"Me either," Brogan agreed. "But they're about to hear from me."

I looked at the address of the agency. I didn't know L.A. well, but I knew that part of Melrose Boulevard was better known for hookers and second hand furniture shops than acting agencies. With an agent like that, her career highlight would be auditioning for soap opera one-liners.

He grabbed the phone.

"Hello, may I speak to Robert Schwartz please? . . . Brogan Barlow. . . no this isn't a joke. I'm calling about someone he's representing. . . Yes, I'll hold. . . Hi, Robert, this is Brogan Barlow. How are you? . . . Yes, I'm surprised we've never met either. I hear from my people over at MCI that you've got a good eye for new talent. . . I should get you and my guys together. . . Anyway, I'm calling about one of your actresses, Tori Jamison. . . Well, I'm producing a small picture—a character piece really—and we want all new faces. . . yes, I agree. She is uniquely intriguing. . . Yes, I'm sure she does show all the colors in her performances. . ."

She shows all the colors? I guess this was the way they talked in the film business. No wonder most movies are pure crap. I was willing to bet Brogan or the agent would end the call with *"ciao."*

"Can you tell me if she's working out of town, or is she available?. . . Great! Listen, what I'd like to do is have my casting people take a look at her. But here's the thing. They want to observe everyone without them being aware they're being considered for a part. Shopping in the store, walking down the street type stuff. Use their natural idiosyncrasies and style in the casting. . . Yeah, it *is* interesting. . . So, what's her home address? . . . Right. And remember, if you want her to have a chance at this part, don't call her. If my people get a feeling she knows, I'll need to look elsewhere for my lead. . . You

bet, lunch would be great sometime."

No *ciao* from Brogan, but I couldn't hear Robert's end.

He turned to us.

"Got it! She lives in Santa Monica. We can be there in thirty minutes. Let's go."

I knew the *we* meant me, and Rita didn't argue. In fact, she practically pushed us toward the door. But she grabbed Brogan's arm at the last second.

"Brogan, she *has* to get the baby tested. Don't let her out of your sight until she does. Not for a second. Not one."

"I know, honey. Don't worry." He turned away but she grabbed him again. Rita's eyes looked like they were on fire.

"And Brogan, don't get mad at her. I know we can't make her, but. . . talk about how important it is for the girls to be raised together. I think maybe inside, she still cares."

Brogan forced himself to slow down. He didn't say a word, just gently held Rita's face as their eyes locked. Finally he released her and we ran to the car.

We didn't talk on the way. Would she be there? Would the baby? Travis? Would we finally learn why they had done this and what they wanted from Brogan and Rita? Would she be afraid? Or vindictive? It didn't matter. We had to find and confront her.

Her apartment was easy to find, just off Ocean Boulevard. It was a small two story complex with about a dozen units, built in the '60s and painted in *Miami Vice* colors. A few people sat around the small pool in the center courtyard.

"Hey!" One of the guys said with big eyes as we walked past.

I had been around Brogan and Rita enough to recognize the exclamation. It meant *Hey! Look! It's a movie star! I have nothing intelligent to say to you but I must register my shock publicly, then continue to blankly stare at you.*

Brogan waved back. "Hi."

A quick glance at the apartment numbers on the doors showed her unit would be upstairs, lucky number eight. With the fear she could disappear at any moment, which she had already done all too well, we went as fast as we could short of an all out run.

There would be no back door since we were on the second floor. No escape. Brogan knocked. There was no answer. *Damn it!* She *had* to be here.

Without turning from the door, Brogan asked. "Are they still watching us?"

I surreptitiously glanced below.

"You mean watching *you*. Yeah, they're standing there staring."

That's what usually happened. People would just stand and gawk, as if he were a freak show. I don't know how Brogan and Rita handled it. I couldn't even go out to dinner with them. So many people would stare at our table that I couldn't get food in my mouth.

Still facing the door, Brogan said, "I'm going to talk to them. Stand behind me and see if you can get the door open."

Brogan turned around and stepped to the rail. His body shielded me as I moved to the door. What was I worrying about? Their eyes were so riveted on Brogan I could have striped naked and they wouldn't notice.

"Any of you know Tori?" he asked.

The guy who'd offered the "hey" spoke up. "*You* know Tori? She told us she was an actress but I'd never seen her in nothing. Not even a commercial."

"Sure. She's a friend of mine. Have you seen her around lately?"

"Yeah. Saw her yesterday. 'Bout lunch time. Haven't seen her since."

"Did you see her leave?"

"No, but she's in and out a lot."

I wasn't sure what I was supposed to do to open the door. Did he just want me to try the knob, or extend our breaking and entering streak? I turned the knob. Locked. The only thing I could think of was to slip a credit card in the door jamb like James Garner used to do every week in *The Rockford Files*. To think only a week ago I'd never committed a crime.

Brogan was still talking. "I haven't seen her for awhile. I heard she had a baby. Is that true?"

"Oh yeah. Noisy little thing. Haven't seen it for a couple weeks, though."

Brogan could probably barely contain himself. The baby. Alive and well. At least then.

"What about Travis? Has he been around?"

I didn't care where Travis was at the moment. I was looking for Jim Rockford, because the credit card trick wasn't working for me. I slipped it between the door and the jamb, but the lock didn't slide back. Then, finally, it did.

"Never seen her with someone named Travis."

"Got it," I whispered.

"Well, thanks," Brogan called out. "Great to talk to you. We've got a key so we'll just let ourselves in."

I don't know why he bothered. He could take a circular saw and cut a hole in the door and walk through and all they would say was "Look! It's Brogan Barlow!"

I pushed the door open and we walked in. It was furnished in Early Motel. The living room had one sofa, one TV, and a portable crib folded up in a corner.

Tori was waiting for us in the bedroom. I was no expert in such matters, but I guessed she'd been dead for less than twenty-four hours.

There was no blood and no baby.

Her head was at an impossible angle, as if someone had tried to twist it backwards and halfway succeeded. She looked small and vulnerable. Despite what she'd put Brogan and Rita through, I felt only sadness. She'd been young, pretty and vital. She'd deserved a life.

She was absurdly propped up in bed as if she were watching TV. She was naked except for her underwear. She was wearing the ones with the little eyeballs, but now there was no mischievousness in them, only death, and they looked back at me with the knowledge and sorrow of silent mourners.

Whoever did this had to know her well. Someone she was intimate with. We knew she had that kind of relationship with Travis? How did Stephen fit in?

A small sob escaped Brogan. I was having a tough time handling it myself. But it wasn't just the sight of a dead body—a murder victim. It was the murder of the biological mother of his daughter. He'd lost his birth mother. Now his daughter had forever lost hers.

Worse was what this meant for the missing baby. Fears of ransom were nothing compared to this. Now we were dealing with murder. It was possible whomever now had the baby was Sammy's —Tori's — killer. One comfort Brogan and Rita had since the beginning was the belief the baby would be given to them. The only question was what someone wanted out of them. And when.

Now even that was in doubt.

19

I USED MY cell phone to call Hawkes while Brogan called Rita. I knew the LAPD had jurisdiction, but better the devil you know than the one you don't. Not that Hawkes was a devil. Far from it. But a cop could quickly become your enemy when you break into an apartment and find a murder victim. Especially when the victim was someone who'd given the breaker and enterer a reason to want them dead.

I gave it to Hawkes quick.

"Okay," he said. "I'll phone it in to LAPD. Here's what I want you to do. First of all, go stand in front of the apartment. If you stay inside you could end up getting shot, or contaminate evidence."

I didn't tell him we were already outside. Not worrying about evidence contamination. Just trying to breathe.

"Second, make sure no one enters until we've got somebody there. I don't care if her mother shows up. No one gets inside. Okay?"

"Yeah. I got it."

"I'm taking off right now. I should be there about 3:30 or 4:00. Expect the black and whites in about ten minutes. And Toby?"

"Yes?"

"Don't do anything stupid before I get there."

Too late for that, I wanted to say. Where were you when I was wielding my credit card?

He was off by only a minute.

The first police car pulled up in nine minutes. They were all business. A detective was minutes behind. A full forensics team and a Medical Examiner arrived within an hour.

I'd heard there were about three hundred murders a year in Los Angeles. That's about three hundred more than Fallbrook. I didn't know if the cops arrived so fast at all homicides, or if the presence of a matinee idol was a factor. Since the O.J. fiasco, the LAPD handled potentially high profile cases with much more care. Sometimes I wondered if the new attitude was geared toward actually obtaining convictions, or just avoiding embarrassment to the department.

Hawkes arrived at 3:35. He was on a first name basis with the L.A. detective, Louis Ritchie. Evidently he'd taken the call directly from Hawkes and almost beat the black and whites. Ritchie had spoken to us briefly, but most of his attention had been on the victim and supervision of the forensics team. Now that the M.E. had arrived, he and Hawkes sat down with us.

Ritchie's crew cut and thick neck and body gave him the look of a drill instructor, but he had an air of deference about him toward Brogan, not surprising considering his celebrity status. That didn't stop him from doing his job though.

"So you arrived and found the door locked," Ritchie reviewed. "And you feared for the safety of the baby so you forced the lock." We'd heard Hawkes fill Ritchie in on the history.

The M.E. walked up and caught Ritchie's attention. "I can have something more exact for you later, but right now I'd estimate time of death was last night. Best guess six p.m. to midnight."

"Broken neck?" asked Ritchie.

"Certainly appears that way. We'll have a report by Monday."

Ritchie turned back to us. "Since you gentlemen seem to be at the center of everything going on here, would you like to tell me where you were between six and midnight?"

He smiled when he asked it and I had the feeling he asked just to get it over with, not considering us suspects. I'd seen that on TV cop shows though. Smile guilelessly when you ask a question. Lull the one you most suspect to sleep. Even I'd seen the ones where you kill someone yourself, then pretend to discover the body later. Who knew what Ritchie was thinking.

I wanted to say, "We couldn't be killing anybody last night, we were busy breaking into somebody else's home." But instead I said what we worked out when we agreed to call in Hawkes last night. It was the truth, minus the break-in.

"We were at Brogan's house with his wife from yesterday afternoon until we came over here a couple of hours ago. The only time we were gone was when we were at Stephen Weiss's for about two hours."

"And when was that?"

Brogan answered. "I think we got there about ten 'til nine, and left about ten o'clock or so."

"And you were with this Stephen Weiss the entire time?"

"No. He wasn't there. We waited for him."

"You waited for him for more than an hour?" There was more than mild surprise in Ritchie's voice.

Hawkes cut in here, and with some interjections from Brogan and me, filled Ritchie in on the call from Stephen to Tori. As we were

talking I realized how things had changed with the discovery of Sammy's body. Tori's body. It was hard not to think of her as Sammy. Before, there was little motivation for the police to question Stephen. With Tori murdered, they could now lean on Stephen hard. The police could no longer say there had been no significant crime committed. Maybe if something good could come out of Tori's death, this was it.

"I'm heading over to Weiss's house right now." Ritchie turned to Hawkes. "Want to tag along, Winston?"

"You bet." Hawkes turned to Brogan. "I'll drop by your place when we're done. We can talk about Rosa Wilson then too."

20

HAWKES GOT TO Brogan and Rita's place as we were finishing dinner. Still no Rosa, but by now we weren't expecting her to return.

It was amusing to see him so discomforted by Rita. I forgot that to others she wasn't my pal Rita, she was Rita MacGilroy, movie star, cover girl and presenter of Academy Awards. Her attempts to put him at ease only backfired, as her serving snacks and a drink to him only further discombobulated him.

"First things first," he said. "There was no one at Weiss's. At least no one answered. His newspaper was in the driveway and his mail was in the box, so maybe he left last night."

"He told me he was going to Santa Barbara," Brogan said.

"Yeah, you told me. I called his office and they told me where he was staying, the Fess Parker Doubletree. Never checked in though."

"I'm worried about Rosa," Rita said. "Brogan and Toby said she went in his house and we haven't seen her since. Is there a way to check inside?"

"Can't you get a warrant?" Brogan wasn't worried about Rosa. He wanted a baby found. Second, he wanted the murderer of his daughter's birth mother caught. Maybe Stephen was the key to both.

"We don't have anything firm to tie him to the murder yet, but if his phone records show that he called her in Fallbrook, I think it'll be enough. But it'll be Monday before I can get them."

Hawkes reached for a file he'd set down.

"Speaking of Rosa, let me tell you what I found." He sorted the papers. "First of all, is this her?"

He held out what looked like a photocopy of a Mexican passport. The woman in the photo was younger, but it was Rosa.

"That's her," Rita said.

"What's her real name?" Brogan asked.

"Rosalita Wilson *is* her real name and this is a valid ID."

I could feel the tension go out of Rita from across the room.

"She's a Mexican national," Hawkes went on. "She was granted a one-day visa when she was eighteen, about thirty-something years ago. Looks like she over-extended and stayed."

He focused on another document.

"Married a U.S. citizen eleven years ago. Edward Wilson was his name, and that got her a Green Card, so she's legal now. He died four years ago."

He handed Brogan the copy of Rosa's passport picture. "I made a copy for you. So then, let's see. . . INS shows she returned to Mexico shortly after he died, then she came back on May twelfth of this year."

That was a month before the birth and the selection of Brogan and Rita as adoptive parents. Could there have been a plan in the works then?

"What about the money?" Brogan asked.

"I was able to get her husband's probate records. The entire estate

was valued at $6,237, so she didn't get the money from him. I also got their tax returns from the IRS. He was a baker and she shows a small income cleaning houses. They never made over twenty-five thousand combined."

"But what about it being in our names?" Brogan asked.

"The Merrill Lynch account was opened shortly after she was married. It was a transfer from the National Bank of Mexico. Probably easier to set up an account in someone else's name there. At that time, it was just over $26,000. The stock market took good care of her and exploded in the nineties. She put it in your names just a few weeks ago. July twenty-second, to be specific."

"So it's got to be some scam to put it in our name, then show up in our house," Brogan said.

"Well, I have to say I think you're right. But I checked her out. No convictions here. Harder to get them out of Mexico with their record keeping, but nothing from there yet. One other strange thing. Can't find an address for her. She's got the P.O. box, but the address on her visa isn't valid. 'Course, a lot of time people don't notify the INS of changed addresses. But it could also mean she doesn't want to be found. I've got no way to go after her."

We sat back to digest everything. There was a buzz from the gate intercom. Brogan went to answer it and Gina's voice filled the room.

"Hi baby. It's Godma. Let me in!"

Godma, Gina's new phrase for Godmother.

"Hi, Gina," Brogan said. "Hold on."

He pushed the gate switch and came back to us.

Brogan looked at Rita. "Did you know Gina was coming?"

"No. But she calls everyday to see how we're doing. This morning I told her about Rosa disappearing."

A minute later Gina entered the house without knocking, as was the norm for all of us. She had a suitcase in each hand.

She swept into the room and saw Brogan and Rita had company. Hawkes. I didn't consider myself company.

"Where is my stud muffin to carry my bags?" I knew Gina meant me. Not because I'm a stud muffin. A muffin maybe, certainly not a stud. I was left by default because she did her flirt act with everyone but Brogan. He just got unbridled affection and career guidance.

She stepped forward to introduce herself to Hawkes. "Gina Volenti."

She leaned toward him, and I was afraid one of her giant breasts was going to tumble out and take out an eye. The fluster he'd shown with Rita was back. She was no screen star like Rita, but she was gorgeous and available.

"Winston Hawkes." He stood, either to be courteous or to protect his vision.

"Ah, the detective. I've heard wonderful things about you. Thank you for all you're doing for us."

She meant the *us*. For all her silly flirtatiousness, she would fight like a mother bear for Brogan. Maybe that's one reason Brogan's career moved so quickly. Those casting directors early in Brogan's career likely feared if they didn't cast him, they'd wake up with a severed horse head in their beds.

"Gina, what's with the suitcases?" Brogan asked.

"What, boy of mine? I'm not welcome?"

"Well, of course you are—"

"Rita told me about Rosa, and I'd like to help with my new little baby and," she messed up Brogan's hair like he was four, "my big one." Although I didn't see Gina as the diaper-changing, help-with-the-dishes type of person, she had a good heart, and I think there was a touch of jealousy at Rosa's quick immersion into the family.

She went back to Hawkes.

"I hear you're a smart guy."

"I wouldn't say that, but thank you."

"Don't be modest, detective. Smarts are just what we need right now." Gina had an agent's eye and could size up anyone in about ten seconds. "And you're the kind of man who thinks about his cases twenty-four hours a day. Your job consumes you. Am I right?"

Hawkes shrugged uncomfortably. What could he say to that?

Gina looked at his bare ring finger. "Hmm, never married? Or divorced? I'd say divorced."

"Correct."

"And I'd say six foot even."

"Exactly."

"And you're. . . fifty-one or fifty-two."

"Fifty-one.

"Uh huh. About the same as me. But I'd bet you'd put me at thirty-eight."

He grinned. "Maybe forty."

Good for him. Gina's eyes widened in pleasure. Someone who wasn't intimidated by her.

But as quickly as her smile appeared, it slipped from her face.

"I can tell you one more thing about you."

"What's that?"

Her eyes bored into his, as if willing her prophecy to become true. "You're the man who's going to find Remy's sister, and bring her home to us."

There was an uncomfortable silence before Rita spoke up. "Gina, let me get you some sheets and walk you over to the guest house."

Gina let go of her hypnotic gaze upon Hawkes. "Oh I can manage myself, honey. Unless Detective Hawkes wouldn't mind helping me with my bags. I've got a few questions on how things are going."

Hawkes was a good sport and stood up. "I've pretty much finished up. I'd be happy to do my best to help with both."

He turned to the rest of us. "Thanks for having me over. I'll call you Monday about the search warrant."

We said our goodbyes and walked Hawkes and Gina to the door. Half an hour later I was heading out myself. I was tired, but didn't want to spend a second night on the sofa. Hawkes was just coming up from the guest house.

"Interesting company you keep, Toby."

"Show biz people are different all right. Sorry about Gina's seer act. Brogan and Rita are the only normal ones I know."

"I've never had a woman ask me out before."

"Really? Gina asked you out?" I'd never heard of Gina asking a guy out. Flirting to orgasm, yes. But actually dating? Never.

"I kind of got the feeling she asked everybody out."

"No. She may have the body of a porn goddess, but you may have to marry her to see it. She sure talks a good game though."

"She ever been married? Got kids?"

"Here's Gina—grew up in San Diego like us, but in the city, not the country. Smart business lady. Started with one flower shop and turned it into a chain of fourteen—spread out all over San Diego. Sold them all like twenty years ago, made a bundle and started an agency in L.A. One marriage, no kids. Lasted one year. Said he wasn't *euro* enough to match up with her European heritage."

"What's that mean?"

"Actually, I have no idea. I think she says it to cover the embarrassment of his cheating on her."

I thought for a minute then added, "She's a heck of a nice lady."

He climbed into his car and rolled down the window.

"Thanks, Toby. And in case you were worried about the credit card thing. . ."

Ah, my crime of the day. I hadn't allowed myself to worry about it. Dead body or not, it was still an illegal entry by an officer of the

court.

"... Lou and I talked about how to write it up. What we assumed happened was that you smelled something suspicious from outside. Everyone knows a deceased body produces a foul odor. Fearing there may be the missing baby alone inside, you entered the apartment. Did we figure right?"

What a guy.

"Yes, detective. Thanks."

With today starting with a murder, and the only high note of the day being that I wasn't going to be arrested, I assumed tomorrow could only be an improvement. After all, tomorrow was Sunday. Sundays were good. Sundays were full of Sunday Things—good cheer for mankind, the big fat Sunday paper with the color comics and the book review section, a quality baseball game on TV. The official day of rest.

I was going to take a break from both crime solving and crime committing. Hawkes would let me know when he had something on Stephen. Until then, I was going to veg, do Sunday Things, and play some tennis.

When I arrived home late Saturday night, that was the plan. None of it came to pass. Sunday became Saturday, Part Two.

21

I COULD NEVER remember if the Evil Empire referred to the media, or the Darth Vader bad guys in *Star Wars*. Whatever. To me, it's the media. At least today.

We knew it would happen eventually, and it turned out Sunday was the day. I was in my *Cat in the Hat* jammies, walking downstairs for the Sunday paper, 8:40 a.m., into my Sunday Things.

They jumped me at the bottom of the stairs.

Microphones. Reporters. Cameras. It wasn't exactly a presidential-sized press conference, but it was a horde of seven or eight people with dangerous objects in their hands. Pens. And paper. We all knew how painful paper cuts could be.

"Mr. Dillon! Can you confirm the kidnapping of Brogan and Rita's baby?"

"Is it true that Remy Barlow has a missing twin?"

"Mr. Dillon! Are the babies really identical?"

"How are Brogan and Rita handling the strain?"

"Are you aware of any suspects in the murder of Tori Jamison?"

"Do you have any theories on the location of the missing baby?"

If I'd been smart, I'd have told them I would return to answer their questions, then go upstairs to change. But I wasn't smart. At least not that morning. I had a month of media experience, but it was with pre-framed questions lobbed up gently, and I had hours to think of a reply in my dressing room. And if I goofed, they'd cut tape and do it again.

But I had no paparazzi experience. So instead I stood there in my pajamas as the cameras clicked. At least my vent wasn't open. Only one good thing could come out of this—I was sure my dad would formally retract any further job offers when he caught my jammied picture in the paper.

I wondered how long they would continue to shout questions. I assumed if they wanted answers they'd actually wait for a reply, but firing the questions seemed to be the competitive goal. Now I know why reporters said "he had no comment." It was because the poor guy they were questioning couldn't get a word in.

I had to think quick. That doesn't mean I thought well, but I did think quick. Obviously, the press knew the whole story. Or almost the whole story. There'd been no questions about Stephen Weiss or Rosa, so maybe they were in the dark there. That was good because we didn't want them alerted before the Monday search warrant got Hawkes and Ritchie into Weiss's house.

I was sure if these reporters were here, there were ten times as many at Brogan and Rita's. I got the San Diego grade B reporters. The real story was in L.A. But if the story was out and we had no choice, better to use the media exposure to our benefit.

I tried to speak. "Can I ask you. . . Can I ask you. . ."

The questions finally slowed and I pressed forward.

"Can I ask you the source of your information?"

One of the field reports I recognized from our local Channel 8 news spoke up. "Mr. Dillon, the LAPD report on the murder of Tori Jamison was made available to the media this morning, as well as the SDSO's on the kidnapping. Do you have a comment?"

Before I could even answer, the others jumped in.

"Has there been a ransom demand for the baby?"

"Do you feel you were negligent in not discovering the false identity of the birth mother?"

"If the baby's found, who has the rights to the kid?"

It was like the one reporter's question triggered a Pavlovian response from the other reporters. I was surprised they were talking about it as a kidnapping. I hadn't seen the LAPD report, and was surprised it was made public. I guess that was the new, improved, post-O.J. LAPD. Was it just too early in the story for the press to really understand it, or would "kidnapping" make a better headline and TV teaser than something accurate but less juicy?

Then it hit me. I should have realized it before. Since Tori was the lawful mother of the missing baby, and she was now dead, the taking of the child would finally *be* kidnapping. After more than a week of a look-like-it, smell-like-it, but-it-isn't a kidnapping, maybe we finally had one—unless Tori gave the baby to someone before her murder. It could be someone completely innocent of any wrongdoing. Someone who knew nothing about the adoption and what followed it. A parent or friend. That person would certainly come forward when learning about the adoption and Tori's murder, even more so when learning about the urgent need to get the baby to a doctor. And maybe, just maybe, they'd even think identical twins belonged together.

But even if the baby was with the murderer, maybe the time for caution and silence was gone, and the media attention would help. There had been a murder, after all. It was time to be aggressive. Al-

though Brogan and Rita would have liked to make the decision them-
selves, they probably would have decided to go public in the next day
or so anyway, if nothing came of the police questioning of Stephen.

A quick sound bite from the lawyer might help. I'd leave a sum-
mation of the case to the police, since they appeared to have a big
mouth anyway, and the emotional pleas to Brogan and Rita.

"Yes, I can make a statement. Brogan Barlow and Rita
MacGilroy and their daughter, Remy, ask for the help of the press
and the public in finding Remy's sister. She needs to be brought to a
doctor as soon as possible, and she needs to be with her twin sister.
We would ask that anyone knowing about the whereabouts of the
baby contact the police as soon as possible. Thank you."

"Mr. Dillon, are Brogan and Rita going to post a reward?"

*"Do you know if there are any movies being planned about the
adoption?"*

"Do you know the identity of the birth father?"

"Why was the story kept from the press?"

And so it went. But I had said my piece and headed up the stairs,
wondering why I could still hear the cameras rolling. Did they really
have a use for footage of my pajamed backside?

The first thing I did was call Brogan and Rita. I got their answer-
ing machine. Where could they be this early in the morning? When I
turned on the TV a minute later, I found them. All four networks had
the story live. Brogan and Rita were at their gate, facing a sea of
press. They were not wearing pajamas.

Their thoughts had matched mine, and they laid out the story
well, especially about the likely severe thyroid disorder and the two
weeks remaining before it became critical.

I changed and went downstairs.

*"Mr. Dillon, are Brogan or Rita suspects in the murder of Tori
Jamison?"*

"Has the kidnapping of the baby put pressure on their mar-riage?"

"Are Brogan and Rita considering retirement?"

They were still out there! Were they planning to camp out until the baby was found? I ignored them and walked to my car. They did-n't seem to mind. Now they had their "He had no comment" quote if they wanted to use it.

But what bothered me even more was that they all started taking pictures of me again when I got into the Falcon with Kemo Sabe. Why would anyone but *Classic Car* magazine want a picture of that?

22

FOR AWHILE, I drove aimlessly, emotionally winding down under the calming branches of the ancient oaks arching over Live Oak Park Road.

Then it hit me. My grandpa. I'd been meaning to visit but had been too caught up in Brogan and Rita's adoption. That's exactly why I didn't want a big practice. The really important things—and people—get pushed to the back. But grandpa understood. He'd been an attorney too.

I enjoyed driving to his property. It was like the Fallbrook of my youth. A little outside of town, where there were still hundred acre parcels filled with avocado groves, and the occasional macadamia or fuyu persimmon orchard. Seas of endless green.

I turned off Live Oak Park Road, passed the Junior High, then over to Stage Coach Road. It was known as *Church Row*, with every place of worship lined up side by side. Presbyterians, Mormons, Jews, Baptists, Catholics, Seven Day Adventists, all living in multi-

denominational harmony.

I always enjoyed driving past the Baptist Church. It had a sign board in front and every week they posted a new inspirational slogan. Some of them were really good. One that stuck in my mind was "It's hard to rock the boat when you're busy rowing." Sounded like one of those things grandpa would say. Sometimes though, they came up with one which made me do a double take. Today was one of them. It said, "It feels better when you do it on your knees."

I made a quick left at Fallbrook High, and winded my way up to Sleeping Indian Road, where grandpa lived. From a distance, the hill-top clearly resembled the outline of a sleeping Indian, and was one of our local landmarks. Grandpa owned the foot.

I didn't see him when I first drove up the dirt road which led to his small house, but I knew where I'd find him.

I parked and walked down into the grove. He had personally planted his orchard over two seasons, starting when I was seven. I could recall at the time telling him the trees were too far apart. Barely two feet high, they were in even rows twenty-five feet apart. He'd laughed and told me they'd grow, just like me. Within two years they were over five feet and yielding a fair amount of fruit. Just over eleven hundred trees, each one nurtured like a child.

I could have walked on the picker's path, but I enjoyed walking under the giant trees, the decomposing leaves covering the ground making a soft carpet under my feet. The trees now rose thirty to forty feet in the air, and I could walk with only rarely having to duck my head under the lower branches. The trees were so full, and the leaves so broad, that virtually no sun made it to the ground. In the heat of the day, it would be ten degrees cooler here.

I found grandpa where I expected, in his favorite spot under my tree. He'd always called it the *Toby Tree*. It was the first of the trees we planted together. Dad, mom, Curtis and Brent had trees named

after them as well, but they only showed a polite interest at the time. Now they showed none at all.

There were two weathered Adirondack chairs under its limbs, with old green and white striped cushions to soften them. There was a idyllic view of one of his property's small ponds, and beyond the groves of Fallbrook stretching for ten miles beyond.

He was there waiting. Somehow, it seemed he always knew when I'd come. Or maybe he just sat there all day, waiting for me to visit.

"Hello, Toby! Thought I'd be seeing you today!"

"Hi grandpa. How's the fruit doing?"

Discussing crops was a virtual religion in Fallbrook, so much so there should be a Church of the Avocado on Church Row. The commonality of the avocado in our town was enough to end any religious contrariety. Kind of like the Green Party goes religious. Grandpa got out of his chair and reached up to one of Toby Tree's lower branches, caressing a cluster of avocados.

"I'd say another week. Maybe two. No fruit better than the Toby Tree," grandpa said proudly.

He never let the commercial pickers who came twice a year pick from the family trees. That was family fruit, for us to eat or give to friends. In a good year, each tree might produce over two hundred pounds. Toby Tree was always by far the best producer, either because grandpa was right and it was a magical tree, or he just gave it extra attention.

"You're looking good grandpa." He really did. He'd reached a point where he was ageless.

He laughed. "You're not. No offense. You eating right?"

"Yeah, yeah."

"Not sleeping enough though. I can tell that. So what's on your mind. Guilt or worry?"

Grandpa's theory was that everyone should sleep with the peace

of a child. Says we force ourselves to learn how *not* to sleep. Either we do something we feel guilty for, or we allow ourselves to worry, usually over something that can't be changed.

"Both." I tried to say it as a joke, but it was the truth.

He knew I wasn't joking.

I'd told him weeks ago about Brogan and Rita's adoption, but hadn't talked to him since we learned of the missing twin, and everything going quickly to hell after that. I brought him up to date.

"Guilt is always the worst, Toby. You do something bad on purpose, you feel guilty. You do something bad on purpose, you *deserve* to feel bad. That's your punishment. So, what bad thing did you do?"

"I didn't do a *bad* thing, grandpa. But Brogan and Rita are in this fix because I didn't see what was happening. The birth mom scammed me. And I didn't see it."

"Okay. So *she* meant to do something bad. I can see her feeling guilty. But when did you become Jesus and bear the weight of all sins? No offense, but I think He's better equipped to handle it than you."

This was part of the selfish reason I was here. Before I left, he would find a way to make me feel better about myself.

"Grandpa, you know what I mean. I'm their attorney. It was my job to protect them."

"No denying how important your job is, Toby. No denying that. But you said she had a false ID? Avoided the doctor? Fooled everybody. You, the social worker, Brogan, Rita. Some pretty smart people in that group. Last I checked you were their attorney and their friend. Not mind reader."

Of course, I'd told myself all these things, but they sounded better coming from him.

He went on. "Reminds me of a divorce I handled once. Represented the wife. Never seen a woman feel so guilty and embarrassed.

Because her husband cheated on *her!* That make any sense?"

I had to smile. "No."

"You're right it doesn't, but she was just like you. Feeling so responsible, she felt the blame for the actions of others."

I knew he'd get there. I felt the guilt slipping away.

"So we're done with guilt."

When I didn't say anything, he said, "right?"

"Right."

"Okay, then. So what've we got left? Worry. What do I always tell you about worry?"

"Don't worry. Work."

"Damned straight. Worry's for pussies, excuse my language. Worry's not gonna feed the world, stop crime or teach somebody to read. Worry does squat. So, you lie in bed and can't sleep 'cause you're worrying, what do you do?"

"Get up. Solve the problem."

He laughed. "See, you don't need me. So let's solve your problem. When you go home, it'll be gone."

When I was a kid and had these conversations with grandpa, I always imagined I was Agent 86 on *Get Smart,* and the Cone of Silence descended over us, putting us in a secret world of higher thought. As I got older I didn't need the Cone of Silence any longer, but I still needed grandpa.

We spent over two hours going over every aspect of the case, every lead. This was the same way he'd convinced me to become a lawyer. Analyze. Eliminate. Analyze again. Deal with what's left.

Finally, we came up with something.

Travis's parking ticket.

Hawkes had told me the address of the citation, but I hadn't thought much about it. Now that grandpa called my attention to it, I realized that part of Main Street had nothing of likely interest to

Travis. A ballet studio, the Mission Theater, where they once showed movies but now only did plays, the library, and a row of ladies boutiques and small stores. Something there must have drawn Travis's interest. Could I find out what it was? And if so, would it help? Grandpa rarely led me astray.

He sat back and smiled, content in our shared wisdom. "So how are Brogan and Rita holding up?"

"They're okay I guess. Better than I'd be."

"I always liked those kids. You and Rita would have been good together."

"You always say that. She's married, grandpa. She lives in a different world."

"That's now. I meant then."

"Even then, she was in a different world."

Rita and I may have started out in the geek club together, but she'd turned gorgeous at some point. I'd stayed a pumpkin.

He could read my thoughts. "Only in your mind, Toby. Only in your mind."

Grandpa stood up and stretched.

"Got some 400 grit sandpaper with your name on it if you want to stick around," he said.

Actually, spending a sunny Sunday working at grandpa's place sounded pretty good. Besides, the reporters were probably still camped out at my door.

"Sounds good grandpa."

We started walking up to the house, but as always grandpa slowed down as we neared the bright sun beyond Toby Tree's canopy. By the time I turned around, I realized we'd walked too far. I watched him gradually disappear.

This was where he always left me. But I knew he'd be waiting in our spot the next time I needed him. Although he had passed away

when I was only fifteen, dying in the car accident with Rita's father—two pals heading into town for an afternoon beer—I'd never lost him in my heart.

I made my way to grandpa's house. Typical of my grandpa, his house wasn't actually a house. It was a boat. When he'd bought the land in the 60's—then considered in the middle of nowhere, it was dirt cheap. He wanted a little cabin for overnight stays when he worked the land 'til dark. His practice and home were in town, but the grove was his catharsis.

Instead of building a cabin, he bought a fifty-two foot motor yacht. A classic wood 1942 Stevens. It was to be sold for salvage due to a damaged hull and two burned out diesels. So grandpa bought it for scrap. That was when I was nine.

He had the boat trucked in, then craned into a cement cradle inset in the ground. So instead of the sea rising to the decks, there was a sloping hill of soft, green wild grass.

To me the boat was the absolute coolest place, both twenty-odd years ago and now. It was built by hand with pride, the way things were made back then. The interior was handcrafted in teak, with brass trimmings. Every inch had to be used wisely, so there were built-in sofas, cabinets and bookshelves.

Grandpa and I had spent many days after school and weekends fixing it up. Sanding, painting, varnishing. He'd bartered his legal services with El Capitan Upholstery in town, and they made all new seat cushions for the built-in sofas, an appropriate nautical blue with white trim.

In the years after grandpa died, I rode my bike over to keep working on the boat. Sometimes my folks would let me spend the night there alone. That was until I mentioned talking to grandpa, and I wasn't permitted to go anymore.

A grove foreman oversaw the care of the trees over the years

since grandpa died, but the boat became neglected. Since I'd started my practice, I had money for the first time in my life, and I'd been slowly fixing it up. Now, the outside was close to perfect. The hull was painted a gleaming white with blue trim, the rails polished, the wood trim varnished and glowing. It couldn't have looked any better when it first slid into the water sixty years ago. By the time I finished the interior, it'd be like new.

Four steps led up from the grass to the aft deck, where a blue and white striped, ten foot canvas awning provided shade to four sling chairs. There was no better place in the world to sit with a cold drink, a book in your lap, smell the trees and take in the priceless view.

The main salon was comfortably big. Since all the furniture was built-in around the sides, there was a nice open space in the middle. The galley was forward, as compact as a lunar space module. Split stairs rose up to the wheelhouse, or below decks to the two cabins. One small, the other minuscule. The diesels had been removed from the engine room aft, so it was perfect for storage. Now it was piled floor to ceiling with grandpa's old belongings. I could still smell him there among them. Or at least, something which reminded me of him.

I'd been restoring the boat, working my way up. The lower decks were pristine. Now only the salon and galley were left, and they were about sixty percent finished. Although grandpa had the boat wired for electricity and heating, I liked using hand tools. I guess because that was the way grandpa did it. When I was a kid it allowed us to talk when we worked, rather than be deafened by power tools. Today I tuned the radio to Ted Leitner calling a Padres-Cubs game, brewed some Raspberry-Zinger iced tea, and went to work.

I'd been stymied by the space under the stairs. Every inch in a boat was put to good use. But where I would expect to see a cabinet, or a recessed shelf, there was a wall. Worse, the teak paneling wasn't a perfect match to the rest of the cabin. It was a flaw that gnawed at

me every time I passed it, drawing my attention like a rough tooth.

As much as I wanted to keep the boat all original, I needed that space. I'd be perfect for a little TV, so I could watch the Padres instead of listening to them.

The panel was triangular, with each side about three feet in length. I looked for screw heads to remove—you'd never find nails in a boat, thank goodness. Quality construction meant screws. But there was nothing. That meant they were hidden under the molding around the edge, so I'd have to pry it off. I knew I'd end up damaging the wood, but I saw little choice.

It was while I was fidgeting with each molding, trying to find one already loose, that I felt it give. The entire panel moved mechanically inward, like a kitchen cabinet where the magnetic latch is depressed to both open and close. So I pushed the entire panel, first on the left, then the right. Suddenly it opened, revealing hidden hinges on one side and a small cavity beyond.

Why you sneaky grandpa. A hidden compartment.

This was cool.

My grandpa was no Stephen Weiss. I had no fear of finding porno magazines. But suddenly I was afraid of finding something bad. I'd never known grandpa to keep a secret. I almost closed the door. But I didn't.

What I saw inside was a single file.

It was a case file, with the distinctive red stamped case number on the tab which my grandpa always used in his law office.

This one said *In Re Brogan Barlow*.

It was Brogan's adoption file.

23

BACK IN MY grandpa's day the town lawyer handled about everything. There was none of the specialization common nowadays. I guess it made sense he did adoptions too. It never occurred to me he had anything to do with the legal work for Brogan's adoption. I just knew it had been approved by a small local agency no longer in business.

But why was his file here? What was inside that warranted making a hidden compartment to keep the file safe? Brogan had always lamented the closed nature of his adoption, never knowing his birth mother. With the turn of a page, that information would be in front of me.

Grandpa's will had given his law practice to dad and Uncle Charlie. His home and assets he'd directed to be sold and divided between Curtis and Brent. Instead of money, he'd left me his land. I can remember Curtis and Brent kidding me. They'd received what seemed like a fortune to them as teenagers, while I got trees.

But grandpa knew I cherished the land. And the boat. Toby Tree. All of it. Money was the last thing I wanted. Then. Now. His only way to keep the land in our family was to give it to me, knowing any other Dillon would have a *Century 21* sign up before the funeral.

So I considered the file properly mine. If I wanted to be technical, the file was still covered by the attorney client privilege, but I was an attorney and the heir to grandpa. More importantly, I just wanted to open the damn file.

The top document was Brogan's original birth certificate. In adoptions there are two. The first one is created when the baby is born. It names the actual birth mother. When the adoption is granted, that first birth certificate is sealed and a new one is created in its place, naming the adoptive parents as the biological parents, with no reference to adoption. They can also rename the baby at that time.

I kept staring at the name of Brogan's birth mother.

I *knew* her.

Brogan knew her.

He just didn't know her as his birth mother. Would he be ecstatic to finally know her as his biological mother, or feel betrayed that she had misled him? Who knows why people do what they do?

I thought back to what I knew about her and realized the hints had been there, but why would I see them? Who'd think to look?

I looked at the spot for the birth father's name. It was blank, as it often was in adoptions. Either she didn't know his name, or didn't want to state it.

The rest of the file was what one would expect. Health history information, the Petition for Adoption, the home study, the court order granting the adoption. Under the last page was an envelope. Inside was a letter to grandpa from Dr. MacGilroy. It filled in the gaps. He'd delivered the baby and helped plan the adoption, the Barlows being friends of his unable to have children.

His letter told the birth mother's story with sensitivity, and asked for grandpa's help in distorting some facts to give Brogan a fair start in life. I could see now why the file was here, and not where my dad or Uncle Charlie would have stumbled across it in his office. They'd have been young lawyers working with grandpa then.

I took the letter and put it in my wallet to give to Brogan. It was his letter, not mine. It answered every question he'd ever asked about his adoption. His birth mother, his birth father, secrets from thirty-two years ago rising up to bring his life to a new beginning. Or maybe an end.

24

I MADE WHAT seemed like my daily drive to L.A. to see Brogan. On my way out the door, I'd looked at the newspaper and saw Brogan and Rita on the front page, with an inset of Remy. An imaginative editor put a mirror image of her picture to represent her missing twin.

I had to show Brogan the letter. It was also time to talk about the information I'd learned at Stephen's. The reporters had abandoned my place, but pulling up to Brogan and Rita's I could see the media trucks and vehicles parked for a hundred yards down the street. They had brought folding chairs and sat in the shade under the trees hanging over the fence by their gate. I guess if you have to spend your day waiting, might as well be comfortable.

The Indian and I had ourselves photographed by a few dozen cameras again as we drove up to the gate. I was glad I kept the Falcon nicely waxed, and Kemo Sabe polished. They rushed en masse from their chairs to throw questions at me, but this time I ignored them and

drove through the gate.

Rita and Remy were in the living room. Remy's full attention was on the bottle in Rita's hand, but Rita gave me a tired smile.

"Welcome to the zoo," she said.

"I had a few at my place yesterday, but nothing like what you've got out there. You guys doing okay?"

"It's got to be over soon, Toby. That's the only good thing."

"I think you're right."

"Detective Hawkes called an hour ago."

"Had he been to Stephen's yet?"

"I asked him that. It was kind of weird. He didn't really answer. He just asked if we'd be here for him to come by. He seemed kind of formal."

Didn't sound like Hawkes. But maybe he was getting beat up by the press too.

"Where's Brogan?"

"He and Gina are in the study. Going over some business."

I wanted to talk to Brogan alone so decided I'd wait with my news. As it turned out, it didn't matter, since Hawkes and Ritchie called from the gate at that moment. Rita told them to come on up.

Rita adjusted the bottle. "Can you get Brogan, Toby?"

"Sure."

Brogan and Gina were discussing scripts Brogan was considering. She wasn't his agent any more, but he discussed every project with her. She'd encouraged diversity in styles, from thrillers to light comedies to romance. And in characters, from bad boy Greek playboy, to hero in a Zorro remake. So far her advice had been faultless.

We made it to the living room just as Hawkes got there. Ritchie too. That I expected. What I didn't expect were the two uniformed cops with them. I was getting a bad feeling.

"Hello, everyone," Ritchie said in a professional tone. "Mr. Bar-

low, may we speak to you alone, please?"

"Alone? Why?"

"We have some questions we need to ask you, and I think they'd be more appropriate in private, sir."

"Brogan?" Rita nervously got up with Remy and walked to Brogan's side.

What was going on?

Brogan indicated us. "You can ask whatever you want in front of them." I couldn't tell if he was angry or nervous. I'd be both. "Go ahead."

Ritchie nodded to one of the uniform cops, who pulled a card from his pocket and started reading it, although he knew the words from memory.

"You have the right to remain silent. You—"

I jumped in. *"What the hell is this?"*

"Just following regulations, Mr. Dillon." Ritchie nodded toward the cop again.

"You have the right to an attorney. You. . ."

My mind was racing while Brogan was read his rights. What had happened to make them think Brogan had done something? Did they think he had something to do with Tori's death?"

". . . and understanding these rights, do you now wish to speak to us?"

"Yeah, I want to speak to you!" Brogan almost yelled. " I want to know why you're accusing me of something. I haven't done any-thing!"

Ritchie was unflappable. "Is that a *yes*, you wish to speak to us?"

Brogan took a few calming breaths. "Yes," he almost hissed.

"And may we have permission to tape record our conversation?"

"Sure, just—"

"No," I heard myself say. "He does not give you permission to

tape record the conversation."

Brogan looked at me, surprised, but I just shook my head *no*.

"No," Brogan echoed to Ritchie.

I was no criminal lawyer, but I knew nothing good could come of being tape recorded in a police interview. The slightest slip or pause of even an innocent man could later look bad in front of a jury. Never in the history of the world had a police tape *cleared* someone, just incriminated.

I looked at Hawkes, but he was focused on Brogan. Gina was next to me. I was surprised she hadn't said anything, or clawed out some eyes. Instead I saw silent and uncharacteristic tears. It looked like she had physically shrunk.

"Fine," said Ritchie. "Mr. Barlow, can you describe your recent visits to the home of Stephen Weiss, at 304 Mulholland Drive?"

I'd assumed this was about Tori. Now I had no idea where they were going.

"Yes. I was there a few days ago. Friday night. With Toby."

We'd already told Hawkes this. What was Dillon thinking?

"And what time did you arrive?"

"About 8:45, at night."

"And left?"

"About an hour and a half later. A little after ten or so I guess."

"At any point did you enter the house?"

Damn it!

Breaking and entering was a crime, but should be of no interest to the police with murder and kidnapping all around. But I didn't want Brogan lying to the cops in a formal interrogation. Bad things usually happen when you're caught lying to the police. "Brogan, can I talk to you?"

Ritchie looked at me. "Mr. Dillon, are you here as Mr. Barlow's attorney?"

"Yes," Brogan answered for me.

Ritchie nodded to the other side of the room, where we would still be visible. "You can talk over there."

Brogan and I walked as far away as we could get. Rita stuck by Brogan's side.

"You need a lawyer," I whispered.

"*You're* a lawyer!"

"Not *this* kind of lawyer! Brogan, this is serious. How are you going to answer that question?"

"I don't know."

"If you say we stood outside waiting for Stephen, you've just lied to the police after being advised of your rights, and we don't know where they're going with this. Or you can admit we illegally entered, which is a crime. Neither one's a great option. I think you should refuse to answer any questions. Wait 'til we find out what's going on. Okay?"

While Brogan considered, I stole a look at Rita. This was the first she knew of us breaking into Stephen's. We'd told her we waited outside for him and saw Rosa. No more. To her credit she didn't say anything. Now wasn't the time. But the pain of her husband and best friend lying to her, again, was right there in front of me.

"No offense, Toby," Brogan said, "but I didn't *do* anything. I just want to answer their questions and get back to finding Remy's sister."

He didn't wait for me to argue, and headed back to Ritchie and Hawkes.

"No," he said. "I did not go in Stephen's house."

Ritchie gave Hawkes a short look I didn't like.

"And when's the last time you were in his house?"

"I don't know. I guess it would've been about two months. Maybe three."

"Detective," I said to Hawkes. "Can't you just tell us what's going on? Did you find anything at Stephen's?"

"Just a moment, Mr. Dillon," he said. "We'll get there."

Ritchie took it up again with Brogan. "When was the last time you saw Stephen Weiss?"

"That night. Friday."

"And did you speak to him?"

"No."

"So after waiting for an hour and a half, you saw him, but said *nothing*?"

"That's right. Rosa came right after him and we didn't know what was going on."

This is why you don't lie to the cops. I kept shaking my head to Brogan, but he just kept shaking his back at me, rejecting my advice.

Ritchie kept at it. "And he didn't see you waiting?"

"No, we were. . . away from the house. It was dark." Brogan threw up his hands and turned to Hawkes. "We already told you what happened. We saw Rosa! She drove up right after him. There was something going on with those two and we didn't know what to do! We already told you all this."

Ritchie looked straight at Brogan. "Yesterday we were called to the home of Stephen Weiss—"

"I thought that was set for today," I asked.

"It was," Hawkes said. "But after I called Weiss's secretary looking for him, she got worried and went over to the house. She found him and called us."

Found? No. Don't let this happen.

"Murdered," he went on. "Time of death estimated to be between nine p.m. to midnight."

Brogan had been standing, challenging in his posture. Now he sat, stunned.

I spoke up. "Detective, I was with him the whole time! Stephen was *alive* when Rosa arrived and we left! Brogan *couldn't* have killed him!"

Ritchie turned to me. "I don't know quite how you fit into this Mr. Dillon, but I'll tell you what I *do* know. Stephen Weiss was killed by a blow to the head with a golf club. There was a golf bag in his bedroom closet. The club which killed him was put back in the bag, but there was some blood residue on the club."

"That doesn't tell you Brogan had anything to do with it!"

"But it does." He turned to Brogan but he was talking to me. "He remembered to wipe the club handle—the grip—probably where he held the club to swing it at Weiss, but he forgot one spot. . ."

Ritchie mimicked pulling a club from a bag, fingers cupped under the imaginary head of the club where it would be sticking out of the bag, thumb on top where the number of the club is stamped into the steel. "A five iron, in case you were wondering."

Then he held out his thumb.

"Thumb print. Right on the bottom of the club head, not to mention all over the house."

Brogan was starting to look like a fighter in the late rounds. "I've been to his house at least five or six times over the last few years. Of course my prints are there. And we played golf in March at Oakcrest. Bill Darcy from Inkjet Pictures was with us. And Cameron Kristi, Stephen's manager. Just talk to them. I'm sure I touched his clubs then. I bet he hasn't played since."

"One problem with all that, Mr. Barlow. There are oils in fingerprints. The oils dry over time. Your prints were fresh, probably no more than seventy-two hours old. . . And you've already told us you haven't been in his house for two to three months."

The bastard actually smiled at Brogan. "You sure you don't want to put an end to all this and tell us what really happened?"

Brogan just glared. The problem was I knew how the prints got there. Even on the club. Brogan could have easily touched an exposed club head when we were searching.

"What about Rosa's prints?" I asked.

Ritchie nodded toward Brogan. "The only reason we IDed his prints so fast was because he was already printed to eliminate him from the scene at Coral Canyon. We don't even have prints for this Rosa person."

"You can't arrest Brogan and forget about Rosa! We *saw* her go in! No matter what you *think* Brogan did."

Hawkes spoke up. "We're not forgetting about her, Mr. Dillon. We'll have someone here in a few hours to go through her room and make up a set of prints. Then we can compare them with some of the unidentified ones we found."

Ritchie stood up. "None of this matters. There were no other prints on the club but yours, Mr. Barlow. I'm sorry, but it's time."

No! This couldn't be happening.

"Mr. Barlow, you are under arrest for the murder of Stephen Weiss. I need to ask that you submit to a search."

Ask was a joke. It implied he had the right to say no.

One of the cops escorted him to the wall.

"I need you to lean against it, sir."

Brogan did as told. The odd mix of life and fantasy. An early role of his as a Columbian drug runner came to mind. Arrested and jailed on celluloid, then revealed to be an undercover cop.

I watched helplessly as they handcuffed him and quickly escorted him out the door before any of us could say a word.

"Can I come with him?" I asked Ritchie.

"I'm sorry. You can't be in the black and white with him. You can follow us, but he's gonna be in booking about three hours." He nodded at us in finality and followed the uniform cops outside.

Booking put it gently. It sounded so academic. His belongings would be taken. He'd be photographed, then stripped, given an inmate jumpsuit and put in a holding cell.

I turned to Hawkes. "Why are you guys going so fast on this? Since when do you treat someone of his stature this way?

"Toby." At least away from Ritchie we were still on a first name basis. "You're in denial. He's lied to us. We've got footprints in the bushes, staking out the place. His prints are in the house, on the murder weapon. And it appears the victim had something to do with the disappearance of one of the kids. Motive."

"But—"

"Listen," he interrupted more forcefully. "There're a lot of eyes on this. The LAPD can't afford to let him stay here, then have a hundred reporters outside film him as he drives away in a white Ford Bronco. Get real."

I could see the LAPD's angle. There were too many parallels to the O.J. fiasco. The murdered beautiful young woman. The murdered man with a link to her. The celebrity accused. I hope that didn't make me Kato Kaelen.

"Is there a way you can bring him in without the press seeing him?"

"He can lie on the floor of the car, or cover his face if he wants, but LAPD's not gonna cover this up for him. I wouldn't be surprised if they make a statement to the press in your driveway."

He grimaced as he said the last, evidently not agreeing with Ritchie's high profile handling. But how else could Ritchie sell any book rights? Or guarantee himself a key role in the movie?

We made it outside as they were putting Brogan in the patrol car. He gave one last helpless look at us.

"Don't talk until I get there." I shouted. Brogan's belief that his innocence protected him had contributed to putting him in this situa-

tion. I didn't want it to get worse.

Part of me wanted to run to the TV to see how the press would handle it. I knew they'd go to live location feeds the minute Brogan was spotted handcuffed in the back of the car. There would be no way he'd duck or hide his face. He'd look them in the eye as he drove past. Would the press react as they often do, turning on a "fallen" celebrity? Or would they react with outrage on his behalf?

It mattered because I knew it was just a matter of time before they cleared this up and he was exonerated. But the taint of arrest can linger forever. That lingering doubt of "did he do it but got away with it?" It could damage not just his career, but his life. Rosa was the key, provided they could find her.

But Gina couldn't resist. When she turned on the TV, we were looking at ourselves just seconds ago, evidently filmed with a telephoto lens from a nearby hilltop. It showed Brogan being placed in the patrol car, and the rest of us watching from the door. Surreal. After playing the taped footage from just moments ago, they returned live. Hawkes was right. After Brogan was driven past, on his way to booking, Ritchie—with Brogan's gate as a backdrop—addressed the press about Brogan's arrest for murder.

Maybe I was acting like a little kid, closing my eyes to make what was in front of me not exist if I couldn't see it. Still, I turned off the TV.

"We don't have time for this. Gina, you know everybody in this town. Who's the best criminal attorney?"

She didn't have to think. "Alan Reynolds."

"Get him on the phone. We need him at the station as soon as possible."

She didn't need any urging. She practically ran to the phone, anxious to help after feeling so powerless as Brogan was taken away. I turned to Rita.

"Brogan needs some damage control. Are you up to talking to the press?"

"What do you have in mind?"

"We need the world on his side. Like now. Bring home the fact Brogan was doing all he could to find Remy's sister. Now that search has put him at odds with the law. But he didn't *kill* anyone, and he needs everyone's thoughts and prayers."

Suddenly I was a spin doctor.

I had another thought. "And bring Remy."

Shameless, using a baby. What can I say? But it'd make a better photo op.

The only way Brogan was going to get out from under the murder rap was to admit the break-in to explain the prints. That was a nothing crime anyway. He would have done that already if it would have helped, but after being caught in the lies—waiting outside and not being inside for months—it would have only made things worse at the moment. But that, combined with evidence against Rosa could turn things around. I didn't see Rosa as a killer, but what else was there to think?

Rita didn't ask questions or pause to glance in a mirror, despite knowing she was about to appear in front of hundreds of millions of people, to be replayed over and over again until a better news angle came up. She just walked out the door, Remy in her arms.

I didn't know if I'd be cut off from Brogan at the jail even as his attorney, until someone better showed up to take over for me, but I wanted to be there regardless. Ritchie was probably telling the truth that Brogan would be unreachable for hours during booking, but I didn't trust that cop.

I could hear Gina talking to the lawyer. I'd make sure he was on his way, then take off. I walked over and Gina handed me the phone.

"He wants to talk to you."

I filled him in quickly. He boiled it down to the key basics and regurgitated it back, not so much to verify it, but to get it in his head.

"So what they've got," he said, "is evidence which puts him on the scene—his own statement about being there, and the prints inside. Evidence on the murder weapon—the print on the golf club. Lying to the police about not entering, and motive—Weiss may have had something to do with the disappearance of the other baby."

I knew there was an even bigger motive. The blackmail. I was glad no one knew about that. Or at least I hoped the police didn't know.

He went on. "I assume Brogan's going to now say he *did* go into the house, probably searching for evidence for the missing girl, but knows nothing about the murder."

He was brisk and professional, but his tone implied a "yada yada yada" at the end.

"No, that's not what he's *saying*. That's what *happened*. I was there too."

"I understand."

"Do you? Listen, this isn't strategy. I was outside with Brogan when Rosa came. I could *hear* Stephen inside. He was alive when we left. *Alive*. And I was with Brogan the rest of the night. It's not like he could have gone back."

"Mr. Dillon, I've got the same goal as you. Get Brogan released as soon as possible, then get these charges dropped. I'm not saying it's not the truth. But the truth doesn't always play. I care more about what is perceived as the truth."

I guess that was the practice of criminal law. Play the truth, unless it doesn't work, then find another truth.

We agreed to meet at the jail. He confirmed the whole booking process would take several hours, then the arraignment a few hours after that. Alan said that would be one benefit fame and fortune

would give Brogan over the nobody wife-beater. They'd get him be-
fore a judge pronto instead of the next day. Just before the hearing,
Brogan could speak to his lawyer. Lawyers, if you count me. I wasn't
sure of my role now. I hoped to slide over to the one hundred percent
friend slot.

On my drive to jail, the radio stations were running big time with
the story. Combine murder and a celebrity and it automatically be-
came a lead story. Throw in a fraudulent adoption, a missing twin and
as Hawkes had put it, the equivalent of a ticking time bomb in her
brain, and it was off the media Richter scale.

Ritchie's estimate had been right. It was almost three hours before
I was allowed to see Brogan. Alan arrived shortly after me. I had to
calm my face from giving away my emotions when I saw Brogan in
the jail-issue orange jumpsuit. He needed my help, not my pity.

Brogan told Alan everything, except the medical test results he'd
taken, and the resulting blackmail. We were crowded in a small room
the size of a walk-in closet. Alan walked us through the arraignment.

"The purpose of the hearing is to see if there's enough evidence
to charge you. If the judge decides *yes*—and from our facts it will be
a 'yes,' then the issue goes to bail. We'll ask that you be released on
your own recognizance. The D.A. can either ask for bail, or that you
be held without bail. They'll argue no bail, and probably win. If they
do, we'll ask that you be held in solitary confinement, away from the
general jail population for your safety. That would be granted."

"You're saying I can't even get out on bail?" Brogan couldn't be-
lieve it.

"We'll argue for it, but the D.A. is going to talk about the brutal
nature of the crime—a golf club to the head, the fact it looks pre-
meditated, that you lied to the police about being in his house, and
with your assets you'd have the ability to just disappear."

"There's nothing we can do?" I asked.

"Well, the prints are solid evidence on the weapon, but dating them is all theory. It's too new a science. It took the courts, what, five years to trust DNA? So I don't think they'll get the dating part admitted. That'll help."

"So maybe he'll get bail?"

"I really doubt it. They still have too much. But if we lose on bail today, we can bring the motion again in a day or two, if we can cast some doubt on their evidence. Now, though, they've just got too much."

How could things have gotten so bad, so fast? A missing child was enough, but now to be fighting for Brogan's freedom.

"The court will ask for your plea," Alan went on. "Normally, I'd say it for you just to speed things along, but I want you to state your plea. When you say "innocent," I want you to say it loud and clear. Confident. Okay?"

Brogan nodded.

"I'll get permission for you to change clothes. I don't want you seen in the orangies, so I asked Gina to bring in one of your suits. You have any questions?"

"I've got about a million."

"I know. But now all we can focus on is the arraignment. You have any questions about that?"

"No, I guess not."

"Okay, I'm going to see if your clothes are here."

He left, leaving Brogan and me alone. He and I had been through so much together. But this felt like sitting at his deathbed. I had no words of comfort. I had to hope my mere presence was enough. As it turned out it didn't need to be. Twenty minutes later, things began to turn. Alan came back, excited.

"The D.A. just grabbed me. Listen. Something's up. They've got a witness. They're delaying the arraignment. I'm gonna go check it

out."

He practically ran back out of the room. Brogan couldn't leave, but I could. "Be right back."

I ran after him.

There was an electricity in the hallway. Things were happening. There were about a dozen rooms for police questioning or attorney-client meetings. A crowd of officers and detectives were outside Interrogation Room Five.

I overheard one of the cops. "They've got a confession."

There could be only one case they were talking about.

In a minute the interrogation room door opened and one of the detectives came out. In the brief moment the door was opened I could see who was inside.

It was Rosa.

She turned to look out the door and for a second our eyes met. There was only sadness in hers.

25

I WENT BACK to tell Brogan.

"She confessed?" Brogan asked.

"That's what someone in the hallway said. They said she got here about half an hour ago and has been making a statement. Alan's talking to Ritchie now."

Most police detectives would be celebrating a confession. Ritchie must be miserable. He not only made a mistake, but he did it in front of his colleagues and hundreds of millions of people. Maybe he could join Mark Furhman in the private sector.

Alan came back. He was having a blast. I'm sure he'd never had a day like today. Looked like Ritchie just lost his book deal. Maybe there was one for Alan for his short role.

"Okay," he grinned. "Rosa Wilson walked in here half an hour ago. Said she saw the arrest on TV and couldn't let you take the fall. They've been going over the evidence with her. Especially in a case like this, they need to watch out for a false confession."

"What does that mean?" Brogan asked.

"They'll ask her things only someone would know who actually did the crime. Describe the inside of the house. What the victim was wearing. How was the body lying."

"And she. . ." Brogan searched for the right word. "Passed?"

"Oh don't you worry. That lady was one hundred percent dirty."

"So. . . I'm done?"

"They've got a few hours to go with her, but yeah, by the time they're done, we're out of here."

"Thanks," Brogan said.

"Hey, easiest case I ever had," he grinned. "I assume you want me to go make a statement?"

Alan made it sound casual, but he would have been willing to get on his knees and beg for a *yes*. He'd do anything for the publicity. Now that Johnnie Cochran had given up the role as L.A.'s numero uno criminal lawyer, Alan wanted the spot.

"Sure," Brogan said. "Whatever you think."

Alan rocketed from his chair before Brogan could change his mind.

"Hey Alan," Brogan called him back. "Did she say why she did it?"

"Not that I heard. Hey, that reminds me."

Alan turned to me.

"They told me she asked to speak to you."

"*Me?*"

He just spread his hands in an "I don't know" gesture, and left.

I turned to Brogan. His eyes were starting to get real shiny. The relief must be incredible.

"I'll be back as soon as I can," I told him.

The excitement around Rosa's interrogation room had died down. They'd all run off to tell someone the new twist in this year's biggest

murder case. There was one uniformed cop outside the door.

"I'm Toby Dillon. I was told she asked to see me."

He nodded. "Hold on."

He tapped on the door, and Ritchie stuck his head out. When he saw it was me he came out and closed the door. If he felt chagrined, he didn't show it.

"Here's the thing," he said. "We've got a complete confession. She asked for you. I already told her you can't be her attorney, but she wants to talk to you anyway. We don't need to do it, but I'm going to pull everybody out of observation so you can have privacy. Maybe you'll get something to help with the missing baby."

I got it. If you lose your horse, find another one. He still had a high profile case and didn't want us to see him as an enemy. Maybe now he'd try to be the hero by finding the baby. I was okay with that if he could pull it off.

"Did she specifically ask that the meeting be private?"

"No, but since you're an attorney, I don't want to take any chances tainting this, so I'm gonna treat your meeting as if it were privileged. That okay by you?"

"Yeah, thanks. I'm ready if you are."

"One more thing. Talked to forensics earlier today. We ID'ed the hairs found in Tori Jamison's bed. Stephen Weiss. No prints, he probably wiped the place, but didn't think about hair. Looked like he killer her, then he goes home and gets it from this one." He jerked his head toward the room holding Rosa. Thought you'd like to know."

He turned and opened the door, then closed it behind me, leaving Rosa and me alone.

She looked complacent, like the stoic Indians in R.C. Gorman paintings. She actually gave me a small, sad smile.

"Rosa, before you say anything to me, I need to make sure you understand something. I'm an attorney, but I can't be your attorney.

I'm Brogan and Rita's lawyer, and if I were yours too, that would be what's called a conflict of interest."

"*Si*. I know this. I no ask for you because you lawyer."

"Then, why?"

"I ask for you because you bes' frien' Toby of Brogan and Rita."

She looked at the mirror behind me, where moments ago she had been observed and taped during her questioning.

"They watch us?"

"No. There were people there when you spoke to the police, but not now. Rosa, did you ask for a lawyer?"

"I no want lawyer. I tell them what happen."

"Rosa, you need to have an attorney. They'll give you one for free."

"*Si*. These things I know. They say lawyer is coming. Is fine. But I must talk to you."

She seemed to be in no hurry and I didn't want to rush her. I sat back and tried to relax. Or at least look relaxed.

"First, there is the things you must be telling Brogan and Rita. Okay?"

"Yes, Rosa. Rita's been very worried about you."

That brought a smile.

"You must tell Brogan and Rita I am so sorry I make all this happen. This shame. I was wanting to help, but I do this. Please ask they forgive me."

I knew there was more she wasn't telling but I didn't want to rush into it. "We thought you'd run away. You're a good person to come back, Rosa."

"I see Brogan on TV. Is no right he go to jail for what I do. I can no live with myself for this. I am to be helping, not to be hurting them."

"How did you even know Stephen Weiss?"

"I don't know him. But I know he do something with the other baby."

Where the hell did that come from? She had never even set eyes on Stephen until the party, then she never saw him again. I leaned forward.

"Rosa, how did you know he had something to do with the other baby."

"You no hear it? He was outside at the party when Brogan and Rita have the bad call from the doctor about this other baby. He swimming."

"Yes," I prompted. I still didn't know where she was headed.

"He came inside after telephone call from the doctor. *After*. He hear nothing from the doctor. But he comes inside and say 'We find her. She belong to you.' My English not real good but I hear him very good. He say *she*. How he know other baby is a girl? I am thinking he know something he no tell Brogan and Rita."

I tried to think back. I could remember that Stephen had been outside during the call. He'd come in just after, embarrassing himself with his loud chatter before he saw something was wrong. If he did say *she* I'd missed it. But Rosa was right. Unless someone heard that the second baby was a girl, no one would say "she" or "her." The natural tendency was to use the traditional "he" or even "it." Yet out of all the successful people in the room, none of us caught it. Only Rosa, the last one anyone would guess. Certainly the last one Stephen would guess.

"So what did you do?" I asked her.

"I find his address in Brogan and Rita's house. I go there to make him tell me where is the baby. I think if he not tell me, I tell police."

"So what happened?"

"I go, but he no come to the door. Music is very loud, so I go inside. He was in the bedroom. I tell him I know."

"What did he do?"

"He laugh at me, and push me in closet and say if I come out he kill me. He turn out light so all is black, but I find golf. . ."

"Club," I filled in for her.

"*Si*. The golf club. I am holding it and am afraid, and when he open door, I hit him. He fall down and is dead. I not know what to do, so I run away."

Now it was my turn to give her something, but I had to ask her something first.

"Brogan and Rita were new friends for you. Why would you do so much for them?"

"I am alone. My husband is dead now. But they act to me like a family. They very good people."

I wanted to speak gently. I wanted to say it right. I knew she was lying. Leaving the biggest reason out.

"Rosa, I've seen Brogan's birth certificate. I know you're his mother. I know he was your baby."

And she started to cry. She let them fall down her face, making no move to wipe them. She just ignored them, as if doing so would make them go away. But they didn't, and slowly her body gave in to them. I felt awkward, but I went around the table to put an arm around her. She pulled me to her like I was a life preserver.

Finally, she released me, and I moved my chair next to hers. I'd thought she looked familiar when I first saw her, but I couldn't think why. Now, as I looked at her profile, I could see why. Her features were so like Brogan's, before he'd lost his weight. The olive complexion. The almond eyes. And he was naturally obese, like Rosa, but his obsessive exercise kept him trim. I'd always seen Brogan as half-Italian because that was what I believed, but half his roles were playing characters like Zorro and Columbians. The obvious in plain sight. And inside, the same gift for math.

I'd missed the timing as well. Rosa had met Rita right after Brogan's plea to find his birth mother on *Leno*. Everyone knew L.A. Kids was the charity Brogan and Rita dedicated their time to. All Rosa had to do was become a regular volunteer and eventually she'd cross paths with Brogan or Rita. Not that she expected to be invited to their home after a few shared work days.

"You tell Brogan I am his mother?"

"Not yet, Rosa. But I have to."

The tears had stopped, but now looked in danger of starting again.

"But Mr. Toby. I do the murder. I am so bad. I cause much shame to him. Please, is bad he know. Very bad for him. Bad for me. Is best if all people just think I am Mexican lady cook."

She'd been through so much, and here she was giving up her life, all from trying to help Brogan. But I couldn't lie to her. Brogan deserved to know she was his birth mother. Not only that, but the sacrifice she was making from loving him so much.

She bowed her head with resignation.

"If you must tell him, please to tell him I so proud of him. He grow into such a good man. Rita so good too. But together, things not good for them."

I let that one go. It wasn't the time for it.

"Rosa, why didn't you tell him yourself? I mean before all this happened?"

"I want to tell the day of the party. I was going to do when the party is done. But we learn of two babies and one is kidnap. Is such a bad time to tell him. I want to find baby so much to make a happy house, so I can tell him then."

And maybe that was the even bigger reason for her going to see Stephen Weiss and try to put an end to it all with her simplistic plan. Finding a baby. Then a reunion with her biological son.

26

RITA, GINA AND Remy came for Brogan to take him home. He ducked out the back to avoid the press. Of course, they'd be waiting at home, but they could nose the car through them if he didn't want to talk. With the murder resolved, the story would remain juicy, with stories of the "Killer Cook" and "Missing Twin" running for days. But the headlines would get smaller, and be pushed deeper into the paper.

I didn't tell Brogan who Rosa was yet. He'd waited thirty-two years. He could wait a few more days. Today, the day of his birth mother's arrest for murder, didn't seem to be the best one. Besides, I had a baby to find.

My grandpa's suggestion had been a good one. Check out where Travis had got his ticket. Why would he park there? What was there for him? I'd spoken to grandpa on Sunday, when all the stores were closed, then today exploded. It kept feeling like weeks had passed, when in fact it had only been days. Tomorrow I'd catch up on my

other cases, then put on my Sherlock Holmes hat.

It started off as planned. I blew off the courts at seven, gave a lesson at eight, and made it to my office just after nine. Not counting reporter's calls, there were just three messages from Monday. The first message changed the rest of my plans for the day.

"Mr. Dillon, this is Sally Carthman with Los Angeles Department of Children's Services. I'm calling on the Barlow adoption, case number LAC 10955. I'm sorry, but I have to give you notice of an *ex-parte* motion to be heard in Department 17 at the Edleman Children's Court, 201 Centre Plaza Court Drive, Monterey Park, tomorrow, Tuesday, August 27th, at 1:30. The Department will be seeking a court determination of the validity of the consent of the minor who is the subject of the adoption, and a *habeas corpus*."

I just stared at the phone. Tomorrow was today. Tuesday.

It couldn't be. It just couldn't. There is a point where you say "too much."

The message was time stamped at 1:42 p.m. That was hours after the arrest of Brogan broke, but before he was cleared. Maybe this was all moot now, an over-reaction to Brogan's arrest.

I thought about what to do. An ex-parte motion is basically an emergency motion. Usually, attorneys have to give the other side at least fifteen days notice of any motion or hearing to give them time to prepare. Ex-partes could be given with as little as four business hours notice by phone, if there was an exigent circumstance requiring such haste. That wasn't the worst part. The second part of her message said they'd be seeking *habeas corpus*. That technically meant "free the body" in that ridiculous Latin our court system still uses. What it meant in reality was that if the court determined Tori's consent to be invalid, LADCS would be asking the court to remove Remy from Brogan and Rita, and place her in a county foster home.

I dialed Sally's direct number.

Sally picked up on the first ring."

"Sally, it's Toby Dillon."

I didn't know her well. In fact, all my previous clients lived in San Diego County, so their adoptions were approved and supervised by the San Diego County Department of Social Services. Brogan and Rita's adoption was my first experience with LADCS and the L.A. County court system. But she and I had got along well in our earlier communications back and forth in the adoption.

She sounded guilty. "Hi, Toby."

"Sally, I'm guessing, I'm hoping and praying, that your ex-parte motion was motivated by Brogan's arrest, and now that he's been cleared, you're canceling it. Tell me that's it."

A sigh. A guilty one. Not a good sign. Finally, she spoke up.

"Let me tell you exactly what's going on here. We got an amended report from the social worker, Sherry Rosman, about the fact the birth mother signed her consent to adoption using a false name, and showing a fake ID. Toby, I've never heard of something like this before, so I sent it over to County Counsel to tell us what to do."

What Public Defenders were to the criminal system, County Counsel was to the civil side. The Office of County Counsel employed lawyers to represent all branches of the L.A. County government, in this case LADCS. I kept quiet as Sally went on.

"So for the last week or two I'm talking to Willis Drake over there about it. Anyway, yesterday he tells me he thinks the consent isn't valid and we've got to bring the ex-parte. You think I *want* to do this?"

"But the birth mother's dead! Why would he want the child with a foster family instead of the Barlows?"

"Same reason we ever bring this kind of thing. Keep the County from getting sued for a few million. You know how it is."

And there was the answer.

There had been several cases over the years where California adoption agencies, both private and public, like LADCS, had been sued for *wrongful adoption*. Usually these actions are brought by adoptive parents, many years after the adoption was finalized, claiming their child had severe psychological or other problems, and the adoption agency intentionally withheld those facts from the adoptive parents to get the child placed. More recently, birth fathers who never received notice of the adoption started bringing the action. Although most claims were denied, a few had won, successfully proving the agency hid information.

"Sally, if that's the concern, I'll get Brogan and Rita to sign a release of liability. They'll be no risk to LADCS."

"That's what *I* said, Toby. But Willis made a valid point. What if the person suing us five years from now is the birth mother's mom, who decides to pop up, or the birth father, who says he was defrauded of notice and didn't know, and they bring suit that the adoption should never have been granted? And now the adoption's final and they can't get the child back."

When I first learned of the scam, I saw many issues beyond what Brogan and Rita had worried about. This had been one of them. I'd hoped the issue would not occur to LADCS.

"Sally, I'm gonna eat this guy for lunch."

"Toby, between me and you, I hope you do. This is BS as far as I'm concerned." She may have been a county employee, but she was still a social worker whose first concern was children.

My next call had to be to Brogan and Rita. I assumed they were sleeping. They *should* be after yesterday, but I had to have them ready. These types of motions were founded solely on legal grounds and involved no testimony from witnesses, so Brogan and Rita wouldn't take the stand to testify. Emotionally, however, it was per-

suasive to a judge to see the adoptive parents there, having to look them in the eye for any adverse ruling.

Rita picked up part way through my message on their machine. I explained everything. What she should have done was scream at the top of her lungs. She needed to. She deserved to.

But instead when I was done, she calmly asked, "Toby, how worried should we be?"

I should have been honest and told her I didn't know, that from my knowledge, their case was the first ever in California—anywhere as a matter of fact—where a birth mother placed a child under a false name, and then died or was killed so no new consent could be signed.

But I couldn't take worrying her again. Or maybe *I* was the real issue. I was the high school quarterback who wanted to impress my best friend and the cutest girl in school and guarantee a victory.

"We're going to win, Rita, but I need you and Brogan there." I told her the when and where.

"Should I bring Remy?"

I was afraid she'd ask that.

"No."

"Why? With everything going on, I haven't wanted to leave her with anybody."

The real reason was if they lost, the court could order the baby transferred at that very moment. But if the baby was not there, the court would give a reasonable period to make the transfer. This would give us time to file a writ to appeal the decision. But I couldn't say that. Instead I said something stupid.

"Because they don't allow children in court."

"But it's adoption court."

"Yeah, well. I've heard this judge doesn't like babies."

How stupid did that sound?

"Well, okay. We'll meet you there at one."

My next call was to David Bottomly. He was an adoption lawyer in Los Angeles I'd crossed paths with. He'd been in the business for about twenty years and knew every judge in Los Angeles. When you have a contested motion, attorneys always like to check with other attorneys to learn any idiosyncrasies about the judge they'll be appearing in front of.

David started with, "Saw you on TV! Getting a pretty high profile there aren't you, kid?"

"Give me a break. I'll be a nobody again in a few weeks. I hope. Listen, I've got to appear in Department seventeen at the Children's Court up there. Can you tell me who that is?"

"Must be a contested matter you've got."

"Yeah, why?"

"We've got two judges who handle the adoption stuff up here. Martinson does the simple stuff—the finalizations. He likes posing for pictures with the adoptive parents and all that stuff. Real softie. Gives out teddy bears to the kids in court."

"And the other?"

"Davinov is in seventeen. He likes the litigation. Smart guy. Hates chatter. Wants it short and fast. Tends to lean toward attorneys he knows in close cases. Who you going against?"

"County Counsel. Guy named Willis Drake."

"Ouch. He's good. Worse, he's litigating stuff in seventeen all the time. Davidov's gonna assume he's right unless you got something strong to come back at him with."

"Anything else on the judge?"

"Let's see. . . it's reported he's gay but in the closet. Jewish. Immigrant parents from Russia. Put his own way through law school. Registered Republican. So now you know what jokes not to make. . . Likes dogs. Plays golf. Eats Chinese food for lunch everyday."

I thanked David. At least some of the information helped. Helped

me feel nervous that is. And now I knew to avoid any gay, Jewish, Republican jokes. As if I had some planned.

Here's the thing. I'm reasonably smart and I know adoption law well. But I'm not a trial attorney. Most attorneys aren't. Ninety percent of all attorneys never set foot in a courtroom. They spend their day pushing paper, and if they work for my dad, making one minute phone calls.

County Counsels worked in court all day. They were litigators. My trial experience came from watching reruns of *Matlock* and *Perry Mason*. When I went to court, it was to finalize adoptions. That consisted of handing the judge the Order granting the adoption, then posing for pictures with the adoptive parents.

More was going to be expected of me today.

27

THE LOS ANGELES County Children's Court, named the Edelman's Children's Court after a long-serving County Supervisor, was like a bus station. A nice one, but still a bus station. There were six floors, with six courtrooms per floor. Each floor had a huge waiting area, divided into seating clusters. Instead of the loudspeaker calling out departures for Boston, Albuquerque and Portland, they called out cases and courtrooms.

Most of the parents here should be shot, or at least spanked. They had been cited for neglecting or abusing their children and were under court supervision to reunify the family if possible. Only a small number of families were here for adoptions. They sat in the corner trying not to look scared, away from the child-beaters.

At least LADCS had more class than the LAPD. There was no press here. Technically, due to the confidentiality of adoption proceedings, they couldn't release any information. But things get leaked sometimes anyway.

I checked in early with the court bailiff and was told we were the only matter set on the judge's afternoon calendar, so he'd call us when the judge was ready. I thought it was good we were the only case on schedule. Likely the judge had the afternoon planned for something else when LADCS made him stay late for their ex-parte, so maybe he'd be ticked at Willis. The only people who work less hours than tennis-playing adoption attorneys are judges.

One point to me before we even got into court.

I looked outside for Willis Drake. Sometimes you can work out a compromise before going into court and avoid the hearing. I'd tried to reach Drake on the phone earlier but had been told he was in court. He didn't call back. Now, scanning the hundred or so parents, children and attorneys, I didn't see anyone that resembled him. One of David's few comments about Drake beyond he was good at his job was that he was a gangly six foot six and usually wore mismatching clothes. Considering Public Defenders were the closest thing to County Counsel, the clothes part made sense.

I was still looking for Drake when I heard the loudspeaker. "Parties to Department seventeen on case number LAC 10955." I gave up finding him and went to the attorney lounge where I'd directed Brogan and Rita to meet me. Unlike the criminal courts and civil courts in L.A., the Children's Court made special arrangements for high profile people. They have special "media free" entrances for them, with a private place to wait.

It was in the attorney lounge that I found Drake, kibitzing with my clients. Technically, attorneys were never supposed to speak to the opposing parties without their attorney's permission. But he seemed to be more interested in what Julia Roberts was really like than seeking any damaging information to our case. Not that there was any. If this guy had any class, he'd see something wrong with chatting them up, then asking the court to remove their child from

them.

Brogan and Rita looked fairly calm. I didn't know if that was be-
cause of my fibbing to them about the fact we were sure to win, or
their simple exhaustion from yesterday's murder arrest and release.

I introduced myself to Drake, but there was no time to try any
pre-court finagling with him as I'd hoped. The judge's bailiff fol-
lowed me in and barked at Drake. "You want your ex-parte or not?"

We entered the courtroom to find Judge Davidov seated and wait-
ing. He had a wild shock of gray hair with huge eyebrows and wore a
wrinkled robe. I'd never seen him before so I didn't know if he al-
ways looked this way, or we woke him from a lunch-time nap.

"Nice of you to join me today counselors," he said sarcastically.
"Appearances for the record, please."

Drake and I stated our names and whom we represented.

"Not often I get many movie stars in my courtroom," he said,
turning to Brogan and Rita. "Department nineteen gets the easy ones
you know. Michelle Pfeiffer, Steven Spielberg. All the celebrity
adoptions. I get the pedophiles and kid beaters."

I don't think Brogan or Rita knew what to say to that. *Thank you
for being here even though we aren't pedophiles?*

So, instead they said, "Thank you, your honor."

"And congratulations on the dropping of the murder charge, Mr.
Barlow. Planning a nice false arrest suit against the LAPD, I imag-
ine?

Jeez. This guy was chatty.

"No, sir. Actually, I'm just glad to have it over with."

"Hmm. Well, I guess you don't need the money." He turned to
Drake. "Okay, Willis, it's your ex-parte. Go ahead."

I didn't like the "Willis," but what could I do?

"Your honor," Drake began, "It is with no pleasure that the De-
partment brings this action, but as a matter of law, it is critical to

determine the validity of the consent of the birth mother of the child who is the subject of this adoption."

"Objection, your honor," I said. "Counsel is wearing polyester pants."

Okay. I didn't say it. But I thought it. I hadn't seen pants so lacking in wool content since The Partridge Family. And David had been right about his color coordination. Today was gray pants with a gold sport coat. I could swear I could see the stitching that used to hold the *Century 21 Real Estate* patch. His tie had little dogs on it, playing to the judge's reported dog interest.

A point to Drake.

"We have a consent to adoption for this minor signed by Samantha Helen Burroughs," he went on. "It was subsequently learned that in fact that was not her name, her actual name being Tori Lynn Jamison. The court is aware of the fact Tori Jamison has been murdered, so there can be no re-execution of the consent. The result, your honor, is an invalid consent based upon fraud. And without a valid consent, Mr. and Mrs. Barlow cannot legally have custody of the minor. This is not only pursuant to the Family Code, but well established legal authority regarding fraud."

Hearings are pretty relaxed and we were all seated at our respective counsel tables. Drake now sat back.

"Done, Mr. Drake?" The judge asked.

"I've got more, your honor, but I'd prefer to take it an issue at a time if it please the court."

What that meant was, "I want to see how you rule on this one before I decide what approach to take on the others." That was okay with me.

I stood up. "Your honor, first of all, I'd like to register my displeasure over this matter being brought as an ex-parte. The court is well aware that ex-partes are reserved for emergency procedures.

Here, the consent Mr. Drake speaks of is the same consent it was seven weeks ago. He himself has known of it for more than a week, yet he forced my clients into court with only hours notice to discuss the removal of a member of their family."

I said this because judges like fair play between lawyers, or at least, the appearance of fair play. Plus, we were the only matter on his afternoon calendar and the judge was here and not golfing because of the motion. I wanted to remind him of it.

The judge made a frown and pointed it at Drake. A point for me.

"But we're here," I continued, "and I'm not going to ask for a continuance to fully brief this point. That's because I believe this court will need about two minutes to determine the ex-parte is meritless."

I was counting on David's comment that Davidov liked us to be brief. Plus, judges tend to listen better if you tell them in advance they only have to pay attention for a minute or two. Sure enough, I saw him sit forward a little.

"Let's start with Mr. Drake's reference to the Family Code."

One of the dinner table tidbits I'd picked up from my dad was that when your case had a weak point, address it as if there is no doubt it's in your favor, and barely talk about it. It's like liars. Good liars offer nothing. The bad ones keep explaining and explaining.

"Mr. Drake is completely right that fraud vitiates an adoption consent. . ."

I learned about ten big words from Uncle Charlie. He called them his legal buzz words. Words no one uses but lawyers and judges. Vitiate was one of them. Thanks to Uncle Charlie I knew it basically meant to cancel something.

". . . but a review of the case law interpreting that section tells us that it is actually referring to fraud by *adoptive parents*, not a *birth mother*. To look at it as Mr. Drake is asking would be to reward a

birth mother for committing fraud, then allow her to cancel an adoption. Common sense tells us that canceling a consent would make sense if adoptive parents lied to a birth mother to induce *her* to give up *her* rights. *But the other way around?* Punish adoptive parents for someone trying to defraud *them*?"

I paused to subtly give a disapproving look at Drake. He hopped up.

"Your honor, I object to counsel's characterization. He—"

"Sit down, counsel. Continue Mr. Dillon."

I bit back any hint of a smile. "Counsel's other point is the nature of the fraud itself, signing the name of another person. This is even *more preposterous* than his first point. . ."

I could be making a mistake being too aggressive, but the judge was leaning my way and I wanted to keep pushing.

". . . Here's why. We *know* who signed the consent. Tori Jamison. There is no dispute about that. She was the minor's birth mother and she signed the consent. It doesn't affect the consent because she signed something other than her name. Let me give an example. It is well established throughout legal *history*. . ."

Actually I had no idea if it was completely true or I was stretching, but it sounded good at the moment.

". . . that a party could indicate their agreement to a written document by making an *X* in place of their signature. This could be due to being illiterate, injured or other reason. But was their name *X*? No! So the fact that Tori Jamison, who was the appropriate person to sign the consent, did in fact so sign, but wrote another name, does not in any way invalidate the consent. It was, and is, an irrevocable consent."

This was going way better than I expected. Maybe I shouldn't have been afraid of trial work after all. I had a few more points I'd researched, but I liked the way the last line came out, so I sat down.

Davidov scrutinized me and my confidence started to melt. A question was coming my way. If he bought my argument, he'd be asking Drake for authority to back up his argument.

"Mr. Dillon. Are you by chance related to Stuart Dillon, out of San Diego?"

That sure wasn't the question I'd expected.

"Yes, your honor. He's my father."

"Ahh. A good man. Met him at the Siberian Husky Rescue Foundation. Quite devoted to the cause, he is."

Way to go dad! As I recall that donation had been half a mil. I don't recall the dog fancying judge he was trying to influence, but this was a nice little side benefit. Another round to me. These were adding up. Drake would need a knockout to take us.

He turned to Drake. "You got anything else?"

Drake spoke with less enthusiasm than before, going through the motions. "Your honor, we know she lied about herself. It therefore seems likely she also lied about the birth father. How can we, in confidence, terminate the unknown father's rights, when someone else could be the birth father? It puts the entire adoption at risk."

It wasn't a bad point. I'd thought of it myself when I first learned Sammy wasn't Sammy.

Davidov looked to me. "Mr. Dillon. You have any thoughts?"

"Yes, your honor. Mr. Drake has an excellent point. . ."

Another of Uncle Charlie's little wisdoms, always credit your opposing counsel when it costs you nothing. It makes you look more credible, and your disagreements more viable.

". . . But isn't that true in every adoption done in this state? Or any state? A huge number of the pregnancies resulting in adoption are casual encounters in which the birth father isn't known. That's one reason why they end up being adoptions. There's no father to help with the baby. The reality in all these adoptions is we have no

choice but to trust the information provided. If we throw out Tori Jamison's identification of the birth father, perhaps we need to throw out every birth mother's identification of an unknown father. But I've got a question."

I turned to Drake.

"This adoption has been in the news more than any adoption in history. Tori Jamison's name has been in every newspaper and TV show in the U.S. and around the world. So, I ask you, how many men have come forward to say they are the birth father of this baby?"

I knew the answer of course. I would have got a frantic call from LADCS the minute such a call came in.

"Ha!" Davidov actually barked a laugh. "Mr. Drake? How many?"

Drake sighed. "None, your honor."

The judge stood up. "Mr. Drake, Mr. Dillon, I believe we're done here. Motion denied."

He strode from the room. I couldn't help but wonder if I'd won because of my legal arguments, or the Siberian Huskies. Not that I cared.

Drake probably handled ten contested matters a day, so this loss was no big deal for him. For me though, it was my first contested matter. I'd never scored a touchdown in football, or hit a home run in baseball. Now that I thought about it, I never even won a match in Chess Club. This was as close as I'd ever come to the Thrill of Victory.

Drake walked past with a courteous nod and "Good day, counsel."

"Good job, Tobe." Rita said as she put her arm around me and gave me a hug.

"Yeah, way to kick some government ass, Toby," Brogan said.

It was the first thing I felt I had done right in an entirely botched

adoption. Grandpa started the wheels in motion of guilt obliteration. Now I was slowly purging myself of it by doing what I could.

Work, not guilt.

"We never got to celebrate yesterday together," Rita said. "How about you come on over and we can have a double celebration?"

I wanted to, but if I was alone with Brogan, I'd have no excuse not to tell him Rosa was his birth mother. So I did the cowardly thing, and avoided being alone with him. I hated the idea of hurting him.

To learn the identity of his birth mother, then realize she was a murderer, wasn't information I wanted to share. And what of his self-identity? He'd been raised with a fantasy. His mother wasn't Italian. She was Mexican. An illegal immigrant who had likely scraped out a living working farms and cleaning houses. Was there anything shameful in that? No. And there was no prejudice in Brogan, but part of who he was would now be a lie.

I could see why his parents made up the story when they adopted him, thinking it would be for his own good. If his birth mother was Mexican, his light olive complexion and facial features meant his birth father was an Anglo. Back then, to be the half-breed child of one of the migrant laborers would brand him. Limit him. Alter people's perceptions. Especially in Fallbrook at that time when the unspoken caste system was in place between the Anglo landowners and the virtual slaves who worked for them. But make him half Italian and it would be fully accepted, maybe even add a touch of the exotic. And it would explain the olive complexion, the dark eyes and hair.

So I heard myself say no. "Thanks, guys, but I've been neglecting too much at home. I gotta get some work done. Do you mind?"

"Of course not, Toby, " Rita said. "But soon, okay?"

"Okay."

There was another reason I didn't want to go. I also had to tell

Brogan I knew about his medical file at Stephen's. I had to make him tell Rita, and he'd hate me for it. I could accept what I'd learned, but could he accept me knowing?

I was afraid I was about to lose my best friend.

28

MY PLAN WAS to wake up today—Wednesday—help Lars with the morning clinic, then head to the office and get some work done. Of course, that was yesterday's plan, and the day before that. For a change though, everything went as planned.

By two o'clock I was ready to follow my hunch about Travis. I parked in front of 2154 North Main Street, the exact site of Travis's ticket months ago, and looked around. Fallbrook's Main Street was charmingly dumpy in parts, a bit chic in others. Fallbrook had more than gentlemen farmers. It also had a small artist colony, attracted to its greenery and easy pace.

I was directly in front of *Chubby Chicks*. It sold the ridiculously boring and useless things women found essential: scented candles, potpourri and plaster statuettes of angels and dogs, although usually not in the same statue. To the right was *Fallbrook Trophy*, *Bitchin' Stichin' Embroidery, Old Town Sports* and *Bob the Barber*, whose advertising slogan was "We'll cut your hair in five minutes or it's

free!" To the left was *The Breadbasket*, a restaurant that served soups and stews in hollowed homemade bread, the *Fallbrook Art Gallery,* the *Yogurt Palace* and the closed *Mission Theater*.

None of the stores seemed too promising as a place of interest to Travis. I thought I'd start with the most likely—the sporting goods store, and try to eliminate them one by one. If I had time, I'd try the other side of the street.

I brought both the DMV photo Hawkes had given me, and the police sketch showing Travis's longer hair. But several stores later, no one remembered him coming in. Of course I realized he could have come in and they wouldn't remember him, but what else did I have?

Work, not guilt.

Even if the work is futile, grandpa?

I knew I was doing this for myself as much as for Brogan and Rita. My last step to earning a good night's sleep. I didn't really expect results, especially now that I was here doing it, seeing blank faces.

But still, I was diligent. If a store had employees who had been working the day of Travis's ticket, but weren't there when I came in, I planned to come back tomorrow.

When I got home, I rewarded myself with three sets of tennis. A couple of older club members had brought their vacationing niece and were playing doubles on one side, singles on the other, since her partner was a no show. Part of the job of the assistant tennis pro was to keep the members happy, so I stepped in and had a good time. The niece was twenty-eight and recently graduated from med school, starting her internship in San Diego. I took a chance and asked her out. I got a polite *no,* although her uncle made it all better by pointing out some pigeon poop on the court for me to clean up.

Rita called me the next morning. Said she'd be down my way today and could she come by for a quick "hi." I'd planned to finish up

my Sherlocking on Main Street first thing, but was happy to put it off until Rita came and went.

She got to my place at eleven. I knew right away something was wrong. Of course, there was plenty wrong. Still a missing baby. A husband arrested for murder then released, a murdered birth mother, a murdering cook, a LADCS attempt to take away the one child she did have. I mean something *else* wrong. And she didn't even know about the blood tests showing the curse in Brogan's veins, and as his wife, in hers. It was literally criminal not to tell her, but I didn't see how a few more days would matter, and it had to come from Brogan.

"I was going kind of stir crazy," she said. "I told Brogan I just had to get away for awhile. I hope you don't mind it's with you."

Rita was as good a friend to me as Brogan, and I never allowed my mind to wonder how our lives would have been different if I'd had the courage in our early years together to ask her out, before Brogan did. But I'd been fearful of jeopardizing our three-way friendship—or maybe there was nothing truly valiant about it, and I was just afraid of sharing my true feelings. Turns out our friendship stayed just as strong, but with me as the odd man out, in the romance department anyway.

I knew Rita didn't come just to hang out with me. She just wasn't ready to tell me why.

"I don't want to mess up your day," Rita went on. "Have you got something going?"

I filled her in on my detective work yesterday and my plan to continue it today, even though my expectations were low. She thought it was a great idea and asked to join me. So off we went, although she asked if we could take her car. This implied dangerous shades of anti-Falconism, but I said okay.

On Main Street I took yesterday's parking space.

"Oh, *Chubby Chicks!*" she exclaimed. "I love this store. I haven't

been here in years!"

I shook my head. Even the best women.

I gave her the police sketch of Travis and kept the DMV photo for myself. We agreed she'd go back over the stores to the left, while I'd take the right. Fifteen minutes later we'd both drawn a blank. Across the street, taking up the entire block, was the library, set back from the street behind a large parking lot. That would be our last stop, and we headed across the street.

"Can you remember how much time we used to spend here?" Rita asked.

I did. The local library was more than a place to borrow books, it was a meeting place for locals. You could take the newspapers or magazines the library subscribed to and sit on the benches outside, and read in the sun. That was where Brogan and I would check out the new car mags each month, and where we saw a picture of our first topless woman in *National Geographic*.

"Remember Mrs. Gorny?" I asked.

She laughed. "Horny Gorny. How could I forget. Is she still brushing up against every teenage boy in Fallbrook?"

"Boy. Man. Senior."

"Oh, Toby. I forgot how much I loved this place."

I stole a glance at her. She wasn't being sarcastic. Fallbrook would always be a big part of her and Brogan.

We were delayed cutting through the library parking lot by two girls wanting Rita's autograph. Rita, as always, was amazingly patient. One of the girls looked at me.

"Are you anybody?"

"No."

"Oh."

We finally made it to the cool confines of the library.

"My God! There she is." Rita spotted Horny Gorny.

No matter how much room was left in the aisle behind you as you looked for a book, she would find a book which needed reshelving right in front of you, and would squeeze herself in for the job. As she'd gotten older she'd expanded her brush-backs. In my day only high school boys got the treatment. Now it was any walking male. At seventy odd years she wasn't about to be picky.

"Hello, Toby. Rita." She said it as if she saw us every week. Of course, she did see me every week, but Rita hadn't been there for fifteen years. Without a winkie though, Horny Gorny wasn't going to get excited about somebody.

"Hi, Mrs. Gorny," I said. "I was wondering if you could help us. Can you see if the library issued a card to someone named Travis Benton?"

"You know I can't give out that information, Toby. Those records are confidential. You're a lawyer. You should know that."

Yeah, like I spend my free time studying the library section of the Government Code. Even my life isn't that pitiful.

"Well, how about this then. . ." I pulled out the pictures of Travis. "I'm sure there's no law against telling us whether or not you've seen somebody. Do you recognize the guy in this picture? It would have been a couple of months ago."

It wasn't as unlikely a question as one would think. Unlike the stores along Main Street, where tourists dropped in, the library was only used by locals. A visitor would stand out, especially to Horny Gorny, at least if we were talking about a male past puberty but not yet using a walker.

She took the police photo. "Oh yes. I *do* remember helping him. Such nice *broad* shoulders. Why do you ask?"

"We think he may have had something to do with the missing baby." Of course, everyone knew about Brogan and Rita's adoption, especially in Fallbrook. "It may help to know what he was looking

for here."

"Oh, my. Let me think. I know I'm not allowed to discuss what someone checked out, but I don't think that rule would cover what he just *looked* at. Do you?"

I gave her my most lawyerly look. "You can definitely tell us what he looked at."

She nodded. "Well, as a matter of fact, I do remember. He was having trouble using the card catalog system on the computer and asked me for help. Follow me, I'll show you what he was looking for."

She came out from behind the counter and led us to a back aisle.

"Up there," she pointed to the top row. "The big hardback."

I reached for it but before my fingers could grab the spine, she wedged her hip into my pelvis, pushing me backwards. Or should I say grinding. At least my belt buckle now had a nice polish.

"No, I was wrong," she said. "It's this one."

The book she took down was *Campgrounds of Southern California*.

"Did he say what he was looking for in it?"

"No. But he did sit and look at it for awhile. Didn't reshelve it either." Her tone made it clear even the ownership of a winkie didn't excuse that.

Rita and I thanked her and sat at one of the reading tables. The book gave a one or two page description of each campground in Southern California. He'd sold his camper van. Could he have bought another and be hiding in a campground? That'd be a good place to keep a low profile.

We were thumbing through the book when Rita inhaled sharply. "Look!"

A page had been torn out so cleanly that I hadn't noticed, but the gap in the page numbers gave it away. Only a stranger to Fallbrook

would risk the ire of Horny Gorny and rip a page out of a library book.

We needed to figure out what campground was on that page, but the Table of Contents just divided the book up by County. At least it told us the campground was in San Diego.

"C'mon." I got up and headed for Horny Gorny.

I showed her the torn out page and waited for her breathing to return to normal.

"Mrs. Gorny? Can you call another branch that has this book and find out what campground is listed on the missing pages—one-eighty-nine and one-ninety?"

She checked her computer to see who had it in stock then got on the phone. She was back in a minute with a piece of paper.

"Ross Creek Campground, in Valley Center," she said. "I wrote down the address for you."

We were in the car and on our way within two minutes.

29

THE CAMPGROUND WAS on Gopher Canyon Road, about ten miles south on the I-15. I knew the road, but not the campground. It was a winding narrow road which snaked far into the canyon.

There was a small off-brand gas station at the exit, *Jack's Gas, Food and Stuff.* I went into the small food store and asked about the campground. The guy said it was about thirty-five minutes down the road.

"Just past the rock looks like a bunny," he added.

The road was winding and slow going. Probably if we were using our heads, we'd call the police to check out the campground. But it didn't even occur to us. I don't think either of us really expected any success, but it was keeping us busy, following any lead.

"Toby?"

"Yeah?"

"If I ask you something, will you promise to give me an honest answer?"

"Of course."

"Are you sure? It's about Brogan. I know you're best friends. I don't want to put you in an awkward situation."

"You're a best friend too, Rita."

"I know, but you and Brogan. . . Anyway, if you can't be honest with me, it's okay to just say you can't answer. But don't lie. Okay?"

"Okay. I promise to tell you the truth."

She took a deep breath. I was finally going to hear what I'd felt she wanted to ask since this morning. I'm sure it was actually the reason she came down.

"Toby? Is Brogan with someone else?"

"No. Not a chance." I answered without thinking, by reflex. I'd have staked my life on his loyalty to Rita, at least I would have until a few days ago. But his file at Stephen's changed things.

"You didn't even think about it."

What could I say. "All I know is he's never loved anyone but you. Ever."

She was quiet for awhile. I could see her biting her lip.

"Toby. He doesn't make love to me anymore. I mean, never."

I hated to be talking about Brogan behind his back. But I was talking to my other best friend.

"How long are you talking about?"

"Two years."

Two years. Not a month or two or three, a husbandly preoccupation with work, stress, or same ol', same ol'. Two years. That was when the tests were dated that Stephen had hidden. Likely he told Brogan about them right away.

When I didn't reply, she went on.

"I just don't know what to do. I don't know what's in his mind. I just. . . I don't excite him any more, sexually. In the morning, when he's asleep, sometimes he gets, you know. Hard. And I'll climb on

top of him and put him inside me and. . . he just wakes up, looks at me, and. . . loses it. Like he can but doesn't want to, at least not with me. . . I feel so ugly, Toby. And even when he kisses me, it's not like he used to."

Her voice was breaking but she wasn't crying. She'd probably had this conversation with herself too many times to break down finally saying the words out loud.

"What should I do, Toby? He's so kind and loving to me in every other way. But he's not a husband anymore. I don't know what to do. I want him back so bad!"

"Have you talked to him?"

"I've tried, but. . . sometimes he gets so mad about it he gets up and slugs the wall, or storms out. Sometimes he just cries. But he won't talk about it. Just says to 'give him space.'"

I'd promised not to lie. I knew why he couldn't make love to her, but only Brogan could tell her. Should tell her. But she didn't ask me what was wrong. She asked me for advice. So I could answer without having to lie.

"I don't know what you should do. Can I talk to Brogan about it? Get him to talk to you?"

"He'll hate me for telling you."

"No, he'll hate *me* for knowing. I'll come up in a few days. Okay?"

She nodded. "Yeah. That'd be good. Thanks." Then she tried to make light of it all. "Of course, I'd expect nothing less from the Pig King."

The Pig King: Ruler of All Things Swine. I hadn't heard that for sixteen years. In spite of everything, it made me smile. As kids, and into our teens, our 4-H group would caravan our dented campers and

spend a week at the San Diego County Fair. The Fair would attract a total of more than three million people, most of them coming for the arcades and rides, and to eat from the limitless junk food eateries lining the half mile stretch all the way from the entrance to the carnival section. For us though, we were there to show the animals we'd raised since Spring, compete for ribbons, and auction our animals to pay for the animal and feed, and turn a small profit.

When we weren't taking care of our animals, we were free. Friendships were born, risks were taken, romances were begun, boys turned to men and girls to women. At least we thought so at the time. The Fair covered six square miles and we knew every inch of it. It was our ninth Fair. Brogan, Rita and I were sixteen. It would be one of more discovery and adventure than ever before.

There were five giant barns to house the animals, each one big enough for a football field. We'd put up temporary six by six foot stalls to house our animals. With about three hundred pigs in the barn, cleaning the stalls every few hours was a necessity.

Brogan and I were finishing just that when Rita walked over from the sheep barn. She ignored the gate and nimbly hopped over the three foot fence to give my pig a nice scratching behind the ears. Rita looked up at the blue ribbon I'd just hung up above the stall.

"I knew she was gonna blue," Rita said.

"Yeah, why don't you keep her and breed her?" Brogan asked. He leaned against the low chain link enclosure, and his fat stomach pushed through the rectangles. I wanted to remind him he pinched himself pretty badly doing that yesterday, but I didn't want to say it in front of Rita.

Brogan came into the enclosure with us with a smirk. "Speaking of breeding, you ask Rebecca to the Close Out dance yet?"

"Brogan!" Rita gave Brogan a punch in the arm.

"Yeah." I tried to sound casual about it, but Rebecca was a cute

girl and I wasn't exactly Dating Central. It was actually what I'd call my first date.

Brogan grinned. "She's pretty hot."

Rita hit Brogan again, harder. "Stop it! That's not very nice. Rebecca's a nice girl." She put one arm around Brogan, and now she draped the other around me. "And Toby's an even nicer boy."

That picture of us in the pig pen perfectly summarized our friendship. Brogan my best friend. Rita Brogan's girlfriend. Me a best friend to both. While Brogan and I rubbed our pigs' necks, Rita rubbed ours.

"How 'bout if I ask my dad if I can borrow the car?" Brogan said. "The four of us could go down to the beach after the dance."

"Oh, I don't know." I was nervous enough about the dance. Moonlight on the beach with a girl seemed like advanced dating to me. "Maybe we'll just stay here. Check out the midway."

"I think we should all stay here too," Rita said. "We can go to the beach any time. Tomorrow'll be our last night here."

Her eyes widened mischievously and she reached into a back pocket. "I almost forgot, Toby. Made you something."

It was a cardboard headband with a drawing of a pig's head on the front. She'd written "Pig King," in bright letters, and below it "Ruler of All Things Swine."

Brogan cackled as Rita ceremoniously placed it on my head like a crown. "In honor of your contributions to the swine kingdom, Mr. Blue Ribbon Winner."

"I will wear it with pride." And I did, for the rest of the day.

Brogan and Rita decided to take off. I was stuck there for awhile. We all took turns on barn duty, assigned two hours shifts to guard the animals from people wanting to feed them popcorn or pizza, and answer questions for Fair visitors. I'd traded my time yesterday so today I was stuck with both morning and late night shifts.

None of us minded answering questions, but we got tired of people always asking us how we could raise our animals knowing they'd end up going to the butcher. These same people usually asked the question with a bacon cheeseburger in their hands. We were all raised on farms or ranches. We loved our animals, but we knew where dinner came from.

That night Rita and I had barn duty. We had the ten to midnight shift, when the Fair would close. By eleven, the barns were empty of Fair-goers and we had it completely to ourselves. There were bales of hay in the corner, a good place to lay back and relax and watch over our animals. Rita's legs stretched out forever from her shorts, long and narrow like a young colt's.

"So, are you really taking Rebecca to Close Out tomorrow?"

The last night of the Fair was a dance just for 4-H kids. Brogan and Rita were going together. After three years of semi-denial over their attraction, the harsh words of Rita's father were fading.

"Yeah."

"She's a nice girl, Toby. You two want to hang out with Brogan and me?"

This was Rita's way of saying she knew how shy I was and I could take the heat off myself by hanging out with them.

"Yeah. That'd be nice. And thanks for nixing the beach idea."

"I had the feeling you were uncomfortable about it. So, Toby. . . Are you going to kiss her?"

She asked it playfully, but also with real interest. Brogan had joked about sex. That was a laugh. I hadn't even french kissed yet. I was actually pretty nervous about it. It seemed like this was a skill I should have learned by now.

I grinned. "Maybe."

Actually, I had done nothing all day but rehearse in my mind how I would lead into the kiss. Getting my face to hers seemed the most

awkward of moves, but everyone around me was doing it, so it must be doable. Once there though, at those lips, I wasn't too sure about the tongue part. What if I messed it up and she started laughing? Or what if she'd never done it before either, and we each did it wrong to each other? We'd irreparably taint our kissing abilities forever, never knowing we were doing it completely wrong.

"Have you ever tongue kissed before, Toby?"

With anyone else I'd lie. With Rita I wouldn't. If everyone had a Rita, there'd be no wars, pestilence or famine.

"No."

"Are you scared?"

Shitless.

"Sort of. Yeah."

"Toby?"

As I turned to look at her, she did it. She put her face to mine as easily as they did in the movies. Her mouth was open and she gently touched my lips. Then she softly pushed her tongue inside.

Holy Mother of God! I was doing it! I was actually putting my tongue in the mouth of a real live girl, and she was doing it back! And it felt so, so good. Like nothing I'd imagined. Better. Oh, so much better.

And there, on the hay in the swine barn, mindless of the pigs snorting and rutting around us, Rita and I lay locked in our tongue-tied embrace. It felt like an hour, but it was probably closer to a few minutes.

When she finally pulled away, there was that irresistible shy smile on her lips.

"Did you like it?" She asked.

My grin was too big to talk through.

"Yeah. Definitely yes."

I moved forward for another, but this time her lips were closed. It

was hard to read what was in her eyes. Or what wasn't. She pulled away.

"You've got it down, Toby. Have fun with Rebecca."

And with that she quickly turned her face away, and ran from the barn before I could say anything.

It was the happiest moment of my life. And the saddest. I knew with the certainty only a sixteen year old could have I would never kiss her again, and that no one would ever equal her. She was a tall, gangly girl with a face covered with pimples, and I'd give anything if she weren't my best friend's girlfriend.

I know what her plan had been, and it worked. Later that night I did kiss Rebecca, with all the fearless confidence of a teenage boy with two minutes of kissing experience. But I never told Rita I was thinking of her when I did.

"Toby. Toby?"

"Sorry."

We were at the entrance of the Ross Creek Campground. The name was humbly painted on a large rock, next to a dirt road. Rita pulled off to the shoulder. "What should we do?"

I craned my neck to see through the trees lining the road.

"It looks like there's a little store down there. That's probably where you register. Let's go inside."

She nodded and pulled into the drive. What we'd seen through the trees was a small log cabin. The sign next to the door said, "Site rentals by day, week, month."

We parked and went inside. A fortyish man with missing front teeth was manning the counter. A glass-doored fridge covered one wall, filled with milk, juice and sodas. A few racks held food basics and snacks. The walls were decorated with rusty old saws and pitch-

forks, and some antique rifles with bayonets affixed to the front.

"Hep' ya?" Toothless asked.

"Yeah, we—" I started.

But his eyes weren't on me.

"Hey! I know *you! Rita MacGilroy! Son of a bitch, man!*"

Rita held out her hand to shake. "Nice to meet you, Mister. . .?"

"Nicky. Nicky Arroyo. Ain't no one ever gonna believe *you* was here. Rita MacGilroy! *Son of a bitch, man!* I'm calling my buds to come over and see ya, okay?"

"That'd be fine. I'd be happy to meet them."

Speak for yourself Rita, I thought. I was starting to hear the dueling banjoes theme from *Deliverance.*

"Nicky? Can you help us?" Rita turned to me for the pictures of Travis. "We're looking for this person and we believe he might be staying here."

He took the pictures.

"Hey, this is the guy they showed on TV! You think he's *here?* They say he's the dude that's got your other baby! Right?" I couldn't imagine what it was like to have the world know everything about your personal life. If he read *People* he probably knew what shampoo she used too.

"Right," Rita said. "Have you seen him?"

"No, I ain't seen him. But. . ." He scratched his head with one hand and stuck a pencil in his mouth where his front teeth were supposed to be with the other. ". . . there's this guy came here coupla' weeks ago. He looked different, but ya know, it coulda been him."

"Is he still here?" I asked.

"Oh yeah. Asked for the most remote spot we got. So I gave him one-twenny-four, way back in the canyon. Most people don't want it 'cause ya gotta walk like five hun'red yards to the bathroom, but he said he wanted real quiet."

"How does he look different?" Rita asked.

"Well, he's got real short hair, not long like the picture, and he's always wear'n sunglasses." He turned to look in a tiny index card holder. "Said his name was Tom Williams. Got an old motor home, a *Lazy Daze* I think. 'Bout a twenny-four footer."

"Have you ever seen him with a baby?" Rita asked.

"No, but I only seen him a coupla times, when he comes in for food. You thinkin' if it's him he's got yer baby, Rita?"

Celebrity put you on a first name basis with the world.

I answered for her and pulled out Hawkes business card. "We think so, Nicky. Can you call this guy, Detective Hawkes, right away? Tell him where we are and that we may have found Travis. Okay?"

Nicky nodded and gave us directions to space 124. "'Jus follow the road here to the split. Go left all the way ta the end. He's the last space. It's 'bout a mile an' a half. Ya know you're gettin' close when ya see the green buildin' for bathrooms an' showers. It's 'bout five, six hun'red yards after that."

We went out to the car. Too much had gone wrong too fast. We weren't about to wait for Hawkes. Within a few minutes we'd passed the split and found the bathrooms.

"We better walk from here," I said.

Rita nodded and parked the car. There were no other campers near the person we hoped was Travis. If it was him, he'd chosen a perfect hideaway.

We could hear a baby crying before we saw the motor home. I had to put a hand out to Rita to stop her from breaking into a run. A minute later it became visible through the trees, parked in a shady spot under a giant oak. There was a small stream running only twenty feet away and I could see hand washed clothes hanging out to dry. I recognized some of Travis's t-shirts.

"It's him," I said. "The baby's inside."

"I don't see Travis anywhere."

"So he must be inside too."

"What should we do Toby? There's just the one door to the trailer, so he can't get out the back. Should we just walk up?"

Of course, we didn't really care about him getting away. It was the baby we didn't want to lose again.

"What are we going to do if he's got a gun or something?" I asked.

"I don't know," she said. And evidently she didn't care, as an inalienable maternal instinct started her walking boldly to the door. I got there first, some primitive instinct of my own making myself a shield for Rita. Through the screen door there was no movement, but we could hear the sound of a shower.

After all this. Some luck. We'd be in and out before he got out of the bathroom.

"Stay here," I whispered.

I opened the door, cringing at the unexpected squeak, but the shower seemed to drown it out. I looked for the baby and panicked when I couldn't see her within the tiny confines of the trailer. Then, there she was—in a car seat, on the floor, wedged between the two seats serving as a tiny dinette. It was a pitiful form of a crib, but her eyes were bright and active, and locked in on us the second we walked in.

Rita had not only ignored my *stay here*, but pushed past me like a force of nature. For a second I was confused. The baby was Remy. No. Remy's twin. But Rita didn't pause. She lifted her out of the car seat and then ran out the door, with me pausing just enough to stop the screen door from slamming.

We ran for the car. But we stopped a few yards short of it. Fanned out behind it were Nicky and a half dozen of his pals. Most of them

had teeth. All of them had guns. Or pitchforks. Or bayonets. They were fanned in a wide circle, like backwoods *Untouchables*. They moved forward until they made a tight circle around us.

I started hearing the dueling banjoes again.

30

"YOU OKAY?" NICKY asked as he and his kinfolk lowered their guns. "Thought you might need some hep'."

"Thank you, Nicky!" Rita said. "He's still in the trailer. He was in the shower when we went in so he didn't even see us. He's still there."

This brought a grin from Nicky. "Let's go git us a kidnapp'r, boys!" And off they went.

We weren't about to stay there. We climbed in the car, and with Remy II on her lap, we drove down the dirt road. We made it almost to the main road when two county Sheriff cars skid to a stop in front of us, blocking the exit.

Hawkes must have sent over some local units. He'd still be a good thirty miles away at the Sheriff's substation. The deputies took in the situation quickly. One sped up toward Travis's trailer and the other stayed with us.

The last few minutes had been filled with terror-filled running.

Now, finally, Rita could look down at the baby. Like a thunderstorm and without warning she started sobbing uncontrollably, drenching the baby.

I got on the phone and called Brogan.

Brogan and Rita named the baby Emma. They'd had a name ready since they learned there was a twin, so it was waiting for her, along with a sister. I'd heard that twins, particularly identical twins, form attachments in the womb, creating inexplicable connections. I saw it the moment Rita laid Emma down next to Remy. The energy of them both changed. Or maybe the picture was just so perfect, our perception of the world changed it for them.

A week had passed since that day. After LADCS's embarrassment in front of Judge Davinov—or maybe because they just wanted to do the right thing—they approved Emma's custody by Brogan and Rita, despite the fact there was no consent to adoption for Emma. LADCS stretched and found an implied consent in the consent to Remy, since they were born at the same time. It was thin legal ground, but since no one was objecting, who cared?

Brogan and Rita had Emma in the doctor's office within hours of our finding her. She did have hyprothryroidism, just as severely as Remy. But just like Remy, they caught it in time. They'd be fine. Together.

Travis was in custody and told all he knew in hopes of a lighter sentence. It seemed his biggest sin was falling in love—or was it in league—with Tori, and getting sucked into her plans. He'd been left literally holding the baby when she was killed.

A few days later Hawkes dropped by to share a beer and celebrate wrapping things up. "Looks like it all started with Stephen Weiss," he said. "That was one Machiavellian bastard."

We'd known Stephen was at the center of it all, but exactly how it started was still a bit shadowy. Thanks to Travis, Hawkes had the answers.

"Tori read for a part in Stephen's movie, which evidently he thought gave him license to bop her a few times," he said.

"The casting couch lives. Big surprise."

"Yeah, but I think the way it's supposed to work is the girl lets the guy do her in return for a part. Weiss didn't live up to his end of the bargain. Not only did he not give her a part, turned out he knocked her up too."

"Well, I think we all knew he was a class guy."

"Right. So who knows why, either she waited too long to get an abortion, or she saw her chance for some leverage. I mean it's not like she wanted kids from what I could tell. Anyway, she puts the paternity screws to Weiss."

"At least she'd get child support," I said. "Weiss had money."

"Right. But the last thing she wanted was kids. I mean, she's young, trying to break into acting, and suddenly she's going to be the mother of two. Not her plan in life, even with child support. It's not like Weiss would take the kids."

"So along comes Stephen with a plan."

"Yeah. And a good one too, if you've got no morals that is. He's in Brogan and Rita's inner circle, so knows they want to adopt, and that you're their lawyer trying to match them up with a birth mom. So he sends Tori your way, knowing you'd show them as adoptive parents. She gets great adoptive parents, and a one-of-a-kind introduction to two of the biggest stars around. So he's selling how it could boost her career too."

"But why'd she keep one of the twins?" I asked.

"That was Tori's twist, and probably what got her killed. Think how panicked Weiss must have been when he heard Brogan and Rita

adopted *one* baby. He knew there were twins, so knew she was up to something."

"So what was her plan?"

"Well, according to Travis, Tori decided doing the adoption only solved half her problems. She'd have no kids to worry about, but there was no guarantee she wouldn't be right back where she started. One of a thousand wannabe actresses."

"Let me guess," I interrupted. "She wanted more than a *hope* she'd get a career out of it all. I mean, by law adoptive parents can't promise a birth mother anything of value. So she wanted a way to legally keep manipulating Brogan and Rita."

"Right. She knew if Brogan and Rita knew about the twins in advance, they'd never adopt only one. No one would separate twins. They'd say both or nothing."

I picked it up. "But if they learned later that Remy had not just a sister, but an identical twin, she knew dedicated parents like Brogan and Rita would do anything to raise both girls together, or at least keep them in contact. Think how Tori could manipulate them."

Hawkes nodded. "Probably would have worked too if she could have kept her secret another six months or so."

It made sense. The adoption laws forbidding anything but a birth mother's pregnancy-related expenses wouldn't be applicable *after* the adoption. Brogan and Rita could do anything they wanted to help Tori, and it would be perfectly legal as long as it wasn't a condition to the adoption itself.

I could see how it'd play out. "Tori knew Brogan and Rita would want to be sure Remy's twin was safe and living well, so they'd support Tori generously—"

"An eighteen year free ride for Tori."

"Exactly. And Tori would end up letting Brogan and Rita convince her to let them raise both the kids together. A visit that would

never end. Great for Tori who doesn't want a kid, but her support would continue. Great for Brogan and Rita who could raise the kids together. Even better for the girls so they're not separated."

"And think what they'd do for Tori's career to keep her happy."

I nodded. "Yeah. I bet that was the biggie. Anything for stardom. Or a piece of it." One thing still bothered me. "What about the phony name? I can see how she had to use one to stay hidden and make her plan work. But it seems like it'd screw things up for her later."

Hawkes shrugged. "Not really. I mean she gave a false name, but she didn't cheat anybody. She placed a child for adoption just like she said she would. Didn't even take any money that wasn't allowed by the adoption laws. It's a nothing offense nobody'd care about. Even if someone found out, I'm sure she had some sympathetic story planned, like it'd ruin her acting career if anyone knew. I'm sure she's not the first person to try to hide a pregnancy."

Of course, Tori lost more than her career. Stephen took her life as well, evidently afraid she'd turn on him with things going badly and the pressure on. He had everything to lose if the blackmail and fraud came to light. His medical license. His toehold in Hollywood.

Hawkes left happy. I didn't want to tell him things weren't quite finished. Not yet anyway. But I owed it to Brogan to talk to him first. In fact, that time had come.

The next morning, I headed up the coast. A bright, beautiful Saturday morning. I noticed every detail of the day as would a man knowing he was living his last day. It wasn't my life which was ending, but I feared my friendship with Brogan. So, maybe it was part of my life after all.

When my alarm had gone off that morning, I kept pushing the reset button over and over, refusing to open my eyes. But as I stared at the clock, the last piece of the puzzle which had been trying to push through my subconscious hit me in the face.

As I pulled up Brogan and Rita's driveway, I was again stunned at the beauty of the day. Clarity and colors I'd never noticed before. Beauty which wasn't usually granted my eyes. Could I be feeling a predetermined fate? I had the odd feeling I was perhaps experiencing my last day on earth.

"Yo! Toby!"

Down across the field, I could see Brogan on the roof of the barn. He was giving me the chest-thump, finger-point routine with mock seriousness.

I waved and walked down the hill. Brogan had told me he'd bought a weathervane for the barn. He'd found one with a cutout of a sheep which he thought Rita would like. The barn was two stories, so probably twenty feet high at the sides, and thirty-five feet up at the crest of the roof. That's where Brogan was, his butt on the crest, one leg going down each side of the roof, fiddling with the weathervane.

"C'mon up."

If I'd had to climb a ladder that high, I'd say forget it. But there was a stairway inside to the second floor loft. From there you could take a ladder up to the cupola extending from the center of the roof.

I told myself if the rooftop was sitting on the ground, there wasn't a chance in a million I'd fall, so why would I fall just because I was thirty-five feet up? Didn't help. But I'd wanted a private place to talk to Brogan. It didn't get any more private than that.

I got to the top of the ladder inside the cupola and could see Brogan through the vented panels.

"How am I supposed to get out there?"

"Here," Brogan said, opening a hinged side of the cupola, letting me crawl out. "Nice, huh?"

He was right. The day couldn't be more perfect. A pair of red tailed hawks seemed to stand still in the air above us, holding a wind stream.

"How're the kids?"

"Perfect. Gotta schedule another christening. Double your godfather duties, you know."

"Hey, there's Rita." I saw her come out and give us a wave. She was too far away to yell to, so we just both waved back.

"About time you made it up here," he said. "Who'd be here to catch me if I fell?" No joke there. We'd spent a lifetime catching each other.

There was no right moment. I had to get it out.

"Brogan?"

"Yeah?" He was having a hard time getting a bolt to seat properly to affix the weathervane to the cupola's tiny roof.

"I saw your tests."

"What tests?"

"The blood tests. For your and Rita's infertility. At Stephen's that night."

He stopped fidgeting with the weathervane.

"Oh."

I looked him in the eye. He'd prefer that. "How long have you known Rita was your sister?"

He held my eyes for awhile, then looked away.

"Half-sister," he said, as if it made a difference.

I didn't push and let the silence sit. I didn't know how the day could be so beautiful all around us, while his world was falling apart.

Finally he said, "It was two years ago. Rita and I still couldn't get pregnant. We did a bunch of tests. Then more tests. No one was looking for that, of course. But it showed up."

"But Stephen told only you?"

"Yeah. Said he'd let me tell her, so we could discuss how to end the marriage. End the marriage. Just like that."

Brogan seemed to drift off, reliving it in his mind. "So I went

home, but I couldn't do it. I knew we couldn't stay married. And we couldn't just switch to brother and sister. Every time I watched her do anything. . . laugh, comb her hair. . . I knew it'd be the last time I'd see her do it that way in front of me."

Brogan refocused on me. "So I went back to Stephen. Told him I wasn't going to tell her. Begged *him* not to tell her. He said he'd need something from me since he was taking such a risk. Said he'd lose his license if anyone found out he didn't tell her."

"Probably what he planned all along."

"Yeah. He said he understood. Knew the scandal would ruin both our careers. Idiot. He didn't get it. I just didn't want to lose Rita. I wanted to keep the life with her I had. . . So I fund his movie. Who cares? It was a small price to pay to keep my life. My wife."

"So what'd you do?"

"Nothing. I mean, to look at us, everything's the same. But it's not. I can't make love to her, knowing what I know. And I can't tell her why."

"Is that why you killed Stephen?"

He had too much courage not to deny it.

"How'd you know that one, Toby?"

"Took me awhile. It was my alarm clock. I remember when I was at your house with Stephen. He told me he bought you some expensive stereo system, and about how you could program it to turn on and off at whatever times you wanted. Said he had one just like it."

Brogan didn't say anything, so I kept going.

"When we were at his house and trying to get out after he came home, I couldn't figure out why you made us stop at the front door when you said you heard something. It didn't really make any sense, because if he *was* coming, it was even more reason to get out of there. But you set his stereo timer and were waiting for it to go on, so I'd think he turned it on. I was your alibi."

Brogan stared at his hands, maybe questioning their acts. "I blew it, huh. Wiped the grip, but forgot I touched the head when I pulled it out of the bag."

"Yeah. Blew it." I thought *blowing it* was the killing itself, not failing to cover it up. But then Stephen wasn't my blackmailer, and a conspirator to my missing child.

"What I can't figure out is why Rosa confessed." Brogan said. "When she went in, he was already dead. Could it be part of whatever scam she's running?"

"There's no scam, Brogan. She's your birth mother."

I watched as his eyes literally went blank. Looking at some point of the universe, or his past, that no none else could see. "She told me the day she confessed, Brogan. She did it because she loved you. Loves you. She didn't have to raise you to love you. It's a sacrifice she wanted to make for you."

A funny little sound escaped his throat.

"My mother. . . After all this time." He shook his head with wonder. "She was living right here with me. Taking care of us. Of Remy."

"She's *still* trying to take care of you." Taking his place in jail.

"I've got to get her out, Toby. I've got to turn myself in."

I just nodded. Letting Brogan work it through. There was more to tell him.

"Then she wasn't up to something when she had all that money in our names. . . But what?"

The answer was in my pocket. Dr. MacGilroy's letter to my grandpa. I handed it to Brogan.

Dr. MacGilroy had been the best of men, but even the kind are not always virtuous. He'd slept with a Mexican girl, and that baby would become Brogan. The married Anglo doctor and the migrant girl. Rosalita, Lettie for short. They both knew there were no options,

except adoption. And secrecy. My grandpa was willing to help. Lies aren't good, but we convince ourselves they're for the best. The story about the stillborn child was a tale, as was the Italian birth mother. There would be no suspicion, no stigma of migrant blood.

Brogan was born a few months before Rita. When Rita's mother died in childbirth, Rosalita became Rita's live-in nanny. Maybe there'd been real feeling between her and Dr. MacGilroy. Who knows? So Lettie took all the love she couldn't give to her own child and heaped it on Rita. How happy Dr. MacGilroy must have been when Brogan and Rita became friends in kindergarten, becoming almost the equal of a son over time. But how hard on Lettie to see the son she gave up start coming over, but be unable to show her love in a way which would be socially accepted.

Our friendship had began when kindergarten started. That was when Lettie couldn't face it anymore and returned home to Mexico. Rita's dad probably felt just as strongly when he caught Brogan and Rita making out years later. Only he couldn't tell them why it was forbidden.

Brogan lowered the letter.

"So Rosa and Lettie. . ." He started.

"Rosa *is* Lettie. They're both diminutives of Rosalita. She knew you weren't ready for the truth, so she called herself Rosa. But she came back, Brogan, *because you asked her to.* I guess she used *Rosa* in case we remembered her a little from back then."

"I can barely remember her. Isn't that terrible?"

"Brogan, it was twenty-seven years ago. You were five years old."

"With me then and with me now." He just shook his head. "You know when I talked about finding my birth mother on *Leno*?"

"Yes."

"Did you think about why I didn't talk about finding my birth fa-

ther? It's because I knew if Rita was my half-sister, we had to have the same father. We were born a few months apart so it couldn't be our mothers. So I knew Dr. MacGilroy was my biological father. At least I know why he hated me at the end."

"He didn't hate you Brogan—"

"I know. You know what I mean. He just couldn't tell us why Rita and I couldn't be together. The only way to do that was to keep me away.

Brogan looked down at Rita. Unaware of his attention, she was watering some potted plants on the patio, moving to music we couldn't hear.

"So Rosa is Rita's Lettie. That explains a lot," he smiled. He'd been mystified by her immediate bonding with Rosa. It made sense now. There was no way any of us, even Rita, would recognize Lettie. But something in Rita had remembered the essence of her, grabbed on to the feeling of her without knowing why.

"But where'd the money come from, Toby?"

"Rosa told me. Rita's dad gave her $5,000 when she went home to Mexico to get a fresh start. But she never spent it. Never thought it was right to keep it, so saved it for you. Didn't know you'd end up rich. She let her bank invest it and the stock market took care of the rest."

"Oh, Toby. . . I've ruined it all. I've killed a man. I'm going to prison. The world'll know Rita's actually my sister. She'll be humiliated. And she'll be alone."

He stood up on the crest of the roof and I felt my chest tighten.

"Even when I get out. What will I be? Not a husband. Not a brother. I'll be what?"

I suddenly had a vision of Brogan running along the crest of the roof and jumping to his death. But he knew suicide would be one more burden for his wife and children to bear. I couldn't see him do-

ing it. Still, I tried to make it look casual when I stood up, ready to grab him if I needed to.

It was then that he looked at me strangely. Did we have the thought at the same time? If it was me that fell, his life would go on. No prison. No telling Rita. Stephen dead and Rosa willingly sacrificing herself for him. Was our friendship enough to give up everything he had?

I don't know why I did it, but I turned my back to him, as if to study the view. We'd put our lives in each other's hands over the years. I had to do it again, but never as before. I forced myself to relax as I could hear him silently move closer. The slightest touch would send me over the edge.

He spoke to my back. "Toby?"

"Yeah?"

"Let's get down."

I turned around and he paused to look at Rita one more time, then we climbed down the ladder to the loft area of the barn. Brogan had a small workshop there.

"Let me drill out this hole a little more," he said.

The weathervane seemed the least of his worries, but maybe he didn't want to face the real ones.

"Toby, you'll take care of everything for Rita and the kids? And Rosa too?"

"Of course."

"You know where I keep all my papers, right?"

"Yep."

I wanted to say he was going to jail, not Siberia.

"Is this going to mess up the adoption for Rita?"

"I can make it work."

He had a glass of iced tea on the workbench, and he spilled some all over his hands. "Oops."

"Can you grab me a towel out of that drawer?" he asked.

There was an old cabinet on the far side of the loft. I walked over and rummaged through it, but couldn't find any towels.

"Brogan, there's no—"

I looked up to see Brogan had the plug of his drill press in his wet hand. He was bent over the power outlet, one of the big 220 volt ones for heavy equipment with twice the voltage of household 110. I could see his dripping fingers tighten around the back half of the metal prongs.

"Toby. You've got to say it was an accident. It'll hurt them less. You're a great friend."

"Brogan, no!"

He pushed the plug into the wall, his fingers still wrapped around the base of the prongs. His body arched in blue torment. His hand stayed impossibly glued to the plug and I'd swear his feet left the ground before the circuit breaker blew the circuit and he was thrown across the room. It took me a split second to identify what I smelled was burnt flesh.

I ran to him. His body was literally smoking. When I touched him, his skin was absurdly hot. No CPR was going to bring him back. Brogan was dead.

31

THE BOAT WAS perfect. I'd spent too much time away from tennis working on it, but it was worth it. It couldn't have looked better the day it first touched the sea. Of course, some water around the hull, instead of grass, might have been appropriate, but was not to be.

It was the last day of January. The avos were almost ripe for the late-set winter picking. Looked like about eighty pounds a tree. Not bad. Not great. Kind of like my life lately.

Brogan's will had called for a wake. It was my first wake, Rita's too. Felt odd, but somehow appropriate, to celebrate his life, rather than mourn its loss. But there was more than enough mourning in private. Rosa was there, the charges against her dropped. Gina and Hawkes were also there. They'd come together.

We'd amended the Petition for Adoption to a single parent petition for Rita, and it was granted three weeks ago. I think even the media had been exhausted by the previous coverage, so they left the final stages of the adoption alone, which was fine with us.

Brogan's death had been ruled an accident, with the help of my testimony. Felony number five—giving false testimony under penalty of perjury. I didn't even tell Rita he took his own life, although I think she knew. I didn't agree with Brogan's solution, but he'd been right to some degree about it making a less complicated future for Rita and the twins. I did tell her about everything else. She needed to know exactly what Rosa's relationship was to both her and Brogan. She'd lost a husband, but found a mother.

The murder became public information though, as I had to share Brogan's confession to exonerate Rosa. When it was over much of the public saw Brogan's act as heroic, fighting to protect his family. The studio rushed post-production to get his last project on the screen, and the early Vegas line has him as the favorite to posthumously win the Oscar.

I felt the loss of Brogan more than I could have imagined. Even when we hadn't seen each other for long stretches of time, like when I was in Nepal, we still knew the other was there. I had to tell myself he was still here. Part of him would live forever through Rita, the kids. Even me.

The loss of Rita was just as deep. We worked together to wrap up Brogan's affairs, then complete the adoption. But it was clear she'd been politely avoiding me since Brogan's death, almost six months ago. Did she subconsciously blame me for all that had gone wrong? Did she need a fresh start and I was a reminder of too much pain in the past?

It was Sunday and I was committed to making a day of Sunday Things. I'd spent last night on the boat, so I hadn't received my newspaper. I headed into town for a paper and a supply of snacks to watch the football games on TV. Can't watch football without eating.

When I got back to grandpa's there was a pickup parked next to the boat, a new Ford Super Crew, with the full sized cab and four

doors. Fruit thieves wouldn't park out in the open. Besides, the back was full of bales of hay. No one was on the boat, so I started scouting the grove. I followed the sound of voices.

It was Rita.

She was sitting under Toby Tree, oblivious to grandpa sitting next to her. At first neither one noticed me. Grandpa's eyes were on Rita, and Rita's were focused toward the pond, where Rosa, Remy and Emma relaxed on a blanket on the grassy bank.

Both grandpa and Rita noticed me at the same time. Rita waved and got up. But for the first time since he'd died, grandpa didn't come to greet me. He gave me a good long look, a satisfied smile, then headed back into the grove. If I'd have known then I'd never see him again, I'd have run after him.

Rita came up to me. She looked so freshly scrubbed and lovely I almost felt my knees buckle.

"The boat looks *great*, Toby."

"Thanks. You want to see it?"

"Yeah!"

She took my hand as we walked up. All of a sudden, my legs didn't work quite right.

"Can you remember how many days we used to come out here? You'd always say one day you and your grandpa would have the most perfect yacht in Fallbrook."

It was our old joke. "Yeah, and the *only* yacht in Fallbrook."

Her hand felt as soft as a dove's breast in mine.

"What's with the hay?" I asked.

"I thought I'd bring my sheep back some of Fallbrook's finest. The feed stores aren't as good up my way."

"Maybe you should just move back here. You know, for the hay."

She smiled. "Maybe."

We reached the boat.

"You kiss a girl on this boat yet, Toby?"

"No. No girls. No kissing."

She stopped walking and faced me.

"Can I be the first?"

Wow.

"Yes."

"But I kissed *you* last time. This time *you* have to kiss *me*."

As much as I wanted to rush to those lips, I had to look into her face first. Literally drink her in. She was *so* gorgeous. Maybe not as perfect as the pimply, skinny girl on the haystack sixteen years ago, but as close as could be. And best of all, the look in her eyes at this moment was the same as it was then. I thought I'd never see that look again.

And then I kissed her.

Toby Dillon is back!

Baby Crimes

June, 2006

FREE BOOKPLATE

A bookplate is an adhesive sheet, sized to fit on a book page. It's a way to get your book personally signed by the author when you can't attend a bookstore signing.

To get your free, signed, *The Baby Game* bookplate, just mail a self-addressed envelope, with standard letter postage affixed to:

The Baby Game bookplate
WordSlinger Press
9921 Carmel Mountain Road #335
San Diego, CA 92129

If you'd like your bookplate personalized (ex. "To Pat"), please enclose your desired salutation, and limit it to a name greeting.